REMBRANDT AND THE PASSION

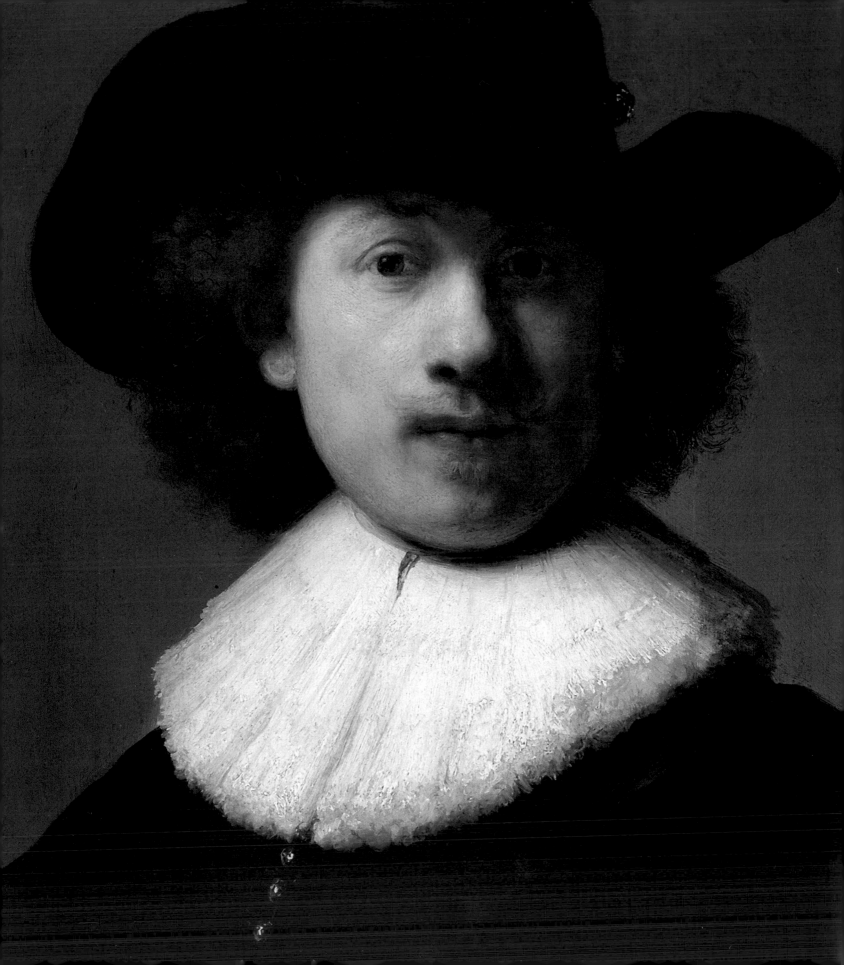

PETER BLACK

WITH ERMA HERMENS

REMBRANDT
AND THE PASSION

PRESTEL

MUNICH · LONDON · NEW YORK

Front cover: cat. 1
Frontispiece: cat. 3 (detail)
Back cover: cat. 26 (detail)

Prestel, a member of Verlagsgruppe
Random House GmbH

Prestel Verlag
Neumarkter Str. 28
81673 Munich
Tel. +49 (0)89 4136-0
Fax +49 (0)89 4136-2335
www.prestel.de

Prestel Publishing Ltd.
4 Bloomsbury Place
London WC1A 2QA
Tel. +44 (0)20 7323-5004
Fax +44 (0)20 7636-8004

Prestel Publishing
900 Broadway, Suite 603
New York, NY 10003
Tel. +1 (212) 995-2720
Fax +1 (212) 995-2733
www.prestel.com

Exhibition
15 September – 2 December 2012

Library of Congress Control Number:
2012939411

British Library Cataloguing-in-Publication
Data: a catalogue record for this book is
available from the British Library.

The Deutsche Nationalbibliothek holds a
record of this publication in the Deutsche
Nationalbibliografie; detailed bibliographical
data can be found under:
http://dnb.d-nb.de

Prestel books are available worldwide.
Please contact your nearest bookseller or
one of the above addresses for information
concerning your local distributor.

Editorial direction: Ali Gitlow
Editorial assistance: Supriya Malik,
Francesca Dunnett and Katie Balcombe
Copy-edited and proofread by: Sarah Kane
Production: Friederike Schirge
Design and layout: Robert Dalrymple
Origination: Reproline Mediateam, Munich
Printing and binding: Firmengruppe Appl,
Wemding

Printed in Germany
Verlagsgruppe Random House
FSC-DEU-0100
The FSC®-certified paper
Profisilk was supplied by
Igepa, Germany

ISBN 978–3–7913–4736–3

Santander

Kingdom of the Netherlands

CONTENTS

FOREWORD

Rembrandt's *Entombment Sketch* is one of the jewels of the collection formed by our founder William Hunter (1718–1783). It is a real delight to have a painting by Rembrandt which has always been regarded as authentic. When it has gone away to exhibitions, the work has often met with gasps of delight when people see it, partly because it is such a moving image of the Entombment of Christ, but also because it is so wonderfully well preserved. It is a puzzling object, however, because although it is a painting on panel, it is also a sketch. In the Rembrandt literature it has been explained as one of a group of sketches for Passion subject etchings that the artist made in the mid-1630s. We had our doubts about this when the painting went to a wonderful exhibition called *Rembrandt's Journey* in Boston and Chicago in 2003–4. There it was exhibited with the group of oil sketches related to the artist's etchings to which our painting was said to belong.

The present exhibition came about in order to put paid to these doubts and has been organised around the relationships between our painting and other works. These include works by Rembrandt but also paintings and drawings that were in his magnificent collection. We have been extremely fortunate in the support we have received, especially from a number of institutions. It was the Museum of Fine Arts in Boston that set us thinking about making this exhibition, and it was thanks to the Scientific Department of the National Gallery, London that new data and imagery has been made available for analysis in this publication and for presentation in the exhibition. I would like to thank especially Ashok Roy, Head of the Scientific Department, for facilitating the work on our painting in London in June 2011. A number of grants have helped with research for the development of the exhibition, and these are acknowledged on page 10.

A crucial role in both exhibition and publication has been played by our colleague, Dr Erma Hermens. Her expertise in technical art history had a decisive influence on the research from the very beginning. Her analysis of the scientific data produced by the collaboration with the Scientific Department of the National Gallery in London has changed the way we look at this painting, which is unique in the artist's oeuvre. I am extremely grateful to Erma for enlightening our approach to Rembrandt.

Putting together the art-historical and technical arguments about the history and making of our painting means bringing to Glasgow a dozen great works of art by Rembrandt. I would like to thank all of our colleagues in the museums, galleries and libraries who kindly agreed to lend works. These works are extremely precious and we are grateful to the Government Indemnity Scheme, and to Olivia Basterfield of the Arts Council, for providing indemnity cover while the works are on loan to us. We have been very fortunate in the generous support we have received from the Fondacion Banco Santander and the Cosman Keller Art and Music Trust. I would like to pay special tribute to the main supporters of the exhibition, Mr Vincent Kas, Head of Commercial, UK & Ireland Air France/KLM, and to the Embassy of the Kingdom of the Netherlands. It has been very fortunate for us that the exhibition came to the attention of Mr Jan van Weijen, Head of Public Diplomacy, Press and Culture, who has been a keen supporter. His advice and help have been invaluable.

PROFESSOR DAVID GAIMSTER
Director of The Hunterian

SUPPORT FOR RESEARCH AND PUBLICATION

Travel for research in Amsterdam, Haarlem, Rotterdam and Munich in 2010 was funded by a grant from the Carnegie Trust for the Universities of Scotland. In March 2011 research in the National Gallery, London and in the Rijksbureau voor Kunsthistorische Documentatie (RKD) and Mauritshuis in The Hague by Peter Black and Erma Hermens was made possible by a grant from the National Gallery's Subject Specialist network; we are very grateful to Mary Hersov, the National Gallery's National Programmes Manager, for all her help.

The costs of preparing the catalogue were generously supported by the Gordon Fraser Charitable Trust. We would like to thank the Trust, and especially Claire Armstrong, for their support.

LENDERS

Alte Pinakothek, Munich

British Museum, London

Burrell Collection, Glasgow Museums

Courtauld Gallery, London

Metropolitan Museum of Art, New York

National Gallery, London

Royal Pavilion, Museums & Libraries,
Brighton & Hove City Council

Scottish National Gallery, Edinburgh

Teylers Museum, Haarlem

University of Edinburgh,
Centre for Research Collections

University of Glasgow Library,
Special Collections Department

ACKNOWLEDGEMENTS

No amount of rethinking our view of Rembrandt's *Entombment Sketch* would have been worthwhile without the support of a number of scientists, especially colleagues in the National Gallery in London to whom we are extremely grateful. We offer our thanks to Marjorie E. Wieseman, Curator of Dutch Paintings, and to staff in the Library for help with our research; to Larry Keith, Paintings Conservator, but especially to the staff of the Scientific Department, Ashok Roy, Helen Howard, Rachel Billinge, David Peggie and Joseph Padfield. They made us welcome, gave us the benefit of their knowledge and experience, and made the new X-ray, infrared and other images that have been essential for the direction of our research.

As well as the team from the National Gallery mentioned above, we would also like to thank Peter Chung, Geographical and Earth Sciences, University of Glasgow, for providing SEM-EDX analyses, Dr Kirk Martinez and Dr Philip Basford of Southampton University for providing us, while the painting was in the National Gallery, with a polynomial texture map for use in the exhibition. Our research in The Hague was greatly helped by Michiel Franken at the Rijksbureau voor Kunsthistorische Documentatie, and Petria Noble, Head of Conservation at the Mauritshuis. The dendro-chronological survey of the panel was done for us by Dr Aoife Daly, Marie Curie Fellow at University College Dublin. We are very grateful to Aoife for coming to Glasgow and not just for dating the panel but for demonstrating to an MLitt class the technique of measuring its growth rings.

We would like to thank the following for reading and commenting on the texts in draft form: Michael Black, Andrew Greg, Pamela Robertson, Gary Schwartz, Christian T. Seifert, Senior Curator of Netherlandish Painting at the Scottish National Gallery, as well as Ashok Roy and colleagues at the National Gallery Scientific Department. Exhibitions require a great deal of extra energy and we would like to acknowledge the good work by all of our colleagues at The Hunterian, especially in design, conservation, publicity and photography. Special thanks to Elizabeth Jacklin, who has worked for 12 months as our Museums Galleries Scotland intern. Elizabeth has compiled the chronology and bibliography, and obtained the imagery with great efficiency.

With thanks also to: Marina Aarts; Stijn Altsteens; Ronni Baer; Christopher Baker; Matthew Barr; Cathy Bell; Jantien Black; Julia Blanks; Bob van den Boogert; Hannah Brocklehurst; Janet Brough; Christopher Brown; Edwin Buijsen; Quentin Buvelot; An van Camp; Caroline Campbell; Andrew Cherniavsky; Jane Clark, Michael Clarke; David Collins; Marcus Dekiert; Julie Gardham; Antony Griffiths; Johnny van Haeften; Claire Hallinan; Craig Hartley; Elspeth Hector; Julian Hogg; David Jaffé; Christophe Janet; Luis Juste; Friso Lammertse; Celeste Langedijk; Jenny Lund; Joseph Marshall; Gregory Martin; Ellen McAdam; Fiona McKellar; Peter Morris; Joanne Orr; Claire Pace; Cassia Pennington; Michiel Plomp; William W. Robinson; Maartje Romme; Martin Royalton-Kisch; Marijn Schapelhouman; David Scrase; Desmond Shawe-Taylor; Michael Simpson; Jan Six; Sandra Tatsakis; Jaap van der Veen; Jørgen Wadum; Arie Wallert; Arthur K. Wheelock Jnr; Christopher Wintle.

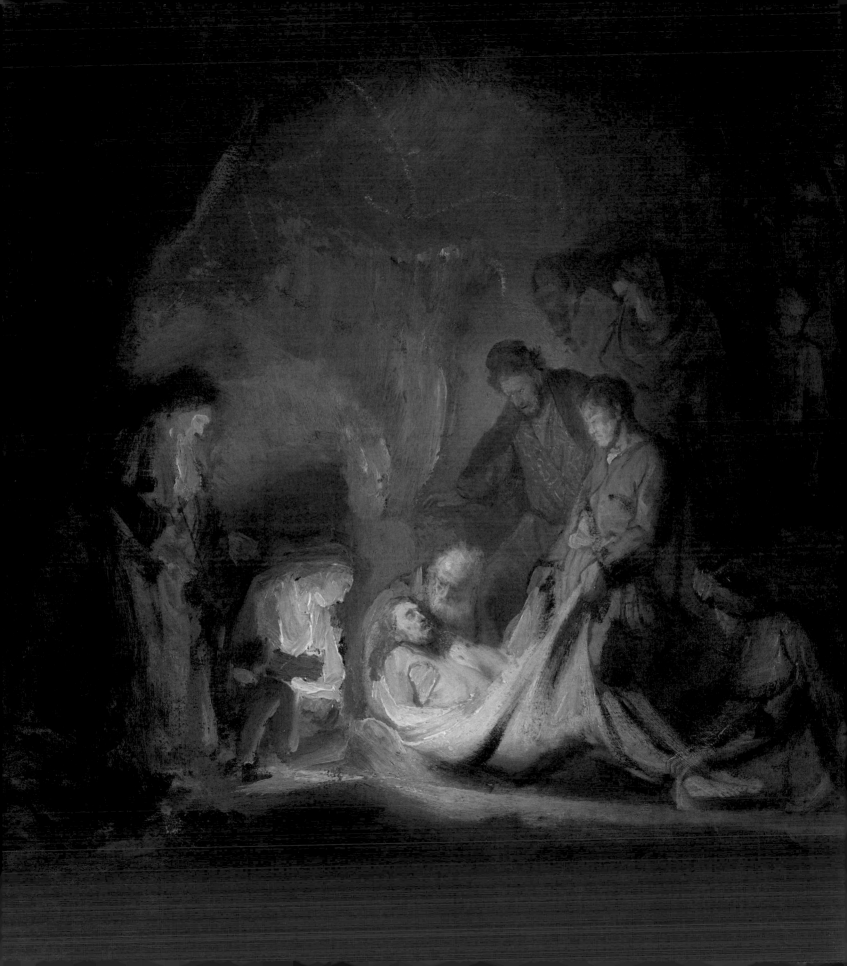

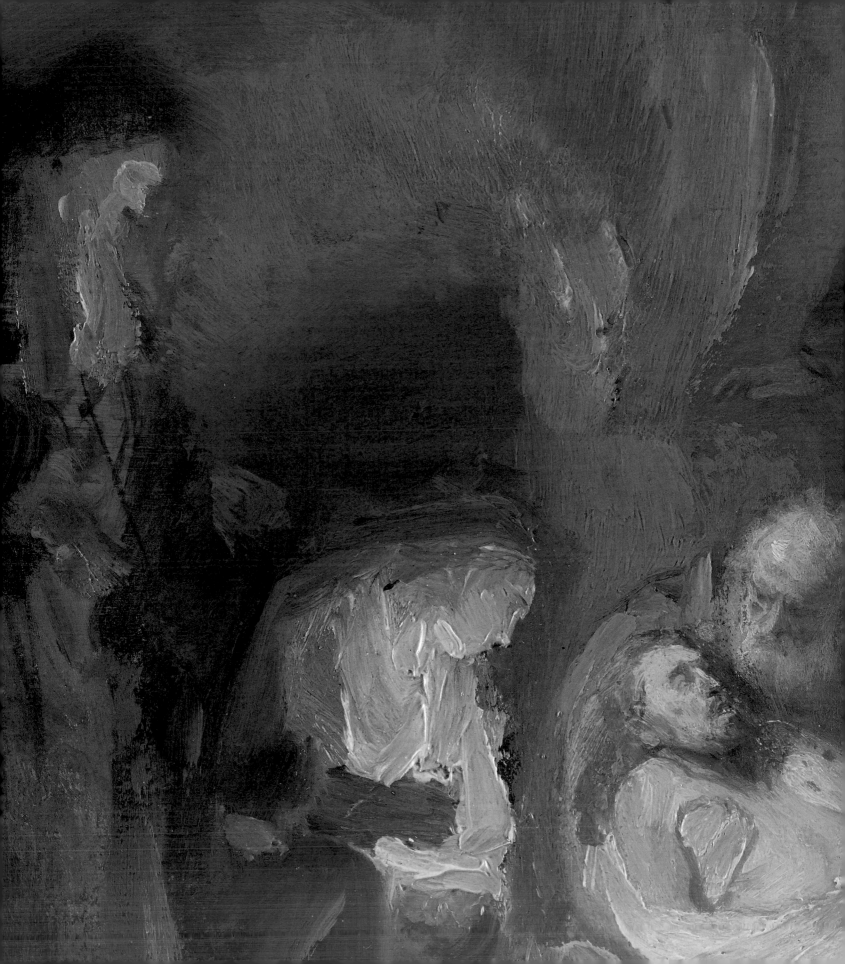

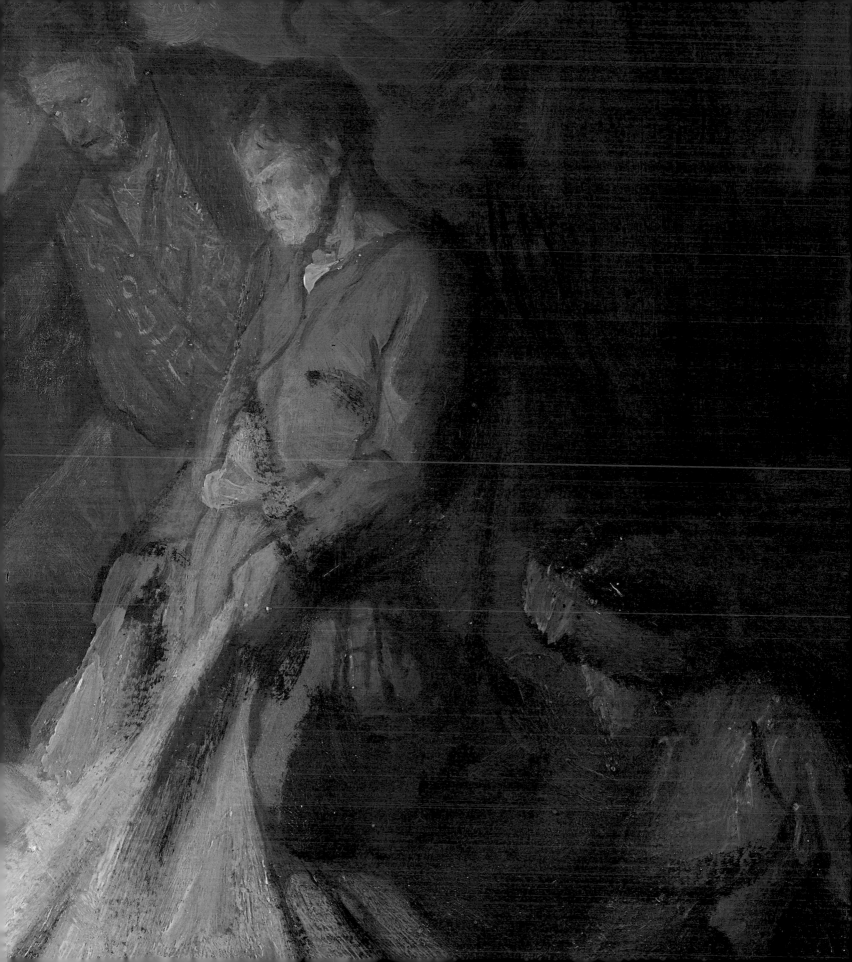

1 REMBRANDT'S ENTOMBMENT SKETCH: AN INTRODUCTION

Rembrandt's *Entombment Sketch* [fig. 1], which is the subject of this book, is part of the collection formed by the anatomist Dr William Hunter that has been on public display in the University of Glasgow since the Hunterian Museum opened to the public in 1807. It belongs to a special group of works by Rembrandt, the authenticity of which has never been doubted. This publication presents the first full study of the painting, relating its history and describing when, how and – as far as we can tell – why Rembrandt made it as he did. In this chapter, the Entombment of Christ is investigated as a subject for artists. This is followed by a history of the painting and an account of its treatment in the Rembrandt literature. Chapter 2 describes Rembrandt's Passion subjects, including the series of paintings made for Frederik Hendrik, which form the background against which the Hunterian *Entombment* was made. The *Entombment Sketch* is compared with Rembrandt's painting of the *Entombment* now in the Alte Pinakothek, Munich [fig. 2]. The differences point to a later date for the *Entombment Sketch*. Chapter 3, which looks at Rembrandt's *kunst caemer*, or 'museum', explains the role played by Rembrandt's impressive collection of prints and drawings in the iconographical research that influenced his treatment of the Entombment subject in both the Hunterian panel and the related Munich *Entombment*. Chapter 4 gives an account of the recent scientific research into the dating of the panel and into the materials and techniques used to make the painting. Two phases of work on the panel are identified, with a core central group very similar to the Munich painting, around which Rembrandt painted revisions in a style that is characteristic of much later work.

The painting is executed mainly in brown, ochre and white paint on a small oak panel measuring 32.2 × 40.5 cm, of the kind used for paintings for the open market. The paint is thinly applied, especially in the central figure group above Christ. In a subsequent campaign, Rembrandt altered the group immediately behind and to the left of Christ and the paint is more thickly applied here. Among other changes, he inserted the woman with the candle, to Christ's left, modelling her with a thick impasto of white paint which very effectively covered whatever was underneath. The

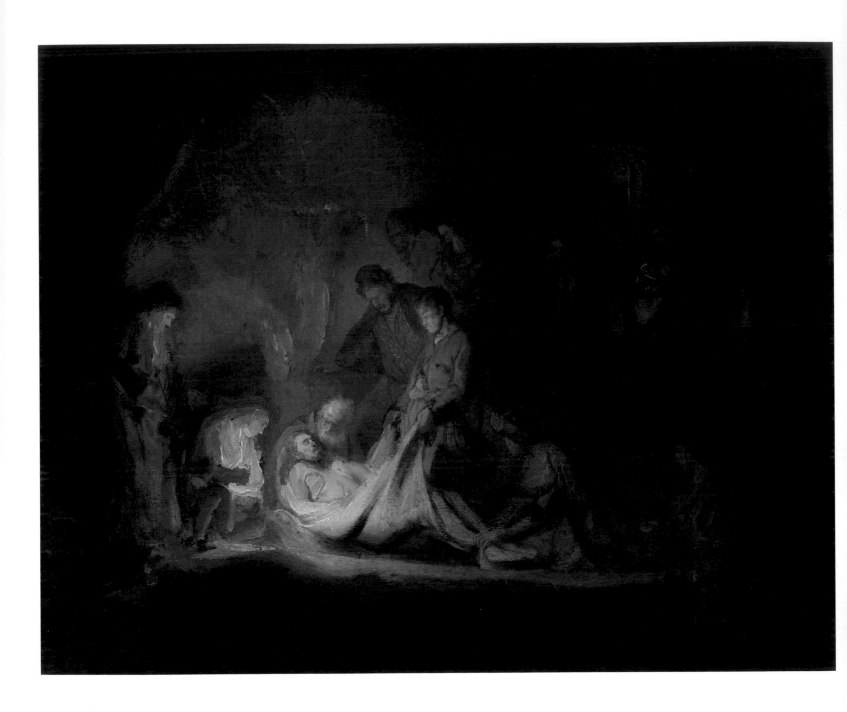

Fig. 1 | *The Entombment Sketch*, oil on panel, 32.2 × 40.5 cm,
The Hunterian, University of Glasgow (cat. 1)

Fig. 2 | *The Entombment*, c.1635–39, oil on canvas, 92.5 × 68.9 cm,
Alte Pinakothek, Munich (cat. 4)

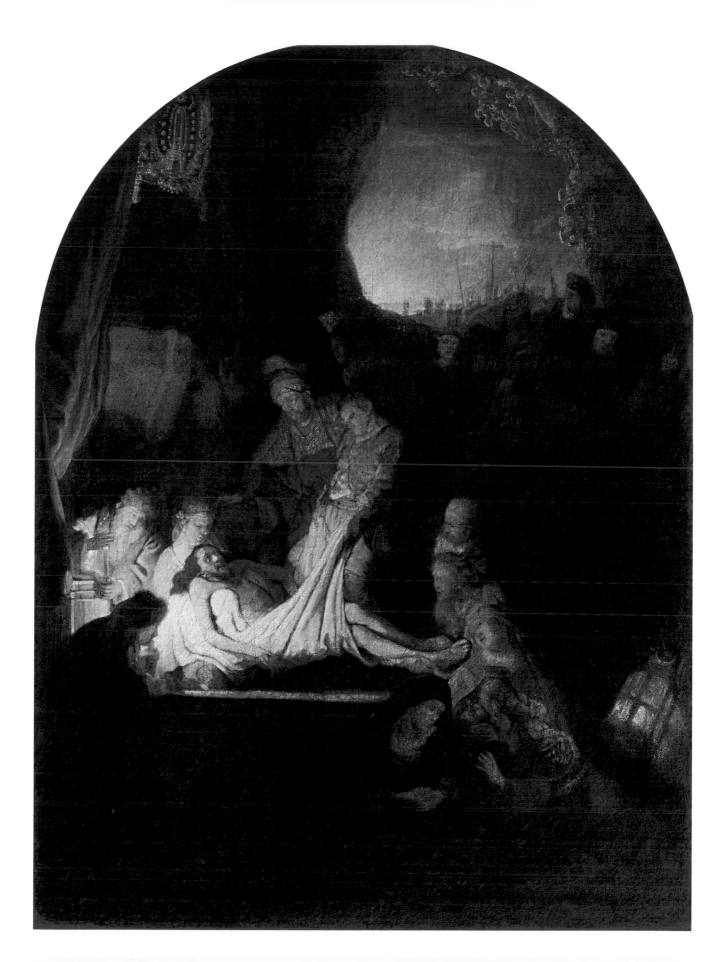

Entombment takes place in a dark cave, with a niche to the left with an arched top. In the darker background to the right, a group of very sketchy figures, including a man with a broad headdress, is descending into the cave. Just to the left of centre, an old, bearded man holds Christ closely to him in an embrace; above, in the centre, stand two men, one richly dressed, looking on, while another, younger, figure lowers Christ's body by the corners of the shroud. To the left, the composition is framed by two very sketchy figures: a tall, bearded man with round cap, and a woman holding the candle that illuminates the whole scene. Two dark figures can be seen in the right foreground, one by Christ's feet and another further off.

Even if it is not a major work, this small painting is nonetheless one of the best preserved of Rembrandt's works, and the study that follows is for this reason all the more revealing about the artist's practice as a painter. It was found to correspond to the mention in Rembrandt's 1656 insolvency inventory of 'A sketch of the Entombment of Christ by Rembrandt' and it has become known as the *Entombment Sketch,* retaining this old label of 'sketch', although there has not so far been a definitive account of its function. In the past, when the painting was discussed in the Rembrandt oeuvre catalogues of Bredius (1935), Bredius revised by Gerson (1969) and of the Rembrandt Research Project (1989) or in exhibition catalogues, it was categorised as a 'grisaille', or painting in monochrome, and was given a place as part of a reconstructed series of oil sketches that were made as studies for etchings of Bible subjects in the years c.1633–35. This group centres around a signed and dated oil sketch on paper – the *Ecce Homo* [fig. 9] – which is the only one of these oil sketches that actually resulted in an etching. A likely date for the *Entombment Sketch* was suggested by its close relationship to the Munich *Entombment*, a canvas from the so-called Passion Series on which Rembrandt worked between late 1635 and January 1639. This date range fitted neatly with the chronology proposed for the group of sketches for Passion subject etchings. The existence of a 'grisaille' *Entombment Sketch* was seen to support the idea of the print project, although there are various ways in which, in our opinion, the painting does not fit within with the group.

Our research has considered these assumptions afresh. A comparison with the Munich *Entombment* from the Passion Series is our starting point as it has been for all previous discussion. In addition, the selection for the exhibition brings together two groups of works that illustrate Rembrandt's working methods. The first consists of two oil sketches of c.1633–35 belonging to the group of designs for prints, with a small number of related works. The second comprises prints and drawings of the kind that Rembrandt collected in his impressive *kunst caemer*. Using his extensive

collection Rembrandt was able to consult images of the Entombment by various other artists. In considering these three groups of works we have formulated our own answer to the principal research question: in what sense is the *Entombment Sketch* a 'sketch'? Is it, as suggested in the past, a preparatory sketch for an etching, or is it, rather, an unfinished painting?

THE SUBJECT OF THE ENTOMBMENT

Rembrandt's *Entombment Sketch* represents a scene from the Passion of Christ. The Passion as a subject in art departs from the text of the New Testament stories of the suffering and death of Jesus Christ. The Gospels tell of Christ's death on the Cross as well as the events leading up to his crucifixion and immediately afterwards. Death is followed by the miraculous resurrection, and so it is a painful story that leads to redemption through the great mystery that is central to Christian belief. Passion subjects were hardly represented at all in early Christian art, but became popular during the Middle Ages, particularly in painting and drama. The story has furnished the subject matter for many of the most impressive and dramatic of all works of art. Passion paintings have not been limited to the role of altarpieces or devotional paintings. In the Renaissance, as the art of painting developed and artists acquired the skill to represent emotion and expression convincingly, the Passion of Christ became a subject that provided the ultimate challenge for those who represented the universal theme of human suffering, with Christ as symbol for Man.

In the Protestant northern provinces of the Low Countries, artists avoided images that could be regarded as idolatrous. The sudden disappearance in the Reformation of church commissions resulted in the development of new kinds of subject matter. Nonetheless, Rembrandt and others continued to paint Bible subjects because there was still a significant demand, especially among wealthier collectors. The Bible was certainly a formative part of Rembrandt's upbringing and training as an artist. This much is clear from the celebrated painting of the *Prophetess Hannah* of 1631, for which the artist's mother modelled (Rijksmuseum, Amsterdam; *Corpus* I, A 37, fig. 3). Hannah, or Anna (Luke 2: 36), is shown responding to a prophecy of the coming of the Messiah, whom she has just recognised in the infant Jesus. This biblical image is also one that Rembrandt singled out to advertise his practice as a painter, for he included it in a group of early pictures that were reproduced for him as prints by the Leiden etcher Jan van Vliet (c.1600/1610–1668). Whatever else was happening in Dutch painting, many of Rembrandt's greatest works, in painting as well as etching, were drawn from the Bible. The *Entombment Sketch* is not itself part of a cycle of paintings but its iconography is closely related to

Fig. 3 | *The Prophetess Hannah*, 1631, oil on panel, 60 × 48 cm, Rijksmuseum, Amsterdam, SK-A-3066

an *Entombment* painting that was part of the 'Passion Series' Rembrandt produced for the Stadholder of the Dutch Republic, Frederik Hendrik, which formed the most important commission of the artist's early career.

The Entombment took place on the day of crucifixion, when Christ's body was obtained from Pilate by a rich man, Joseph of Arimathea. The Gospel accounts are very brief, leaving artists considerable freedom to interpret the scene. From Matthew 27: 57–60 we learn that the burial took place in the evening, and that Joseph of Arimathea, who was a disciple of Jesus, wrapped Christ's body in a clean linen cloth and laid it in a tomb he owned which was carved out of the rock; the tomb was closed with a stone. Two women, Mary Magdalen and 'the other Mary', were sitting nearby.

John's Gospel, 19: 38–42 tells us in addition that Joseph was accompanied by Nicodemus, who brought spices with which to embalm the body and that the tomb was in a garden:

> And after this Joseph of Arimathea, being a disciple of Jesus, but secretly for fear of the Jews, besought Pilate that he might take away the body of Jesus: and Pilate gave him leave. He came therefore, and took the body of Jesus. And there came also Nicodemus, which at the first came to Jesus by night, and brought a mixture of myrrh and aloes, about an hundred pound weight. Then took they the body of Jesus, and wound it in linen clothes with the spices, as the manner of the Jews is to bury. Now in the place where he was crucified there was a garden; and in the garden a new sepulchre, wherein was never man yet laid. There laid they Jesus therefore because of the Jews' preparation day; for the sepulchre was nigh at hand.

The Hunterian panel is one of the most serene and contemplative representations of the Entombment, quite different from those that we might regard as the most celebrated paintings, for example by Raphael (Galleria Borghese, Rome), Titian (Prado, Madrid), or Caravaggio (Vatican). As is well known, Rembrandt did not make the study visit to Italy that was undertaken by numerous Dutch artists in the 17th century, but instead satisfied his curiosity about Italian painting by seeing what he could in the Netherlands and also by amassing an important art collection, especially prints and drawings representing the ideas of earlier masters. As it happens, none of these (to us) most celebrated Entombment images existed as an engraving in Rembrandt's time, and so they were probably not known to him. Raphael's version, which for the author of the *Lives of the Artists* (1550), Giorgio Vasari, was his 'most divine picture', was made as an altarpiece for the Baglione family in Perugia in 1507 and shows a brightly lit landscape with figures who are about to lift Christ into the rock tomb that forms a backdrop. Titian's several versions similarly emphasise the urgency with which Christ was wrapped in the shroud and buried before sunset. Caravaggio, on the other hand, created a powerful subterranean image which has elements in common with Rembrandt's approach, and influenced others, but it was not engraved and Rembrandt seems not to have known it.

Those who have looked at Rembrandt's Passion imagery in the past have identified a number of links with the work of earlier Dutch and Italian painters, and these are explored in chapter 4, Rembrandt's *kunst caemer*. Here it is sufficient to say that, in certain ways, Rembrandt's *Entombment Sketch* is quite original. The action here seems static, as if the painting combines Christ's burial with another scene, that of the Lamentation. The mood of the painting stems especially from the remarkable light effect

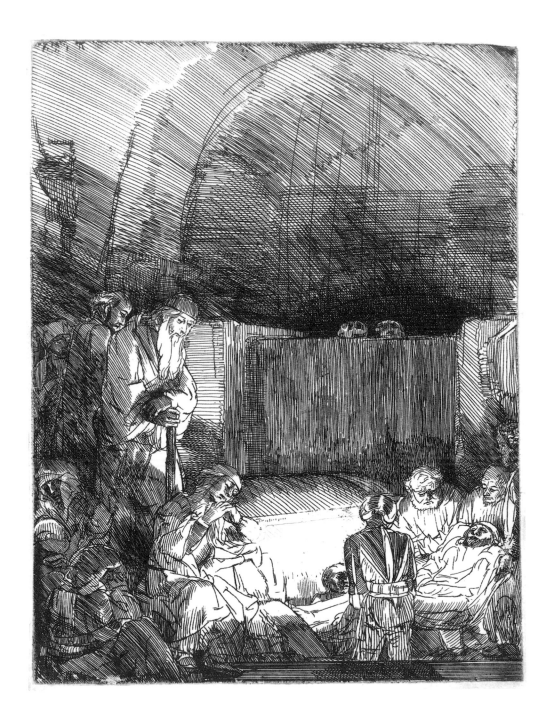

Fig. 4 | *The Entombment*,
c.1654, etching (state I),
21.1 × 16.1 cm, British Museum,
1910,0212.360

which, together with the setting deep inside the cave, is the most distinctive and original element of the painting; they constitute important differences with respect to the Munich version. All of the figures throughout the scene are touched by the light of a single candle near Christ's body that radiates throughout the cave. This light is not intense enough to produce much colour, and it is this remarkably skilful representation of candlelight that deceived past commentators into regarding the painting as a grisaille.

In the main group of figures around Christ, there are five who play important roles, but they are difficult to identify, partly because there is no textual authority for all of them, but also because the two to the left are very sketchily painted. The only people named in the Gospels as present are Joseph of Arimathea, his helper Nicodemus, Mary Magdalen and another woman called Mary. Mark mentions a group of 'many other women', watching from 'afar off', who included three by the name of Mary, and Salome. Others who are not specifically mentioned, however, are traditionally present in the scene, including strong young men to carry the body, and most importantly Mary, Christ's mother. In the *Entombment Sketch,* there is only one figure that is clearly female; she crouches to the left of Christ, holding the candle that illuminates the scene. The Virgin is not mentioned in the Gospels as being present, but artists often had recourse to meditational literature, most famously the *Meditationes de vita Christi* of Pseudo-Bonaventura, in which the image of the Virgin fainting was an important element. She appears in many versions of the Entombment, although post-Reformation scenes showing her fainting were discouraged because they were not based on the Bible. In the Munich *Entombment*, the Virgin is shown seated with her back to the tomb and her hands clasped together in resignation rather than fainting. It is possible that in the Hunterian panel Rembrandt intended us to see the Virgin in this (possibly unfinished) figure, who is linked to Christ by her position and by the dazzling light of the candle with which she has become fused.

Behind the bright figure of the woman with the candle, and framing the composition to the left, stands an older, bearded man with a rounded cap and his head bowed. (An almost identical group of tall bearded man and a woman who is probably Mary, Christ's mother, appears in a corresponding position in Rembrandt's *Entombment* etching of c.1654, White and Boon 1969, B. 86, fig. 4). For Hofstede de Groot, this 'dignified man with a long beard' was Joseph of Arimathea.[1] Here, he may be no more than a bystander, and was perhaps sketched in without detail so as not to draw attention away from the central group. The elderly man with a white beard cradles Christ with an intimacy that marks him as one of the main figures in the scene. He, surely, is Joseph of Arimathea, as proposed by

Christopher Brown in a lecture given at the Hunterian in 1987. Another figure, the richly dressed man with hat leaning forward above Christ, must also be one of the figures named in the biblical text, and so is most likely Nicodemus. The weight of Christ's body is held suspended in the shroud by a young man. In the right foreground are two dark figures, who might be men or women; one attends to Christ's feet – traditionally the role of Mary Magdalen – and another, hooded and probably unfinished figure crouches further off.

THE ENTOMBMENT SKETCH: ITS HISTORY

Rembrandt's *Entombment Sketch* forms part of the distinguished collection of old master paintings bequeathed by the Hunterian's founder, the Enlightenment anatomist William Hunter (1718–1783). Dr Hunter's paintings were part of a much larger encyclopaedic collection, and from 1767 onwards they were displayed in the splendid library and museum that formed the centrepiece of his combined house and anatomy school in Great Windmill Street in Soho. Having moved from Glasgow to London to further his studies as a doctor, Hunter soon took on an important role in London's community of artists, teaching anatomy at the St Martin's Lane Academy from about 1750, and from 1768 at the Royal Academy of Arts. Not surprisingly, his tastes as an art collector were influenced by his

Fig. 5 | Pierre-François Basan, *Les Morts Ensevelis*, c.1764, etching, 24.5 × 29.7 cm, The Hunterian, GLAHA 54348

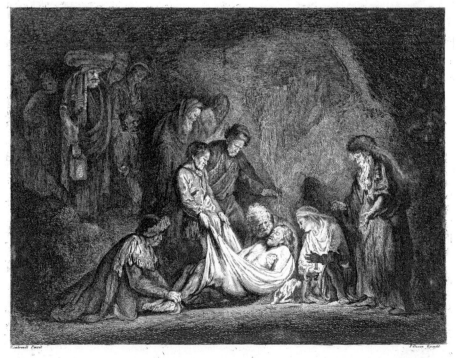

les Morts Ensevelis

experience as an academician and, as we can deduce from their prominent representation in his collection as well as from comments in his surviving lectures, he placed the highest value on Italian paintings. His collection, however, included several important works by Dutch and Flemish artists, which were then much more fashionable.

Hunter acquired the *Entombment Sketch* in 1771 with the title 'Rembrandt – the Entombing of Lazarus'. He bought it for £12.12s.0d. at Christie's in the sale of 'A collection of pictures selected from the Roman, Florentine, Lombard, Venetian and other Schools'. This collection, from which he bought a total of 19 paintings that day, had been assembled by an old friend, the engraver Robert Strange (1721–1792), to whom in 1750 Hunter had entrusted the planning of the engravings for his own magnum opus, the *Anatomy of the Human Gravid Uterus*, which was finally published in 1774. It is apparent that the 'Lazarus' was not the first Rembrandt Hunter acquired, since among his undocumented purchases are three early acquisitions, most likely bought as Rembrandts.[2] Some of Hunter's colleagues among the first academicians were also important collectors, most notably Sir Joshua Reynolds, who owned several Rembrandts, including one of the oil sketches in the present exhibition. That painting, the *Lamentation over the Dead Christ*, National Gallery, London [fig. 13], was in Reynolds's possession at the end of his life, although it is earlier documented as one of a select group of Dutch paintings that was purchased by King George III with the collection of Italian pictures he acquired from Consul Joseph Smith in Venice in 1762–64. Both Hunter and Reynolds would have been aware of the qualities of spontaneity and liveliness found in oil sketches, and the presence of such works in both collections suggests that they prized works which revealed the artist's working methods. There was already an appreciation of oil sketches in Rembrandt's lifetime among collectors such as the artist's friend Jan Six, who acquired the sketch of *John the Baptist Preaching* (c.1634, 62.7 × 81.1 cm, oil on canvas mounted on panel, Gemäldegalerie, Berlin), for which Rembrandt also designed a frame that marks it as a work of special significance.[3]

In 1769, two years before Hunter bought the *Entombment Sketch*, the painting was shown in London in St Martin's Lane at an exhibition of Robert Strange's collection which was cleverly timed to coincide with the first exhibition of the fledgling Royal Academy of Arts and for which Strange had a descriptive catalogue printed.[4] Strange was born in Orkney, trained in Edinburgh with the engraver Richard Cooper Snr, and soon after the 1745 Rebellion travelled to Rouen where numerous Jacobites settled, returning to London in 1750. He managed to rise to the top of the engraving profession, but in the 1750s he yearned to make a tour of Italy

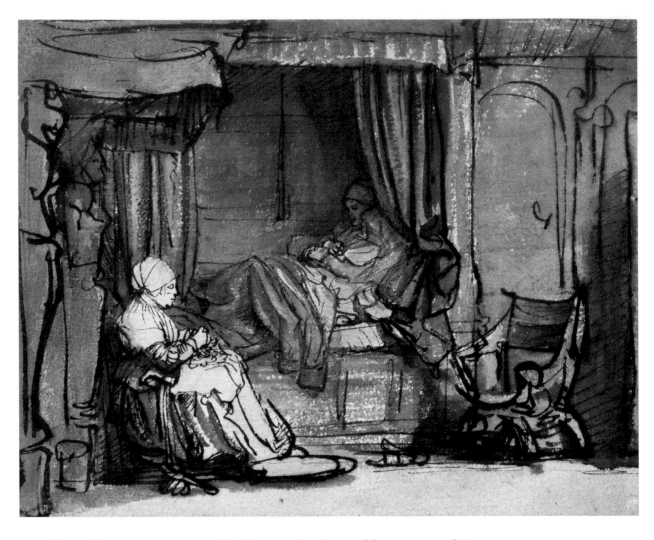

in order to draw masterpieces of Italian art that he would engrave on his
return. Eventually, in 1760, he set off for Italy, via Paris, and in the course
of his travels he bought paintings in order to resell them in London after
his return in 1765.

Strange may have bought the *Entombment Sketch* in Paris where he had
a network of contacts among dealers and experts, including Pierre-Jean
Mariette who advised him on the authenticity of his Raphael, the *Madonna
della Tenda* (now in Munich).[5] If the Rembrandt was bought in Paris, it is
possible that he acquired it from the engraver and dealer Pierre-François
Basan (1723–1797). Basan is best known as the owner of 83 of Rembrandt's
etching plates which he republished in sets known as the 'Recueil Basan'
from 1789. The evidence for his ownership is contained in his undated
etched reproduction of the *Entombment Sketch* with the title *Les Morts Ensev-
elis* (The Burial of the Dead, fig. 5).[6] There was a demand for engravings of
paintings by great masters, and in exchange for an opportunity to engrave

a picture the owner would normally be named in the engraver's inscription. Basan makes no such acknowledgement and so it seems reasonable to assume that the painting was his and that he made the print to publicise it. It shows the composition reversed and cropped slightly at the left and bottom, so that three of the more sketchy figures are left out.[7]

We may say, tentatively, that the *Entombment Sketch* was in Paris around 1760–65, but this still leaves a blank of about 100 years since its earliest mention, as 'A sketch of the Entombment of Christ by Rembrandt', in the 1656 inventory of Rembrandt's possessions.[8] Although we cannot be certain that the *Entombment Sketch* is identical with the work that is recorded as hanging in Rembrandt's living room, it is the only known work that matches the description.[9] The interior of this room is well known from the elaborately worked drawing of *Saskia in Bed* in the Frits Lugt collection in Paris [fig. 6]. For the period between its leaving Rembrandt's living room and its appearance in Paris, where it was reproduced by Basan, we have no firm evidence of its whereabouts. One possibility, but it is no more than that, is that it was bought from Rembrandt's insolvency sale by his pupil, Ferdinand Bol, since in an inventory drawn up at the time of Bol's marriage in 1669, we find 'an Entombment by Rembrandt'.[10] This possibility was raised by the authors of the *Corpus of Rembrandt Paintings* (hereafter referred to as the *Corpus*), who remark that Bol's painting might, alternatively, have been one of the copies of the Munich *Entombment*.[11] (Bol was a student of Rembrandt's in the late 1630s when the *Entombment* from the Passion Series was delivered to Frederik Hendrik.)

THE ENTOMBMENT SKETCH IN GLASGOW AND ITS REPRESENTATION IN THE REMBRANDT LITERATURE

The starting point for our research on the *Entombment Sketch* was, naturally, an assessment of the panel's impact, especially the published opinions of Rembrandt scholars, a body of writing that has been expanding rapidly in recent years. In comparison with the last 40, the first 165 years of the painting's presence in Glasgow were uneventful in terms of a critical understanding of the work. When acquired by Hunter, the painting was new to Britain, and it had lost its identity as a Passion subject. Hunter's engraver and dealer Robert Strange managed at least to link the work with the Bible, replacing Basan's bland title 'Burial of the Dead' with the miraculous 'Entombing of Lazarus', and it was as 'Entombing Lazarus, a Sketch' that the earliest 19th-century visitors to the Hunterian Museum [fig. 7] admired it. This is how it was listed in the museum's first catalogue, published in 1813 by the geologist Captain John Laskey. It was noticed some 20 years later by the Scottish painter David Wilkie, who painted

c.1835–36 an oil sketch of the *Burial of the Scottish Regalia* comparable in size, and inspired both by Rembrandt's composition and light effects.[12] For Gustav Waagen, whose pioneering *Treasures of Art in Great Britain* was published in 1854, it was '[a] rich and very spirited composition in chiaroscuro, but yet warm in tone'.[13] Thereafter, little comment of note was made before the second half of the 20th century. Even since World War II the painting has remained little known; being a fragile work on panel, it has not often travelled to exhibitions.

The painting was among the earliest works surveyed by the Rembrandt Research Project and was published in 1989 in Volume III of the *Corpus*. The authors' view of this authentic but undated and unsigned painting is that it belongs to a group of oil sketches made in Amsterdam c.1633–35 towards the end of the period when Rembrandt was living with and collaborating in the academy of Hendrick Uylenburgh. The *Corpus* summary is worth quoting in full:

> Though it is in its partly extremely sketchy treatment hard to compare with any other Rembrandt work, this monochrome oil sketch convinces one of its

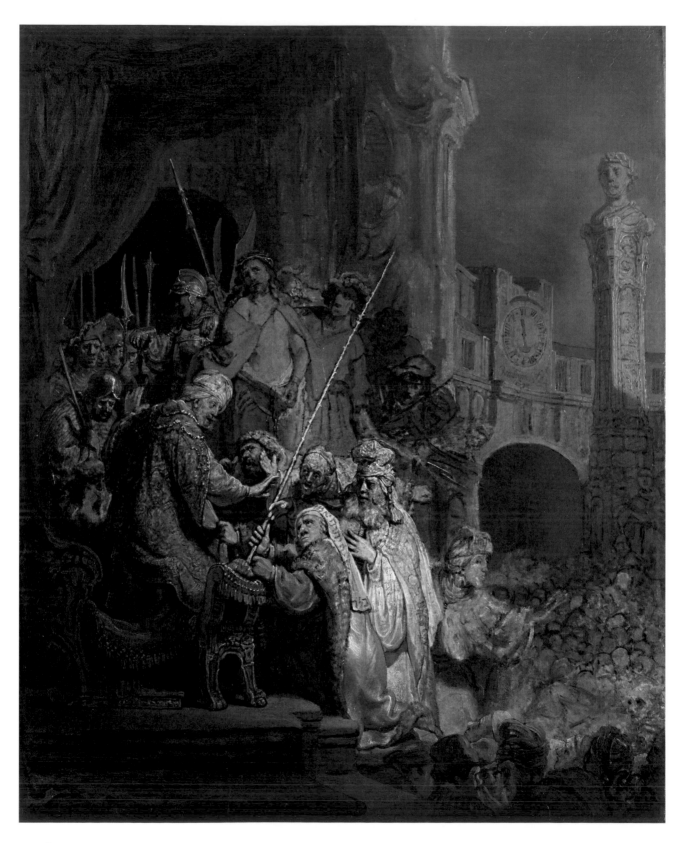

Fig. 9 | *Ecce Homo* (*Christ before Pilate*), 1634,
oil on paper laid on canvas, 54.5 × 44.5 cm, National Gallery,
London (cat. 21)

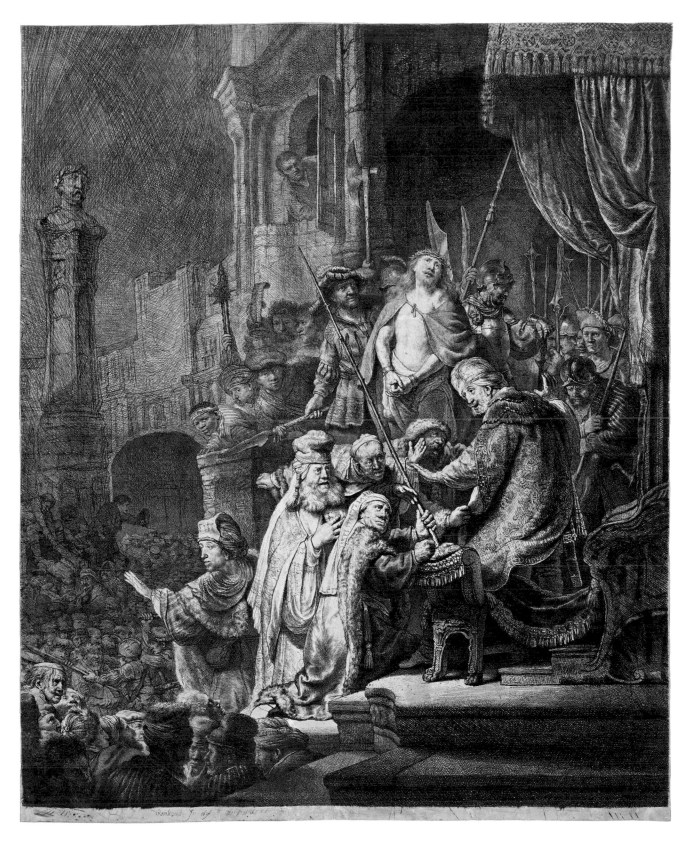

Fig. 10 | Rembrandt and Jan van Vliet,
Christ before Pilate: Large Plate, 1636, etching and burin,
54.9 × 44.7 cm, British Museum (cat. 22)

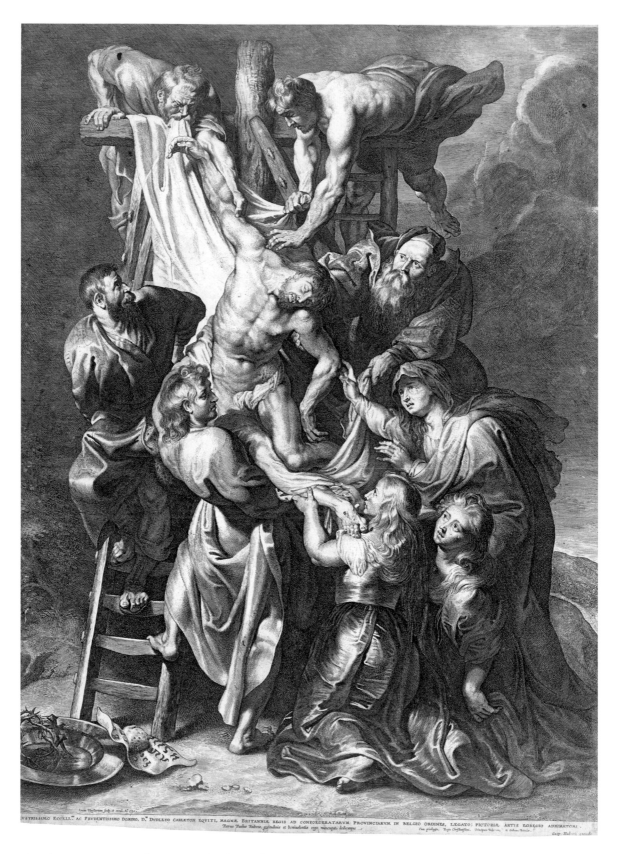

Fig. 11 | Lucas Vorsterman after Peter Paul Rubens, *The Deposition*, 1620,
etching and engraving, 58 × 43 cm, The Hunterian (cat. 6)

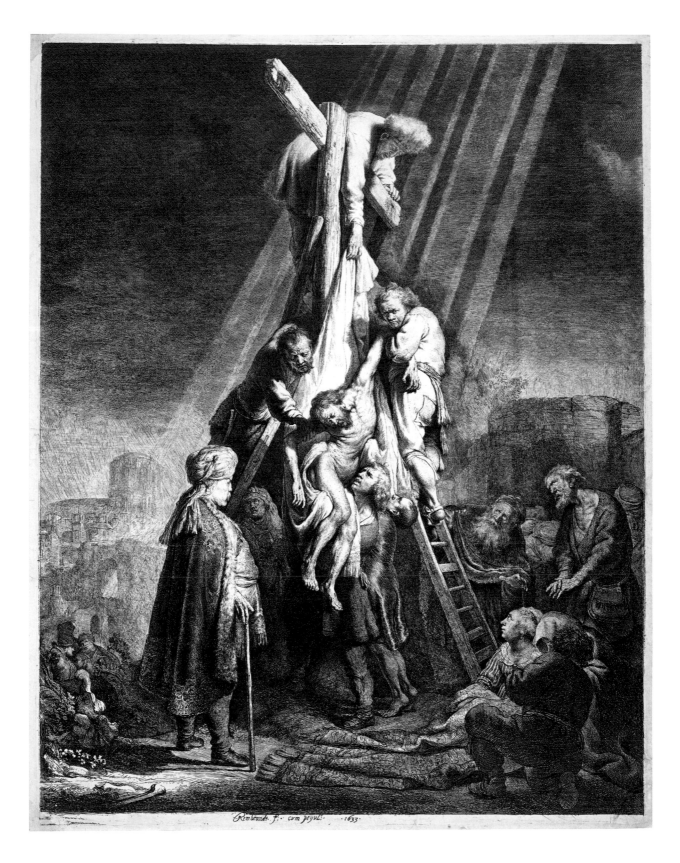

Fig. 12 | Rembrandt and Jan van Vliet, *The Descent from the Cross*, 1633,
etching, 53 × 41 cm, British Museum (cat. 7)

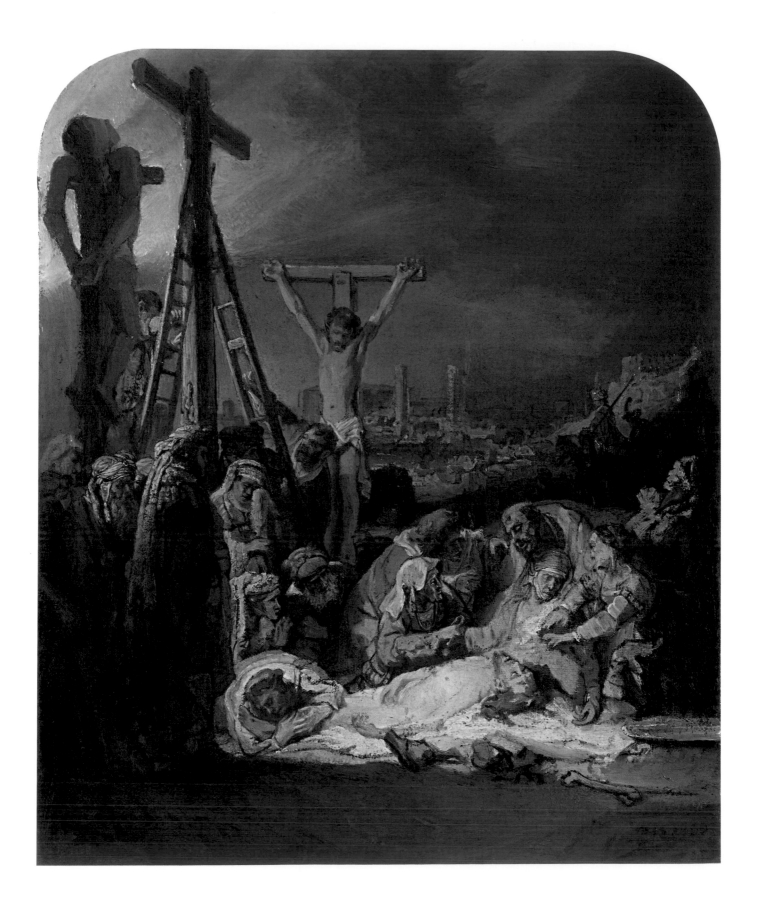

Fig. 13 | *The Lamentation over the Dead Christ*, c.1635, oil on paper and pieces of canvas, mounted onto oak, 31.9 × 26.7 cm, National Gallery, London (cat. 23)

advice on applying to the States General for a privilege to protect against copying in the expanding markets of the Dutch Republic. The prints that Rubens began to issue in 1620 have an imprint claiming privilege, which Rembrandt may simply have copied on his *Christ before Pilate: Large Plate*.[20] There is no evidence at all that Uylenburgh published prints by other artists, and so the print-publishing venture may simply have been abandoned under pressure of other work (portraits), and because Rembrandt married in 1634, then moved out of Uylenburgh's house and ceased working in his academy in 1635.[21]

In 1987 Christopher Brown, who was at the time Curator of Dutch and Flemish Paintings at the National Gallery in London, was invited to talk about the painting in the Hunterian. Summarising earlier opinions, Brown ruled out the possibility that the *Entombment Sketch* might be a *modello* for the Munich painting. He reasoned that there was no evidence of Rembrandt painting an oil sketch for any other painted commission and cited the format as proof that the painting was not preparatory. Since the Munich *Entombment* was the fourth painting in the Passion Series, the format 'was well established and it would seem entirely illogical to adopt a different format for a *modello*'. The technical evidence which Brown had to hand consisted of an X-ray photograph as well as an infrared image, and this also emphasised for him 'the separateness of the Glasgow painting from that in Munich. None of the changes Rembrandt was toying with were taken up in the Munich version. Rembrandt was apparently using the central composition to create an independent work, which permits two possible explanations – a sketch for an etching which was never carried out, a suggestion supported by Horst Gerson, who revised Bredius's Catalogue of Rembrandt's paintings, or an unfinished independent painting.'

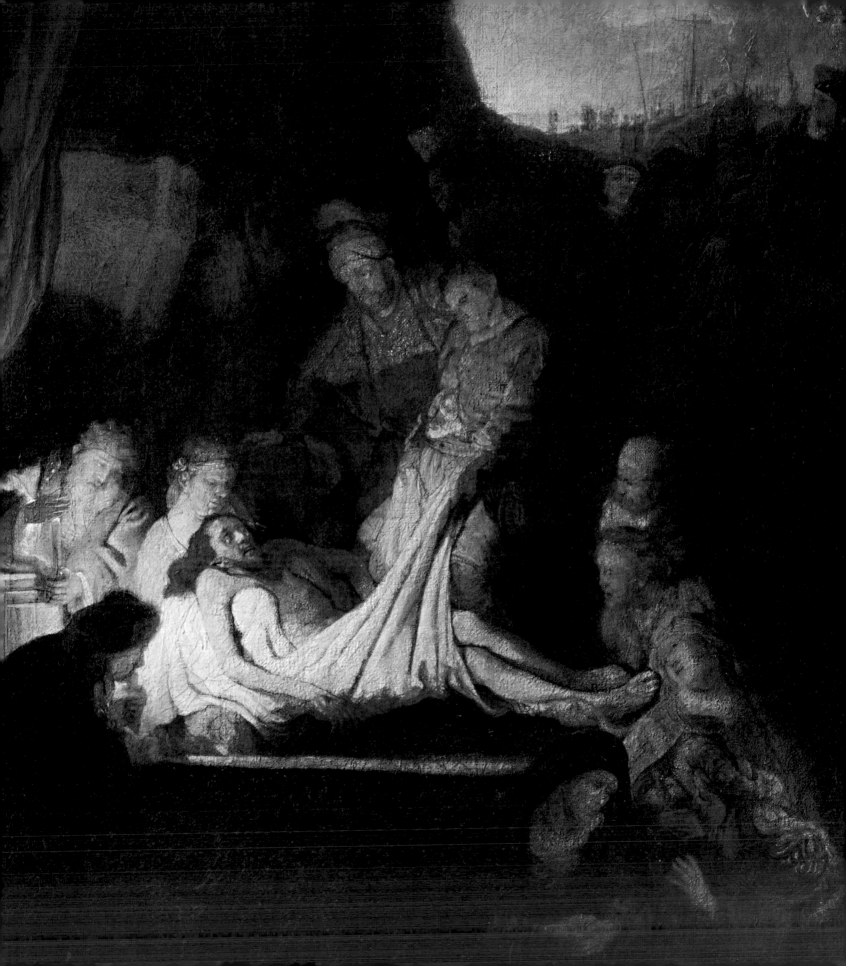

2 REMBRANDT'S PASSION SUBJECTS

If Rembrandt's *Entombment Sketch* was not painted in preparation for the Munich *Entombment*, then what is its relationship to that painting and to the various other Passion subjects in Rembrandt's oeuvre? The relationship with the Passion Series, on which the artist worked from c.1632 to 1646, is clearly of central importance, but there are other episodes in the artist's output when he was focusing on the Passion, including two sets of Passion etchings in the 1650s, among which there is a closely related *Entombment* subject [fig. 30].

THE PASSION SERIES, c.1632–46

Before describing the genesis of the Passion Series, it is worth first considering a couple of aspects of Rembrandt's production, beginning with the demand for biblical images in the Dutch Republic during Rembrandt's lifetime. The Reformation brought a dramatic increase in people's familiarity with the Bible stories, which was a direct consequence of the Bible becoming more accessible through translation into the vernacular. Even if potentially idolatrous images were banned from churches, biblical imagery was given an unexpected stimulus through a new demand for illustrated Bibles. One of the few books which we know Rembrandt owned was an 'Old Bible'. Precise identification is impossible, but it was probably a large illustrated text, something like Willem Vorsterman's 1528–29 Antwerp Bible, which was one of the earliest printed in Dutch [fig. 15].[1] The related trade in popular prints allowed people of modest means to buy sets of prints of morally improving biblical stories. In fact, anybody could own versions of the Passion scenes that a sophisticated collector such as Rembrandt held in the form of expensive, original engravings by Albrecht Dürer (1471–1528) or Lucas van Leyden (1494–1533), or that a wealthy prince such as the Stadholder Frederik Hendrik could enjoy by acquiring a series of paintings by Rembrandt. Of course, an ambitious artist such as Rembrandt saw no restriction on his artistic output, religious or otherwise. As is well known, in his early work the artist he idolised was Rubens, who was the most successful painter of the age. Rubens's painting represented a transplantation of the Italian Catholic tradition to northern European

Fig. 14 | Detail from *The Entombment*, c.1635–39, oil on canvas, 92.5 × 68.9 cm, Alte Pinakothek, Munich (cat. 4)

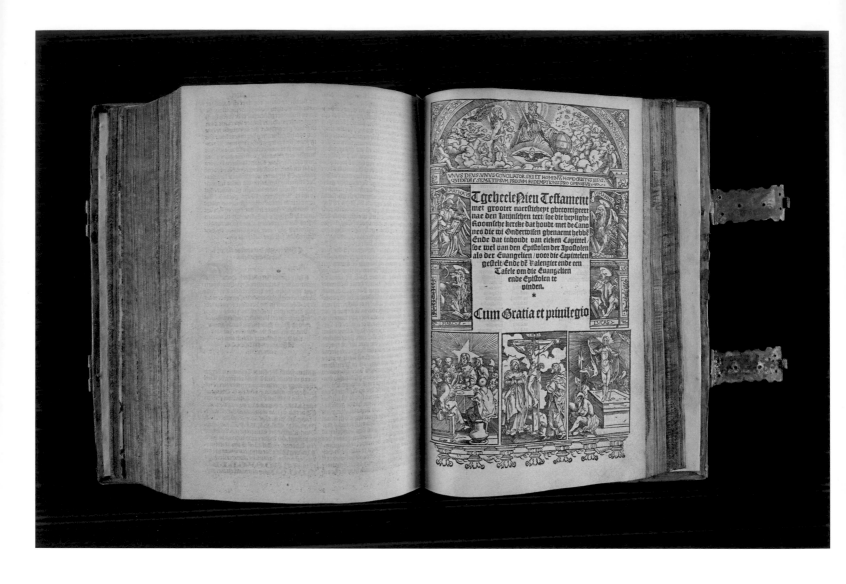

soil. Rubens's 1612 altarpiece commissioned by the Guild of Harquebusiers for Antwerp Cathedral, the *Descent from the Cross* [fig. 16], is undoubtedly one of his greatest paintings, and its iconography, which Rembrandt knew through Vorsterman's engraving of 1620 [fig. 11], was one of the decisive influences on Rembrandt's Passion Series. While Rubens's contribution to the painting of Passion subjects is immense, there is nothing in his oeuvre to compete with the body of etchings produced by Rembrandt, among which are Passion subjects that many regard as the greatest of all prints.

It is also worthwhile considering the nature of the three men involved in commissioning and making the Passion Series. Besides the artist, these were the Stadholder and art collector, Frederik Hendrik, Prince of Orange, and his secretary, Constantijn Huygens. The Passion Series was under way, it is very likely, in 1632. That year Willem Delff (1580–1638) published

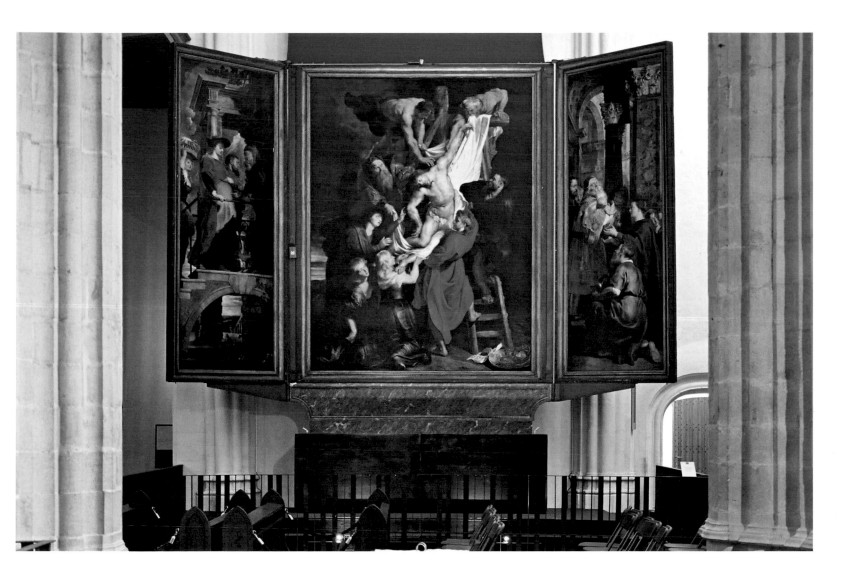

an engraved portrait of Frederik Hendrik [fig. 18] which he based on an official portrait of 1623 by Michiel van Mierevelt (1566–1641), showing the prince in armour. Although we see him as soldier, ready for war with the Catholic forces to the south, Frederik Hendrik was also a very important customer for Rembrandt's paintings. Their relationship as collector and painter was already established when the Passion Series was conceived, as we know from an inventory of 1632 showing that Frederik Hendrik already owned two paintings by the artist. Between c.1631 and 1646 he purchased as many as 15 paintings by Rembrandt.[2]

Rembrandt's *Self-Portrait* from the Burrell Collection [fig. 19] is a painting of a completely different type from the work of Frederik Hendrik's court painter, Van Mierevelt. It also dates from 1632, and may have served as a model for the many portraits Rembrandt now began to paint

Fig. 16 | Peter Paul Rubens, *The Descent from the Cross* altarpiece, 1611–14, Cathedral of Our Lady, Antwerp

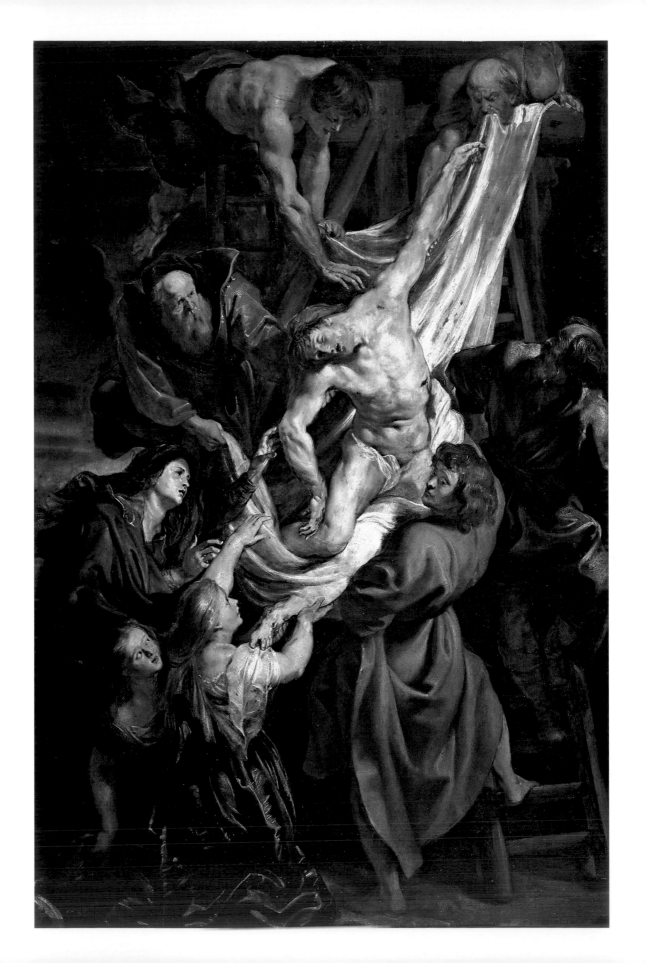

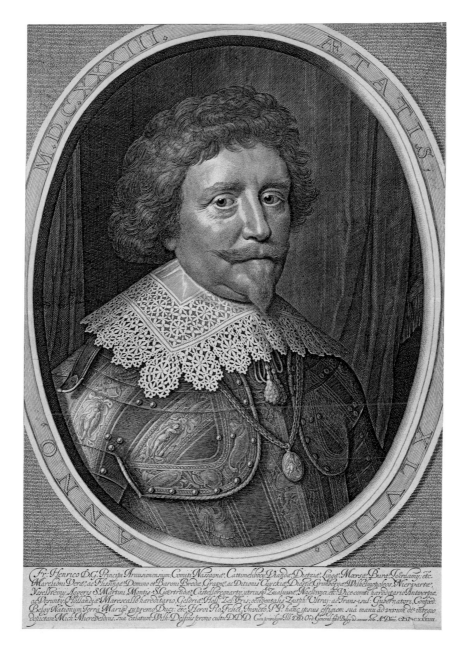

Fig. 17 | Peter Paul Rubens, *The Descent from the Cross*, c.1611, oil on panel, 115.2 × 76.2 cm, The Courtauld Gallery, London (cat. 5)

Fig. 18 | Willem Jacobsz. Delff, *Frederik Hendrik, Prince of Orange*, 1632, engraving, 41.9 × 29.1 cm, The Hunterian (cat. 2)

in this fashionable oval format. The painting signals the artist's arrival in Amsterdam. This it does confidently, and with a quiet echo of a formal self-portrait by Rubens.[3] Rembrandt moved to Amsterdam in order to live and work with the painter and dealer Hendrick Uylenburgh (c.1584/9–1661), who was already selling paintings for him. Working alongside Uylenburgh transformed Rembrandt's personal life too, for in 1634 he would marry Saskia (1612–1642), Hendrick's cousin. By 1632, Rembrandt's business was going well, with many portrait commissions coming in through

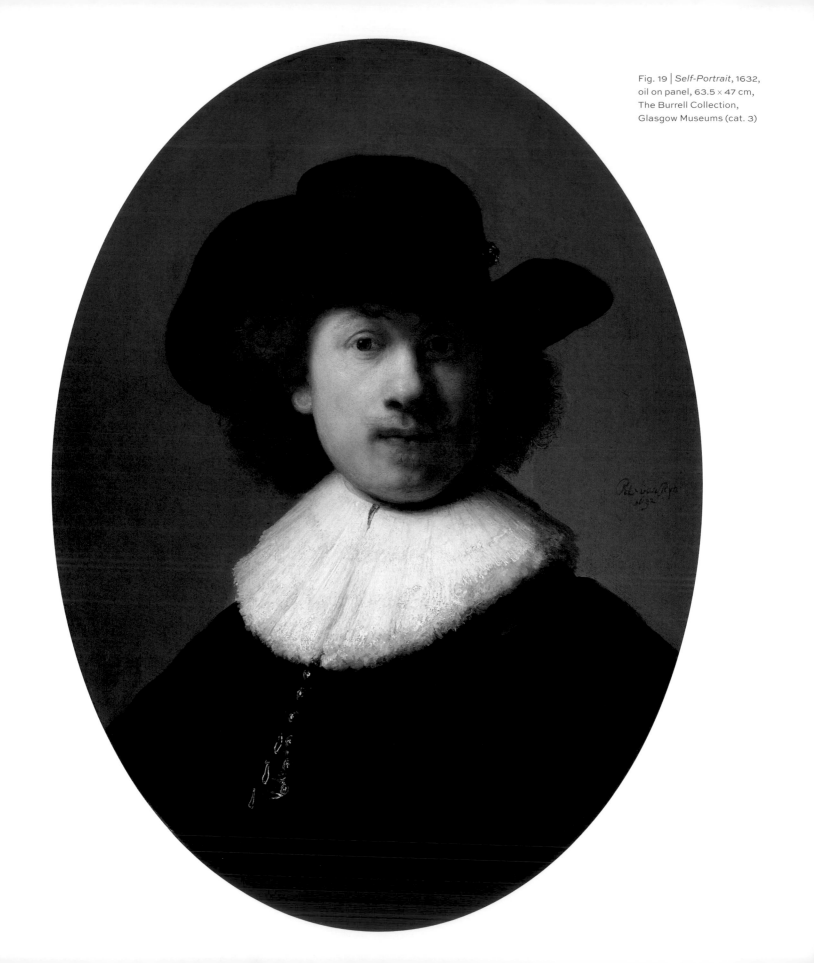

Fig. 19 | *Self-Portrait*, 1632,
oil on panel, 63.5 × 47 cm,
The Burrell Collection,
Glasgow Museums (cat. 3)

Uylenburgh, and he had other important works in hand, including the famous group portrait, the *Anatomy Lesson of Dr Nicolaes Tulp* (Mauritshuis, The Hague). The year 1632 was certainly important in terms of the artist's relationship with Frederik Hendrik, for Rembrandt travelled to The Hague that year to paint a group of portraits, including Frederik Hendrik's wife, Amalia van Solms (Musée Jacquemart-André, Paris). The key influence behind these early acquisitions, which led almost immediately to the Passion Series, was the Stadholder's art-loving secretary, Constantijn Huygens.

The erudite face of Constantijn Huygens (1596–1687) appears in various

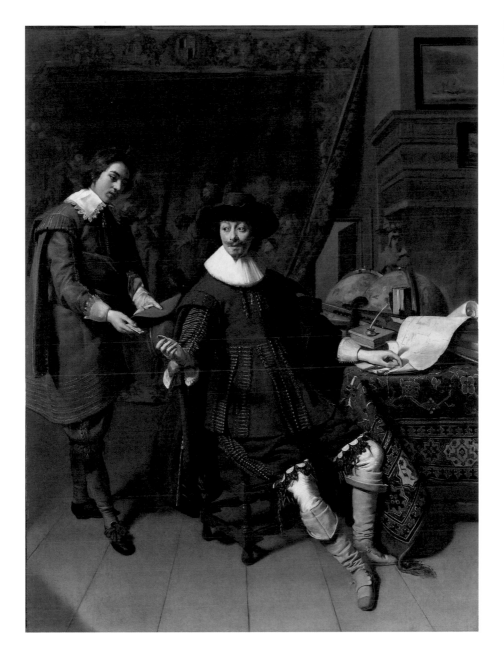

Fig. 20 | Thomas de Keyser, *Portrait of Constantijn Huygens*, 1627, oil on panel, 92.4 × 69.3 cm, National Gallery, London

portraits including that by Thomas de Keyser (1596/7–1667) who was an Amsterdam painter some ten years older than Rembrandt [fig. 20]. De Keyser painted Huygens in 1627, the year of his marriage, and the portrait shows him in action as secretary to the Stadholder, being handed a letter by his clerk; he is also surrounded by evidence of his own artistic talents and interests. Shortly afterwards, in about 1630, Huygens wrote an auto-biography in which he describes his discovery in Leiden of two prodigiously talented young painters, Rembrandt and Jan Lievens (1607–1674). Huygens regarded Lievens as having great potential as a portrait painter, and he identified Rembrandt's greatest strength as the representation of biblical subjects, especially on a small scale: 'Rembrandt, on the other hand, obsessed by the effort to translate into paint what he sees in his mind's eye, prefers smaller formats, in which he nonetheless achieves effects that you will not find in the largest works by others.'[4]

Huygens used his knowledge and excellent contacts to persuade his master Frederik Hendrik and others close to him in The Hague to buy paintings by Rembrandt, of whose future prospects he talked in exalted terms. Thanks to Huygens, a group of seven letters written to him by Rembrandt has been preserved which together provide a chronology of the Passion Series.[5] They are, in fact, Rembrandt's only surviving letters, which means that we have more information about these paintings than almost any other works by the artist. Rembrandt's first letter [fig. 21] was received by Huygens in The Hague in February 1636, and it records the commission for three Passion subjects, which were to match two works that had already been acquired:

> I am very diligently engaged in completing as quickly as possible the three Passion pictures (*drie passij stucken*) which His Excellency himself commissioned me to do: an Entombment, and a Resurrection and an Ascension of Christ. These are companion pictures to Christ's Elevation and Descent from the Cross. Of these aforementioned pictures one has been completed, namely Christ ascending to Heaven, and the other two are more than half done...

The first two paintings, the *Elevation* and *Descent from the Cross*, had been completed about three years earlier, by 1633, which is the date on Rembrandt's etching of the *Descent* [fig. 12]. This was the largest and most impressive etching he had so far made, and as a commercial reproduction, more or less, of a painting in the Stadholder's collection, it formed a powerful advertisement for his work as an artist. The print led to another large Passion print in 1636, the *Christ before Pilate: Large Plate* [fig. 10]; it may also have led to the making of a group of oil sketches for etchings, mentioned above.

Fig. 21 | Rembrandt's first letter to Huygens, February 1636, The Houghton Library, Harvard University, Cambridge, Mass., b MS Eng 870 (14)

Mijn Heer mijn gunstige Heer
Huijghens Hoepe dat U Ed wil sijn Excellentij
gaet aen seggen dat ick seer naerstich
doende bey met die drie passi stucken voorts
met begaueuheijt aftemacken die sijn Excellentij
mij selfs heeft geordijneert : een graft legsij
ende een verijsenis en een hemelvaert
Christij de selb bijden anhoorderen met
opdoenung en afdoeninge vant Chruijs Christij
van wel bey die voornoemde stucken
iteurkens alsoe van opgemaeckt is doer
Christus ten Hemel opbaert ende
die ander twee mijn halt gedaen sijn
en soe sijn Excellentij dit opgemaeckt stucken
doer belust te hebben d ofte die drie stucken

Mijn Heer biddende doet van te laeten wete
op dat ick sijn groote Excellentij in sij lusten
bey besten dienen stat mach

en hen oock niet naer lusts volgens mijn dienst willije
dienst mijn Heer te weeten bey mijn gou stes
noch verwinende dat meten besten stat
afgenoomen over der

Mijn Heer dienst willijge ende
toegenegen dienaer

Rembrandt

voon naest der
konadis boeveel
nieuwe doel straet

A.o 1636

In his second letter, Rembrandt offers to come to The Hague to see for himself how well the *Ascension* fits with the others. There is a problem with this painting; Rembrandt thinks the solution might be to hang the work in a stronger light. The *Entombment* is mentioned again in the third letter, which is dated 12 January 1639. Three years have passed since his statement that this painting was more than half done; the last of the pictures mentioned in February 1636 have now been completed and Rembrandt explains the delay as being due to the care with which he has finished them:

Fig. 22 | *Christ on the* Cross, 1631, oil on canvas mounted on panel, 92.9 × 72.6 cm, Church of Saint-Vincent, Le Mas d'Agenais, France

> My Lord
> Because of the great zeal and devotion which I exercised in executing well the two pictures which His Highness commissioned me to make – the one being where Christ's dead body is being laid in the tomb and the other where Christ arises from the dead to the great consternation of the guards – these same two pictures have now been finished through studious application, so that I am now also disposed to deliver the same and so to afford pleasure to His Highness, for in these two pictures the greatest and most natural emotion has been expressed, which is also the main reason why they have taken so long to execute...

Rembrandt's comment about his care in the depiction of emotion in these paintings seems calculated to please Huygens, whose own taste was very much for the expressive suffering seen, for example, in Rembrandt's *Repentant Judas* painting of 1629 (Private collection; *Corpus* I, A 15). Nonetheless, the comment is interesting in relation to the Munich *Entombment* painting, an image he went on to refine in the variant *Entombment Sketch*. Rembrandt has indeed paid careful attention to the emotional responses of the figures in this painting as certain modifications of the Munich composition reveal. The delay is now universally regarded as being due to Rembrandt's bad manners, or to his being overwhelmed by the number of lucrative portrait commissions he was receiving in the mid-1630s. The remaining letters settle details of payment, and mention the offer of an unspecified large painting as a gift to Huygens, and then the correspondence ends.

This part of the story of the Passion Series is refreshingly clear, but the story does not end here, and there is also one undocumented Passion picture which requires comment. This is an earlier painting of *Christ on the Cross* [fig. 22] which has a strong visual claim to be considered as the starting point for the series. It is one of several subjects which Rembrandt and Lievens painted at the same time, as if working in friendly competition. Rembrandt's painting (*Corpus* I, A 35), which is signed and dated 1631, is now in the parish church at Le Mas d'Agenais in south-western France. There is no longer any record of why, or for whom, Rembrandt made it,

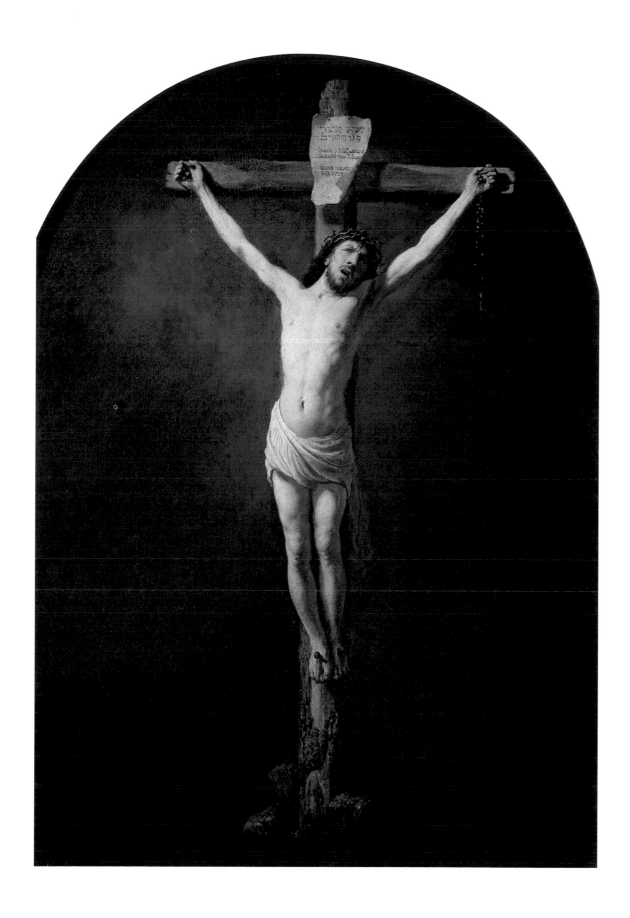

or why Lievens made his own version, very similar in size and format, in the same year (Musée des Beaux-Arts, Nancy). Both were inspired by pictures of the Crucifixion by Rubens. To many a connection with the arch-shaped paintings of the Passion Series seems obvious. Writing of the two paintings, Arthur K. Wheelock concluded that they were painted in 'response to a competition proposed by Constantijn Huygens as a means of determining who would secure a commission from the Stadholder for a series of paintings of the passion of Christ'.[6]

In addition to the five paintings of the Passion Series proper, Rembrandt was paid for two further paintings in 1646: the *Adoration of the Shepherds* and a *Circumcision*, which is now lost. Their subjects show us that the series was assembled without a firm programme. The early Passion focus seems to have shifted, and the two later purchases emphasise Christ's humanity as a prelude to the Passion. The six surviving paintings from the 'Passion Series', or what we might more accurately call a collection of biblical paintings by Rembrandt, are in the Alte Pinakothek in Munich. All were painted on canvas, except for the *Descent from the Cross*, which is on panel and was probably the first to be completed.[7] If we look at the listing that appears in the inventory of Frederik Hendrik's widow, Amalia van Solms, drawn up on 20 March 1668, we see that the series was complete with seven paintings:

Fig. 23 | Unknown Rembrandt pupil, *The Entombment*, c.1650, oil on canvas, 144 × 128 cm, Museum Boijmans Van Beuningen, Rotterdam, inv. no. 2513

> Seven paintings made by Rembrandt, all with black frames, oval at the top and with carved gilt leaves all round:
> The first being the nativity of our Lord Jesus Christ.
> The second the circumcision.
> The third the crucifixion.
> The fourth the descent from the cross.
> The fifth the entombment.
> The sixth the resurrection.
> The seventh the ascension of our Lord Jesus Christ.[8]

COMPARISON BETWEEN THE MUNICH *ENTOMBMENT* AND THE *ENTOMBMENT SKETCH*

This brief history of the Passion Series has been helpful in establishing that the Munich *Entombment* painting was begun probably towards the end of 1635 and completed in January 1639. The closely related Hunterian *Entombment*, which we have already concluded was not a sketch for this painting, is likely to have been started during this time, while Frederik Hendrik's painting was still in the workshop. It was normal to make a copy before an important painting left the studio, and several copies of the *Entombment* are known, including the version made by an unknown pupil

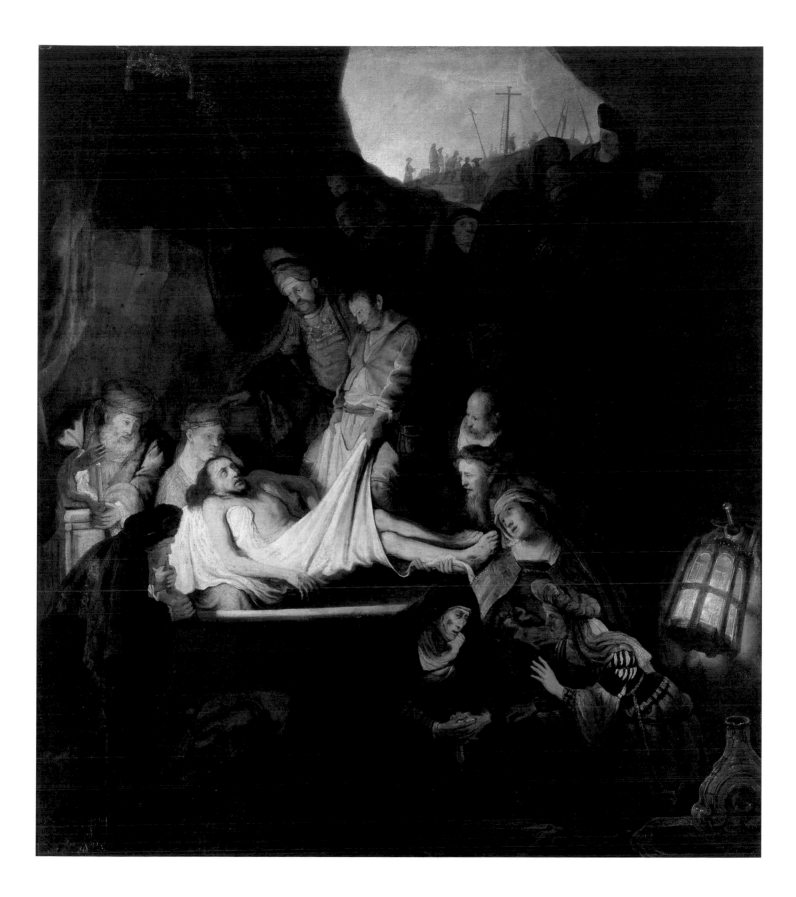

of Rembrandt in the Museum Boijmans Van Beuningen in Rotterdam [fig. 23]. The opportunity could also have been used by Rembrandt himself to sketch the important central part of the composition onto a panel with the intention of making a related painting. A date close to 1639 has been proposed by those such as Gary Schwartz who view the *Entombment Sketch* as a 'variant on the *Entombment* for Frederik Hendrik'.[9]

The *Entombment Sketch* shows in its paint surface evidence of changes to the image that were not taken up in the Munich *Entombment*. Rather they can best be explained as modifications and improvements on that painting. The essential, central motif consisting of the figures holding and watching Christ's body suspended in the shroud held by a young man is – in the *Sketch* – painted fluently and thinly so that the grain of the wood shows through. But towards the edges of this figure group there are *pentimenti* and areas more thickly painted which provide clear evidence of a second campaign of painting in which Rembrandt added, for instance, the thick impasto of white paint from which the woman holding the candle is modelled. The alterations or modifications to the Munich composition can be listed as follows: the more central placing of Christ; the unified light source; the simplification of the figure group around Christ; the replacement of the woman behind Christ holding him by his shoulders with the emotionally more convincing figure of Joseph of Arimathea, face to face with the dead Christ; the insertion of the tall figure of a bearded man with round cap at the left-hand edge of the composition where, in the Munich painting, there is a heavy curtain.

'DIFFERENT SKETCHES OF ONE AND THE SAME SUBJECT'

There is an aspect of Rembrandt's practice which appeared very unusual to his biographer Arnold Houbraken (1660–1719) which may be helpful to consider in relation to the Hunterian *Entombment*. Houbraken is a reliable source since he trained as a painter with Samuel van Hoogstraten (1627–1678), who was himself one of Rembrandt's pupils. Van Hoogstraten was also the author of a treatise on painting, the *Inleyding tot de hooge schoole der schilderkonst* (Introduction to the Academy of Painting) of 1678 [fig. 24], which incorporates first-hand accounts of the master's practice. What particularly struck Houbraken was the constant evolution of a given subject as the artist's ideas were put down in his sketches:

> In his art, at least, he had a wealth of ideas, which often led to the number of different sketches one sees of the same composition, and at the same time these are full of variations in the figures shown, in their postures and in the arrangement of their clothing…Yes, in that respect he outdid everybody: and I cannot think of anyone else who made such numerous changes to

Fig. 24 | Title page from Samuel van Hoogstraten, *Inleyding tot de hooge schoole der schilderkonst* (Introduction to the Academy of Painting), Rotterdam, 1678, Edinburgh University Library, Special Collections Department (cat. 34)

INLEYDING
TOT DE HOOGE SCHOOLE DER
SCHILDERKONST:
Anders de
ZICHTBAERE WERELT.
Verdeelt in negen Leerwinkels, yder beftiert
door eene der
ZANGGODINNEN.

Ten hoogften noodzakelijk, tot onderwijs, voor alle die deeze
edele, vrye, en hooge Konft oeffenen, of met yver zoe-
ken te leeren, of anders eenigzins beminnen.

Befchreven door
SAMUEL VAN HOOGSTRAETEN.

Tot ROTTERDAM.
By *Franſois van Hoogſtraeten*, Boekverkooper,
M. DC. LXXVIII.

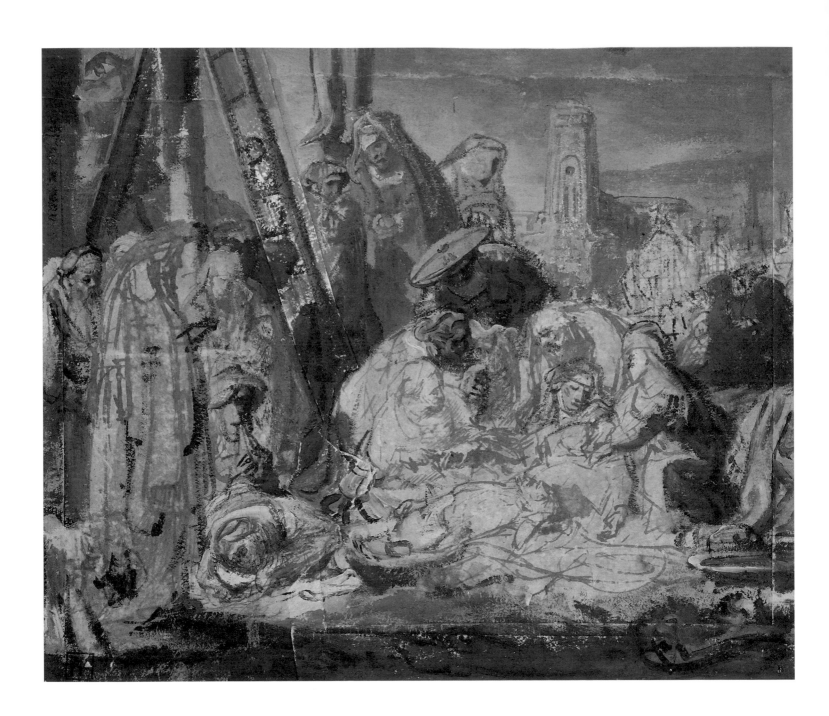

sketches of one and the same subject; this is something that grows out of careful analysis of the great variety of the passions.[10]

Houbraken gives the impression, almost, that Rembrandt was incapable of making two versions of the same subject the same. If this observation is accurate, we should not be surprised that the *Entombment Sketch* is different from the Munich version. We need to take care with Houbraken's comments because it is not clear what medium he is talking about; he may be referring to drawings, which would certainly account for the greatest number of 'sketches' that Rembrandt produced. However, the main point is that these changes sprang not from restlessness but from a constant refining of posture and expression in order to render as accurately as possible the minds of his figures. This applies equally to paintings. This sense of the studious investigation of mental states that Houbraken has learnt from his master, Van Hoogstraten, certainly pervades the group of oil sketches for Passion etchings of c.1633–35, referred to above, which are characterised by precisely the changes of mind described by Houbraken. One work above all which shows the intensive study of the emotions is the *Lamentation* oil sketch [fig. 13]. It reveals in its cut and reassembled surface an extraordinary series of changes, and the artist's supporting study on paper [fig. 25] is similarly composed of a patchwork of cut and reassembled pieces of paper, on which he apparently worked out some of the dense groupings of expressive heads that were afterwards incorporated in the oil sketch itself.

Houbraken's explanation of Rembrandt's constant changes of mind in his sketches accords with what we learn about Rembrandt's treatment of emotion in Van Hoogstraten's *Inleyding*, which includes a passage about the qualities of great painters. 'Which of all the great Italian masters, or Dutch', he asks, 'did not have something special that was unique to him, either in his whole approach to the art, or in one small part?' Starting with Michelangelo, he lists the greatest artists according to their most distinctive contribution: 'Lucas van Leyden [was praised] for his integrity, Rubens for his rich compositions, Anthony van Dyck for his grace, Rembrandt for the passions of the soul (*lijdingen des gemoeds*).'[11]

Comparison of the *Entombment Sketch* and the Munich *Entombment* reveals a number of ways in which Rembrandt reworked and improved the emotional power of the image, confirming Houbraken's observation. Perhaps the most obvious difference is the setting. The oblong panel of the *Entombment Sketch* focuses on the main action and frees the artist from the need to extend the image into the arch at the top. The action is contained deeper within the cave, and this provides the pretext for the beautiful effect of light which unifies figures and setting. A single candle radiates light onto

Fig. 25 | *The Lamentation at the Foot of the Cross* c.1634–35, pen and brown ink and brown wash, with red and perhaps some black chalk, reworked in oils 'en grisaille', 21.6 × 25.4 cm, British Museum (cat. 24)

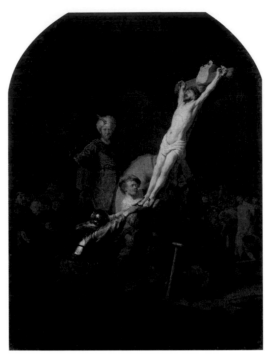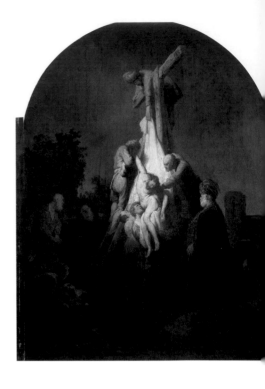

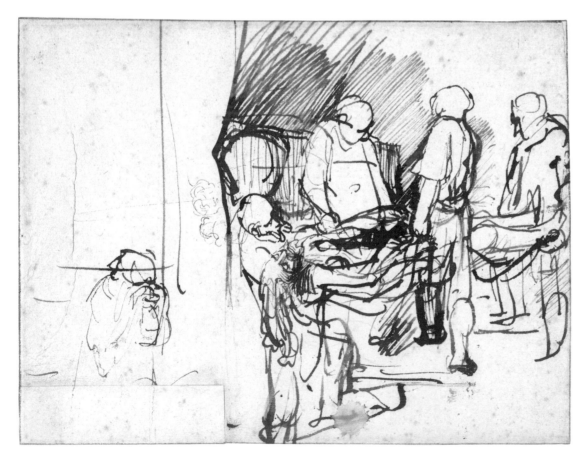

Fig. 26 | The Passion Series,
Alte Pinakothek, Munich, left to right:
The Adoration of the Shepherds, 1646
The Raising of the Cross
The Descent from the Cross
The Entombment, c.1635–39
The Resurrection
The Ascension, 1636

Fig. 27 | *The Entombment*,
c.1640–41, pen and bistre,
15.3 × 20 cm, Rijksprentenkabinet,
Amsterdam, RP-T-1930-28R

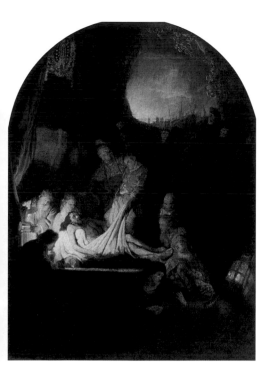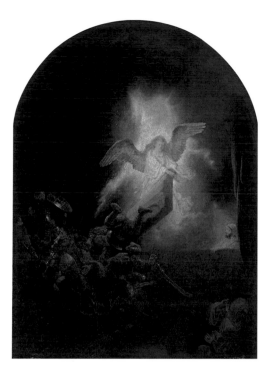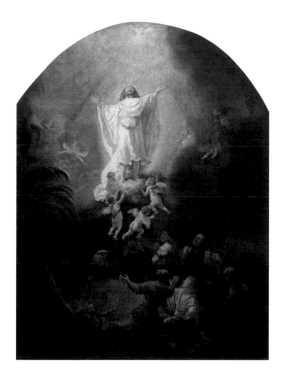

Christ and into the cave behind his body; it contrasts with the multiple light sources in the Munich painting: the two candles held by the men to the left of Christ's head, the lantern on the ground to the right, and finally the evening light glimpsed in the distant view of Golgotha above.

The action itself is quite different in the two paintings. In the Munich *Entombment,* Christ is being lowered into a stone-built tomb, while in the *Entombment Sketch* his body is being lowered to the ground before the actual burial. The ten figures close to Christ in the Munich *Entombment* are replaced by seven in the *Entombment Sketch* and this creates a greater intimacy, especially in the group around Christ's head. *Pentimenti* visible on the surface, and confirmed by the X-ray image [fig. 63], show that in the *Entombment Sketch* Rembrandt may originally have painted a version of the head of the young woman seen just behind and above Christ's head in the Munich painting; the paint surface still shows an oval where her head may have been painted over and replaced, to the right, by the bearded head of the old man who looks into Christ's eyes.

A pen drawing in Amsterdam provides a restatement of part of the Entombment subject [fig. 27], focusing on a group of figures carrying Christ towards the tomb. It has no obvious link to the Hunterian *Entombment Sketch* but takes its starting point from the curtain that frames the composition of the Munich *Entombment* on the left, thus providing another example of Rembrandt's tendency to rethink and recast his images.[12] The

Entombment Sketch is framed to the left by the tall figure of a bearded man with a round cap. He is very thinly painted, however, and in places an underdrawing in black chalk on the primed surface can be seen underneath him. The lines do not correspond with his form, and they might rather represent a curtain like that in the Munich painting. The Amsterdam drawing is datable to c.1640–41 on the basis of the sketch of an executioner on the verso,[13] and this indicates a period in which Rembrandt was rethinking the Entombment subject: we should therefore consider the possibility that the *Entombment Sketch* was made at the same time as this drawing.

LATER PASSION ETCHINGS

Although the series of Passion prints that Rembrandt and Uylenburgh planned in the mid-1630s did not go beyond the two large and important etchings, the *Descent from the Cross* [fig. 12] and *Christ before Pilate* [fig. 10], Rembrandt did return to the theme in two important groups of prints in the early 1650s. This was a moment when, in his paintings, he had moved away completely from the compositions with small figures characteristic of the 1630s and was producing paintings of single, monumental figures, such as the *Man in Armour* (Kelvingrove Art Gallery and Museum, Glasgow), or the great portrait of Jan Six (Six Collection, Amsterdam). This monumentality equally characterises his series of four Passion etchings: the *Presentation in the Temple in the Dark Manner*, c.1654 [fig. 28], the *Descent from the Cross by Torchlight*, 1654 [fig. 29], *Christ at Emmaus: The Larger Plate*, 1654 [fig. 31] and *The Entombment*, c.1654–56 [fig. 30].

 The etching of the *Entombment* (White and Boon 1969, B. 86) is another work with which the Hunterian *Entombment* must be compared. True to Houbraken's dictum about the variety of Rembrandt's sketches, the subject is treated in a new way, different from both the Munich *Entombment* and the Amsterdam pen drawing. Even if it reverses the action of the Entombment seen in both paintings, we can be sure that it was nonetheless dependent on them for its fundamental layout. The etching incorporates a figure group of tall bearded man with round cap, and crouching woman, which corresponds closely to the figures that frame the composition of the *Entombment Sketch* on the left. The correspondence is so close that it is tempting to believe that the figure group in the *Entombment Sketch* painting is taken from the etching. Certainly the opposite is impossible because of the reversal of image that occurs in printing the etching. It would be problematical to suggest the influence of this etching of c.1654–56 on a painting of c.1639 were it not for the fact that the figure of the woman in the painting shows evidence of having been revised in a later campaign of painting. She is modelled with a thick impasto that very effectively covers

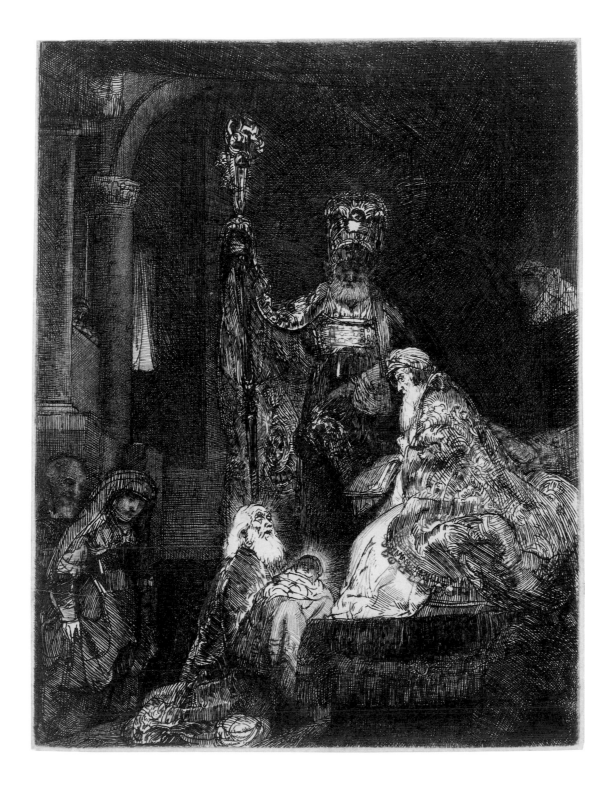

Fig. 28 | *The Presentation in the Temple in the Dark Manner*, c.1654, etching and drypoint,
21 × 16.3 cm, British Museum (cat. 16)

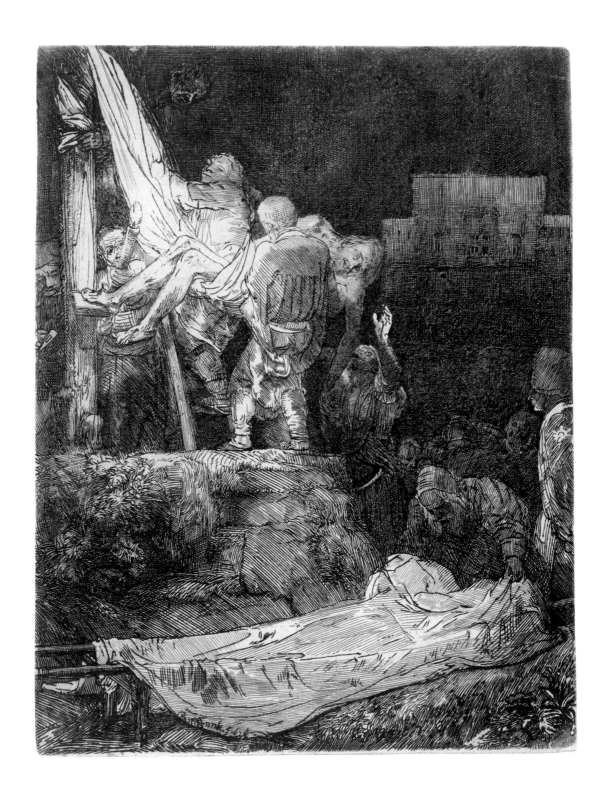

Fig. 29 | *The Descent from the Cross by Torchlight*, 1654, etching and drypoint, 21.1 × 16.3 cm, The Hunterian (cat. 17)

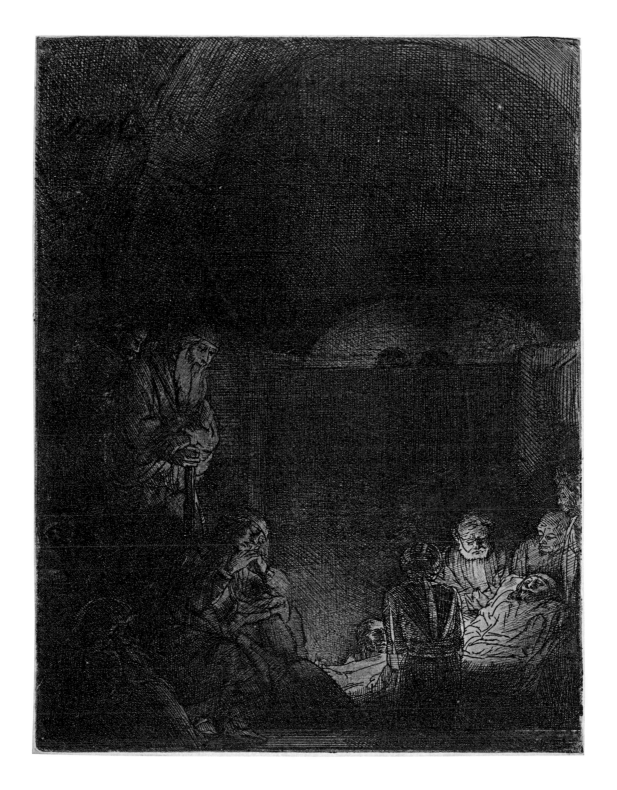

Fig. 30 | *The Entombment*, c.1654–56, etching, 21.1 × 16.1 cm,
Scottish National Gallery, Edinburgh (cat. 18)

Fig. 31 | *Christ at Emmaus: The Larger Plate*, 1654, etching, burin and drypoint,
20.8 × 15.8 cm, The Hunterian (cat. 19)

the layers of paint underneath. In the etching, this crouching woman represents the Virgin Mary, her hands clasped in prayer. She is very similar to the figure in Mantegna's *Virgin and Child* engraving (B. 8, fig. 42), which Rembrandt used as the model for the Virgin in another etching of 1654, the *Virgin and Child with the Cat and Snake* [fig. 41]. Other elements of this etching are similar to and might have been taken from a drawing by an artist in Raphael's circle that was in Rembrandt's collection [fig. 55]: the niche with its arched top and skulls, as well as the static calm of the figures present. The drawing is discussed in the next chapter.

There is one further aspect in which the *Entombment* etching seems very close to the Hunterian *Entombment Sketch*, and that is in the extraordinary light effects that were created in printing. With this plate more than any other, the artist experimented with different types of paper and with surface inking to create an effect of chiaroscuro to rival that in the *Entombment Sketch* painting. The example of this etching in the exhibition, from the Scottish National Gallery, is one of a surprising number of rich, dark impressions, inked in the manner of a monotype. Some impressions printed in the conventional manner with the surface ink removed, as was more usual, reveal the underlying drawing with widely spaced parallel shading [fig. 4].

Painterly effects are also a characteristic of the Passion prints that form a pair of late masterpieces, *The Three Crosses* of 1653 [fig. 32] and the *Ecce Homo* of 1655 [fig. 34]. The Passion Series paintings that Rembrandt produced for Frederik Hendrik were expensive works, made to hang in a chapel or private gallery. Rembrandt's etchings, however, were widely distributed and they are therefore the artist's Passion subjects with which the public would have been most familiar. In these remarkable, late prints, Rembrandt created Passion scenes on the same scale as some of his paintings of the late 1640s and early 1650s, for example the *Rest on the Flight into Egypt* in Dublin [fig. 33]. The technique of drypoint chosen for these two prints does not permit the making of large editions, signalling his intention to make prints aimed at specialist print collectors rather than the wider art market. The pure drypoint dramatically alters the quality of the lines, communicating a force and vigour appropriate to these very emotive subjects. They are dramatic works of art that demand to be seen on the wall as a painting would. It is especially in the fourth state of *The Three Crosses*, the one exhibited here, that Rembrandt radically transformed the plate by scoring many drypoint lines to create the effect of darkness that fell at the moment of Christ's death:

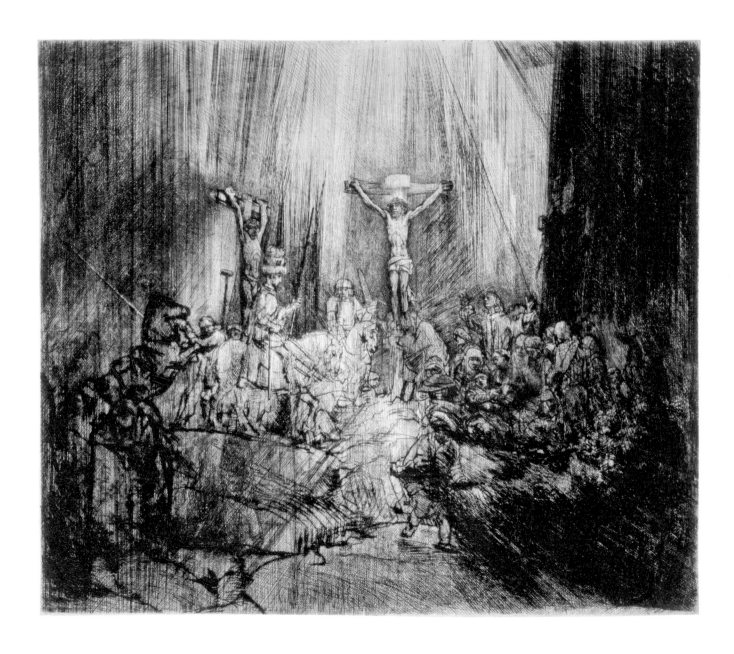

Fig. 32 | *Christ Crucified between the Two Thieves* (*The Three Crosses*), 1653, drypoint and burin, 35.8 × 45.5 cm, Scottish National Gallery, Edinburgh (cat. 14)

Fig. 33 | *The Rest on the Flight into Egypt*, 1647, oil on panel,
34 × 48 cm, National Gallery of Ireland, Dublin, NGI, 215

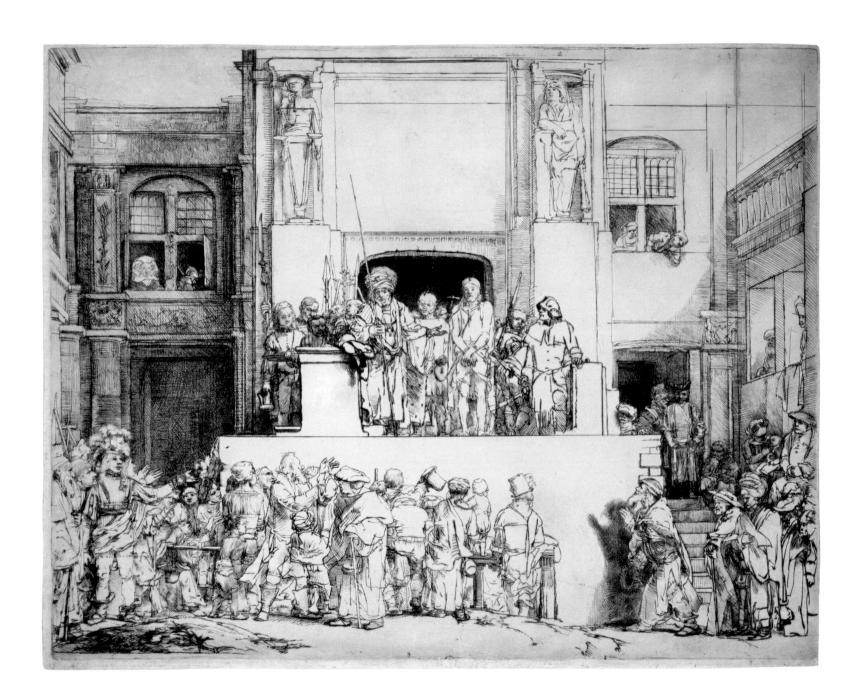

And it was about the sixth hour, and there was a darkness over all the earth until the ninth hour. And the sun was darkened, and the veil of the temple was rent in the midst. And when Jesus had cried with a loud voice, he said, Father, into thy hands I commend my spirit; and having said thus, he gave up the ghost [Luke 23: 44–46].

In both works Rembrandt made a major transformation of the plate after the image was already complete, resulting in a later state that can be regarded almost as a different print. With the *Ecce Homo*, Rembrandt removed the crowd of bustling spectators that we see in this early state in the foreground. In the later state, the space in front of the main figure group was instead used to show the blank face of the tribune on which the captive Christ stands, emphasising his loneliness. In the centre of the later state, the arched mouths of two drains appear, with the head of a classical god between them suggestive of the entrance to the underworld. In each case, the altered image was a brilliant device that extended the life of the plate and created another powerful print. Each of these monumental plates reveals a debt to a major Passion engraving by Lucas van Leyden. In this print, the presentation of Christ on a podium with architecture behind as well as the bustling crowd is modelled on Lucas's *Ecce Homo* engraving of 1510 [fig. 35]. His engraving of *Golgotha* of 1517 is reflected in the composition of Rembrandt's *Three Crosses*. This exchange with the work of other artists respected and admired by Rembrandt is the subject of the next chapter, which examines Rembrandt's *kunst caemer,* or museum.

Fig. 34 | *Ecce Homo: Christ Presented to the People*, 1655, drypoint, 35.8 × 45.5 cm, Scottish National Gallery, Edinburgh (cat. 15)

Fig. 35 | Lucas van Leyden, *Ecce Homo*, 1510, engraving, 28.7 × 45.2 cm, British Museum, 1868,0822.603

3 REMBRANDT'S KUNST CAEMER, OR MUSEUM

The single most important document that we have concerning Rembrandt's practice as an artist is the inventory of his possessions that was drawn up for the sale of his house and its contents in 1656 after his bankruptcy.[1] That document tells us in which rooms paintings and other objects were kept.[2] This chapter takes its title from the room, named in the inventory, in which Rembrandt kept some of his most precious objects, his *kunst caemer*. This 'art room' refers not to his studio, but to a small museum containing the artist's broad-based collection which ranged from classical statues to rare objects from the natural world. Here, in this 'cabinet of curiosities', things classed as *naturalia,* such as shells, geological specimens or rare animals, complemented the *artificialia*, or man-made rarities, a category which included works of art. The *kunst caemer* was for inspiration as well as being a store for props to be used in paintings.

We can glimpse a *kunst caemer* in the painting of a *Young Artist* by Rembrandt's friend Jan Lievens (1607–1674) in the Louvre [fig. 38]. The subject of the painter at work appears often in the work of Rembrandt and his contemporaries. Mainly they were preoccupied with the image of the successful artist, but among the variants is the image of the young artist, such as the one shown by Lievens seeking inspiration in a dedicated corner of the studio, or even perhaps in a *kunst caemer*. He is watched over, appropriately, by a figure of the infant Christ, in the form of a plaster cast taken from Michelangelo's early marble *Madonna and Child* of c.1505 in the Church of Notre-Dame, in Bruges. This was one of the most famous Italian works of art in the Low Countries and a cast of it is listed in Rembrandt's 1656 inventory, almost hidden by the phrase used to describe it: 'A Child by Michelangelo'. It was kept in Rembrandt's large studio.[3] The Lievens painting seems to illustrate the comments of Gérard de Lairesse, who was briefly a pupil of Rembrandt, and recommended in his treatise on drawing, the *Grondlegginge ter teekenkonst* (Foundations of the Art of Drawing, 1701), that the artist should immerse himself in relevant imagery before beginning work:

> But before putting charcoal to paper to create a sketch, it is important and extremely beneficial for the student to look first with utmost concentration

Fig. 36 | Lucas Vorsterman after Rubens, detail from *The Adoration of the Magi*, 1621, engraving, 56.9 × 73.5 cm, The Hunterian (cat. 29)

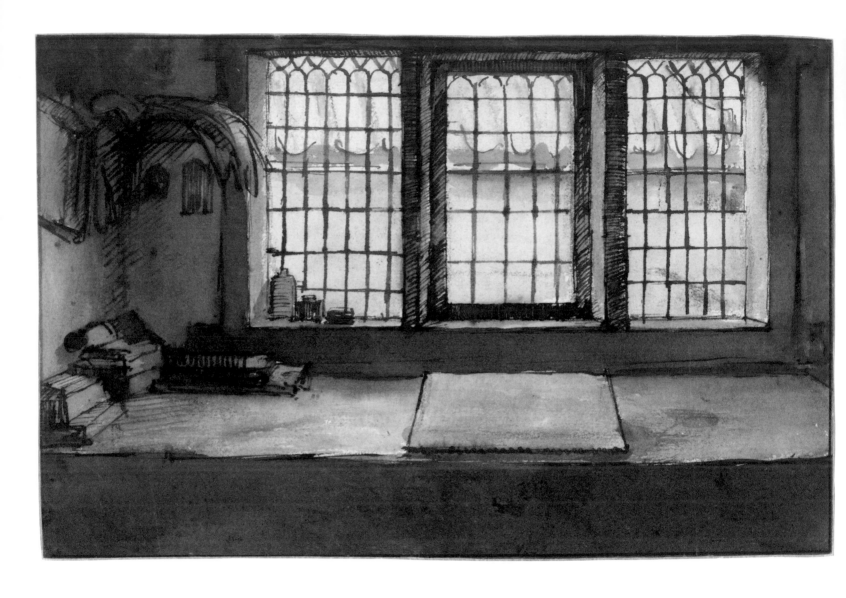

Fig. 37 | Attributed to Willem Drost, *An Artist's Worktable by a Window*, c.1650–55, pen and brown ink with brown and grey wash, 13 × 19.8 cm, British Museum (cat. 37)

Fig. 38 | Jan Lievens, *A Young Artist*, c.1666, oil on canvas, 129 × 100 cm, Louvre, Paris, RF 2562

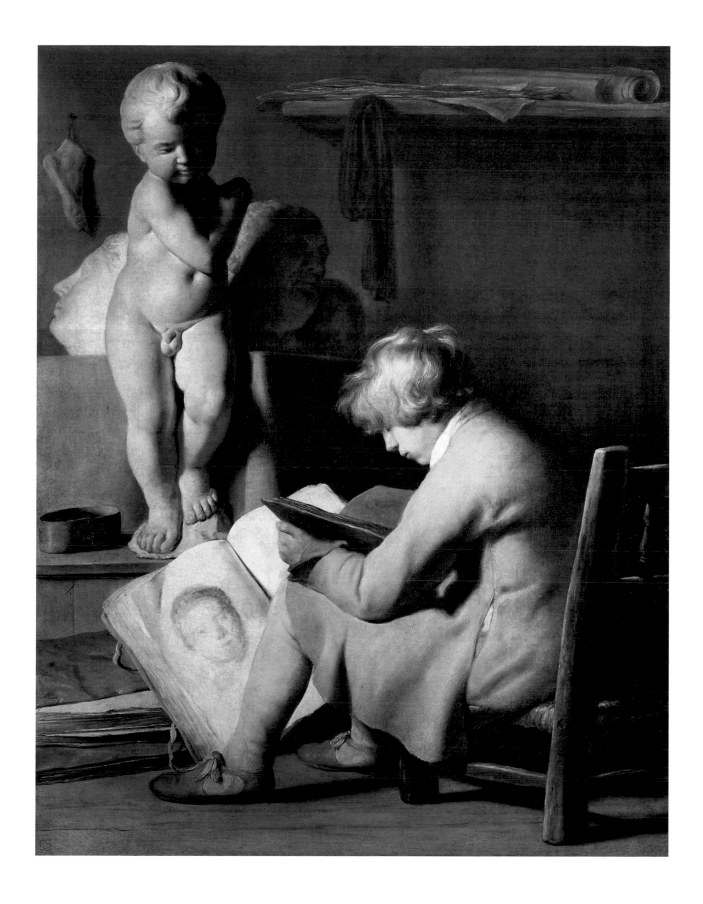

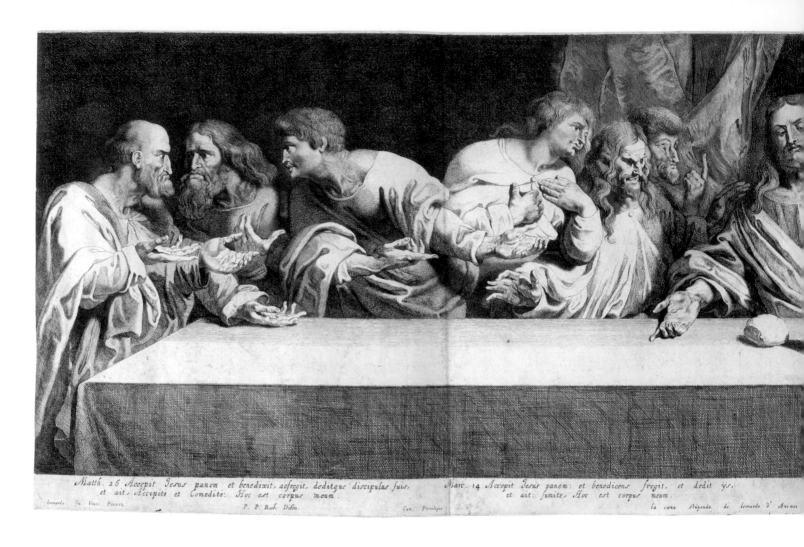

Matth. 26 Accepit Jesus panem et benedixit, acfregit, deditque discipulus suis. Marc. 14 Accepit Jesus panem: et benedicens fregit. et dedit ijs.
et ait, Accipite et Comedite: Hoc est corpus meum. et ait. sumite, Hoc est corpus meum.

Leonardo da Vinci Pinxit. P. P. Rub. Delin. Cum Privilegio la cæna Stupenda di Leonardo d' Aumici

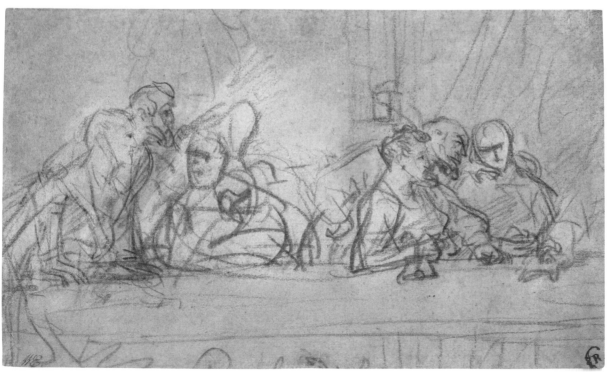

luc. 22 *Accepto pane gratias egit et fregit et dedit ijs, dicens: Hoc est corpus meum, quod pro vobis datur: hoc facite in meam commemorationem.*

Clement de Jonghe Excudit

Corinth. 11 *Dominus Jesus in qua nocte tradebatur accepit panem, et gratias agens fregit et dixit Accipite et manducate: Hoc est corpus meum, quod pro vobis tradetur: hoc facite in meam commemorationem.*

Fig. 39 | Pieter Claesz. Soutman after Leonardo, *The Last Supper*, c.1630, etching, 29.4 × 97.7 cm, The Hunterian (cat. 31)

Fig. 40 | Rembrandt after Leonardo da Vinci, *The Last Supper*, c.1635, red chalk, heightened with white, on paper probably washed pale greyish brown, 12.5 × 21 cm, British Museum (cat. 30)

and for some considerable time at the objects that he wants to draw, noticing how the principal forms and components of the image fit together, where the highest and lowest points are &c. Indeed, one will observe that one's practical skills are greatly improved when one has spent enough time looking in order to have memorised the exact arrangement of the image.[4]

The greatest treasure in Rembrandt's *kunst caemer* was undoubtedly his collection of prints and drawings, stored in albums of the kind that we see being studied by the young artist in Lievens's painting. The collection constituted an iconographical reference library, which helped Rembrandt and his pupils to paint an image in the mind 'before putting coal to paper'; some estimate that it may have contained as many as 8,000 sheets, consisting of works by living artists as well as great figures from the past. There were drawings by Rembrandt himself, and by his master Pieter Lastman, and engravings after Rubens. In one album Rembrandt kept the etchings of his friend Jan Lievens together with those of a pupil, Ferdinand Bol. In most cases we can only guess at the actual contents of the volumes, but where prints are concerned, he aimed at forming complete collections. His

holdings of prints by some artists were exceptional, most notably Raphael (four albums) and Lucas van Leyden. He was so obsessive about collecting Lucas's prints – Rembrandt's pupil Samuel van Hoogstraten described it as folly (*zotheyt*) – that he once paid the incredible price of 179 guilders for a genre print known as the 'Uilenspiegel'.[5]

Renaissance prints and drawings were certainly the most valuable to Rembrandt, not just in monetary terms, but because they often provided the best and most authoritative compositions for Bible subjects to which he turned for ideas when inventing his own subjects. He had Italian engravings of such works as Leonardo's *Last Supper,* which was considered exemplary among Rembrandt's contemporaries for its treatment of expression. Rembrandt studied the groupings of figures in this great work in three drawings of 1634–35, including the red chalk drawing in the British Museum [fig. 40] which treats only the left half of the composition. The influence of Leonardo's work, which Rembrandt probably knew through several sources, including an etching by Pieter Soutman (1580–1657) [fig. 39], is clearest in the painting of *Samson Posing the Riddle to the Wedding Guests* of 1638 in Dresden, but it has also been traced in the clusters of expressive heads in the oil sketch of the *Lamentation* [fig. 58] and related drawing [fig. 25]. These are works that he was producing at the same time as the Passion Series for Frederik Hendrik.

The inventory also contains a tantalising reference to a collection of drawings by the great Quattrocento painter and engraver Andrea Mantegna (c.1431–1506), whose work had a particular influence on Rembrandt's work in all media in the 1650s. This 'precious book by Andrea Mantegna' ('t kostelijcke boeck van Andre de Mantaingie') was almost certainly a collection of drawings, which very likely included a drawing of the Entombment, now only known from the copy by Rembrandt [fig. 54]. The book probably also contained Mantegna's drawing of the *Calumny of Apelles*, which Rembrandt likewise copied. Both copy and original are in the British Museum. Rembrandt must also have owned engravings by Mantegna which, like engravings after Raphael, were commonly used as the basis for compositions in Italian workshops during the High Renaissance. Mantegna's *Madonna and Child* [fig. 42] was the model for Mary and Jesus in Rembrandt's beautifully peaceful *Virgin and Child with the Cat and Snake* etching of 1654 [fig. 41] as well as inspiring the mourning Madonna in the *Entombment* etching of c.1654–56 [fig. 30]. Elements taken from prints by his great predecessors are frequently to be found in Rembrandt's work, but in responding to his source he always modifies the expression of each figure. So while a small etching like Rembrandt's *Virgin and Child in the Clouds* of 1641 [fig. 43] closely follows the composition, format as well as

Fig. 41 | *The Virgin and Child with the Cat and Snake*, 1654, etching, 9.6 × 14.6 cm, The Hunterian (cat. 38)

Fig. 42 | Andrea Mantegna, *Madonna and Child*, c.1470–80, engraving, 21.9 × 19 cm, The Hunterian (cat. 39)

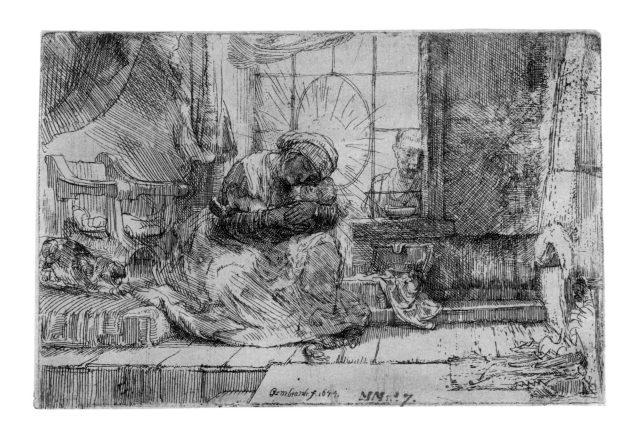

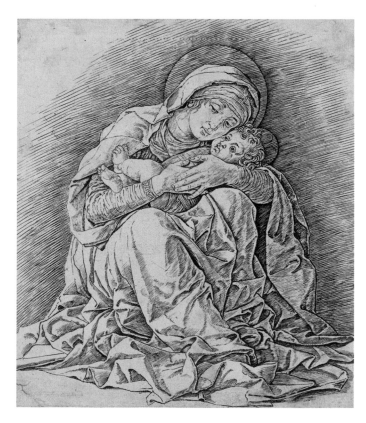

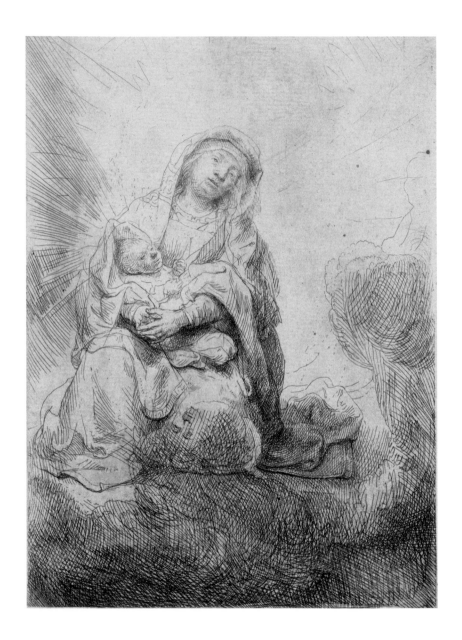

Fig. 43 | *The Virgin and Child in the Clouds*, 1641,
etching, 14.6 × 10.8 cm, The Hunterian (cat. 40)

Fig. 44 | Federico Barocci, *The Virgin Seated on a Cloud*, c.1580, etching, 15.3 × 10.9 cm, The Hunterian (cat. 41)

technique of the etching of the *Virgin Seated on a Cloud* [fig. 44] by Federico Barocci (c.1535–1612), it nonetheless achieves a completely different effect. In place of Barocci's idealised Christ Child we recognise the face of a real Dutch baby, perhaps Rembrandt's own son who was born that year. The print might represent a prayer for Titus's survival.[6]

REMBRANDT AND LIEVENS:
LAZARUS AND THE ENTOMBMENT OF CHRIST

It was essential that artists knew how best to make use of other masters' imagery. Rembrandt's pupil, Samuel van Hoogstraten, saw how Rembrandt acquired his great collection of *papierkunst*, and explains in his book on painting how a master should explore and experiment with compositions by honoured predecessors. An important distinction is made between slavish copying – described by Hoogstraten as culling (he uses the Dutch word *raepen*) – and the more creative process of entering into the spirit of the earlier artist:

> Endeavour with all your might, O diligent young painters, to become skilful inventors yourselves. Apelles and Protogenes departed from the ways of Micon, Diores, Arymnas and their predecessors. Thus also did Paolo Cagliari and Tintoretto break new ground. Who knows to what further heights art can be raised? Be bold, have a go and risk your paper; it is possible that the practice will turn you into a first-rate designer. However, if you happen to come across a well-designed piece by someone else, you may still borrow its tone of voice….There is nothing shameful about writing a couple of new verses to a tune that already pleases the world. But you must remember that you are devising a different subject: and praise will come to the painter who creates a painting of Achilles with the same artistry that was found in the Alexander by Apelles.[7]

While the prints and drawings were stored upstairs in Rembrandt's house in the *kunst caemer*, the whole house was hung with paintings so that it formed an impressive gallery, not just for Rembrandt's own work, but also for the paintings by famous masters such as Van Eyck, Rubens, Raphael and Giorgione that he also owned. The placing of the various paintings within the house is just as revealing as the contents of the *kunst caemer*. We know, for example, that in the *agter caemer* or living room at the back of the house on the ground floor where Rembrandt and Saskia slept [fig. 6], there was a painting described as 'A sketch of the Entombment of Christ by Rembrandt'. This appears to be a description of the Hunterian *Entombment Sketch*. The presence of this painting in Rembrandt's living room, rather than in one of the rooms used for showing work to customers, suggests that it had a personal significance.

Fig. 45 | *The Raising of Lazarus*, c.1631, oil on panel, 96.2 × 81.5 cm, Los Angeles County Museum of Art, M 72.67.2; *Corpus* I, A 30

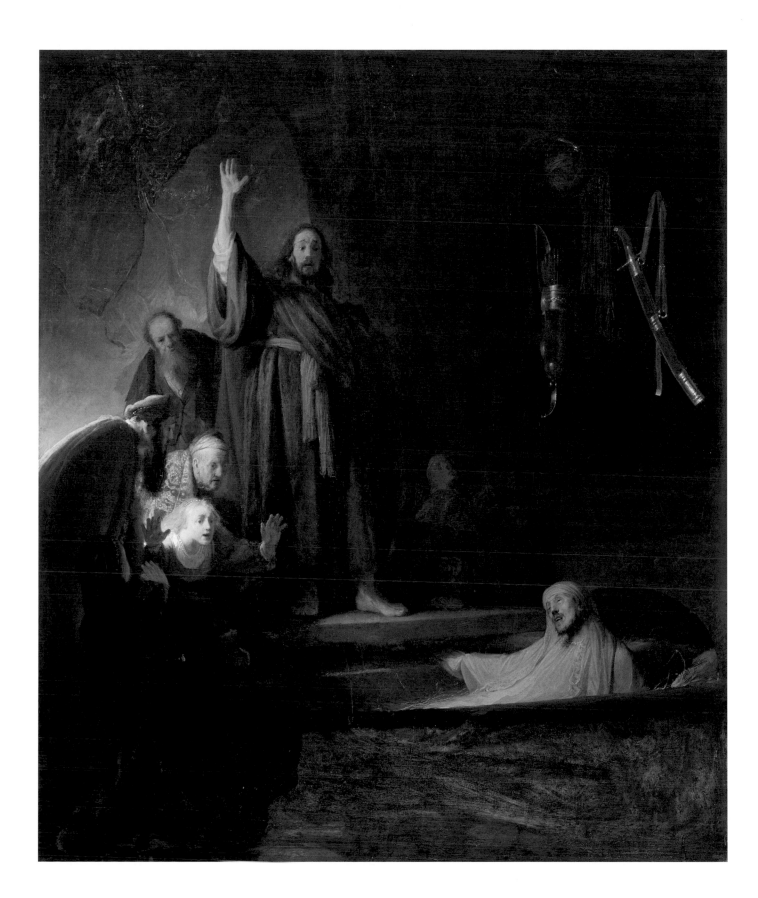

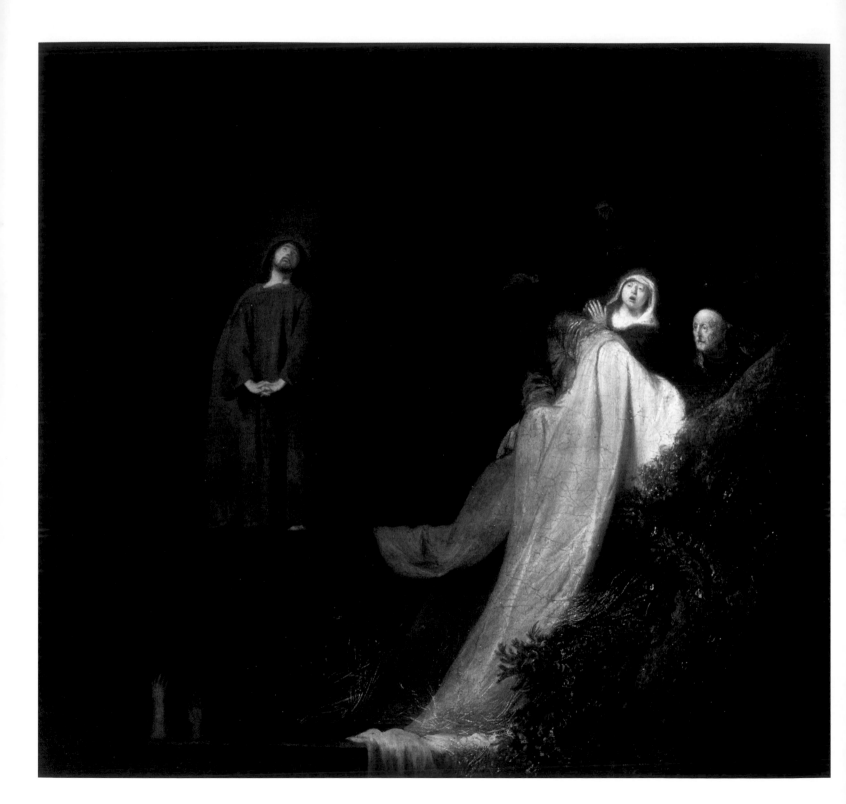

Fig. 46 | Jan Lievens, *The Raising of Lazarus*, 1631, oil on canvas, 107 × 114.3 cm, Brighton Museum & Art Gallery (cat. 8)

There were two rooms at the front of the house on the ground floor, the *voorhuis* or entrance hall, and the *sijdelcaemer* or anteroom, where much of Rembrandt's dealing in pictures was done. The paintings listed here tell us something important concerning Rembrandt's relationship with Jan Lievens that has a bearing on the Passion Series. Hanging alongside works by other artists, there were a total of eight paintings by Lievens. Three of these were examples of one of the artist's specialities – moonlit landscapes – and these were kept in the entrance hall, nearest the door. Perhaps Rembrandt placed works here that sold easily. In the slightly more private anteroom, adjoining the entrance hall, were three further paintings (a 'grisaille', a 'small hermit', and a 'priest') which sound like works of greater commercial than artistic value. Near them, however, was one of Lievens's most important paintings of all, his *Raising of Lazarus* of 1631 [fig. 46], which was paired with Rembrandt's own (undated) painting of the same subject [fig. 45].[8] They play a part in the story of Rembrandt's depiction of the Entombment because his earliest known representation of the subject is a drawing in which he derived the imagery not from his own, but from Lievens's *Raising of Lazarus*.

This prominent placing of the *Lazarus* paintings meant that it was possible for visitors to see side-by-side one of several pairs of paintings that the artists had made in competition with each other.[9] This rivalry with a friend functioned in a similar way to the silent exchange that Rembrandt had with the old masters whose prints and drawings he kept in his *kunst caemer*. The humanist education of the Latin School in Leiden, which Rembrandt attended, introduced students to essential rhetorical concepts that were applied also to the study of painting, since painters aspired to be the equals of poets. The key terms to consider in relation to Rembrandt's use of Lievens's *Raising of Lazarus* are *imitatio* and *aemulatio*. Artists began their training with 'imitation'. They copied the work of established artists from engravings and, having grasped the rudiments, would graduate to 'emulation', a process that some of them knew from their Latin composition, consisting of taking elements from an excellent model and trying to improve on it. Hanging the two *Lazarus* paintings together where they could be seen by visitors was a palpable demonstration of Rembrandt's superior skills as an artist. The idea of *aemulatio*, of demonstrating a better version of an already excellent model, can be found expressed in numerous examples of Rembrandt's work. The topos of the contest between painters, which good students would know from Pliny, or in translation from Karel van Mander, is also very clearly expressed by Rembrandt's patron, Huygens, when he praises Rembrandt: 'I tell you that no one, not Protogenes, not Apelles and not Parrhasios, ever conceived…that which (and I say this in dumb

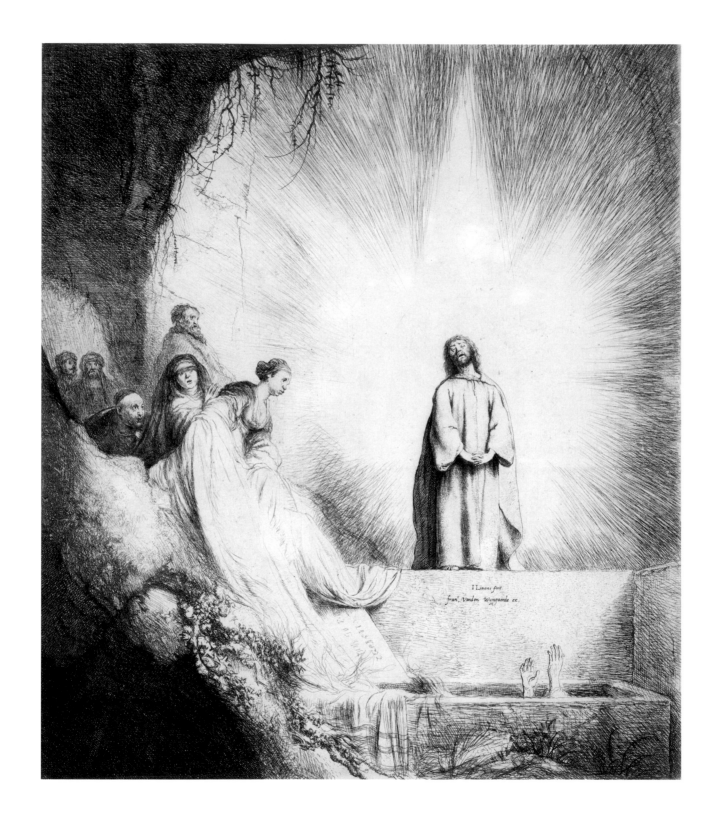

Fig. 47 | Jan Lievens, *The Raising of Lazarus*, c.1631,
etching, 35.8 × 31.2 cm, Brighton Museum & Art Gallery
(cat. 9)

amazement) a youth, a born and bred Dutchman, a miller, a smooth-faced boy, has done…Truly my friend Rembrandt, all honour to you!'[10]

Lievens's *Lazarus* was painted in 1631, just before – as far as we can tell – Rembrandt began to paint the first works in the Passion Series, the *Descent from the Cross* and the *Elevation*, which were completed by 1633. It was this *Lazarus* painting by Lievens, rather than a work by a famous Renaissance master, that provided the starting point for the imagery of one of the paintings that followed next in the series, the Munich *Entombment*, which Rembrandt tells us was half done in February 1636. The British Museum houses a red chalk drawing by Rembrandt of *'The Entombment' over a 'Raising of Lazarus'* of c.1635 [fig. 51] which has long been recognised as having a relationship both to the Passion Series and to the *Lazarus* paintings, although it is only recently that the full story has emerged. Both Rembrandt and Lievens made a painting of Lazarus; each then made a large, closely related etching. Rembrandt's *Lazarus* is one of his greatest etchings. Rembrandt also returned to the theme in 1642 in the *Raising of Lazarus: Small Plate* [fig. 49].

In addition, because he was proud of his achievement, Lievens had a reproductive print of his *Lazarus* painting made by Jacob Louys (1595/1600–c.1673) [fig. 50]. It was this print which, as Martin Royalton-Kisch has demonstrated, was used by Rembrandt as the starting point for his fine, searching drawing.[11] The drawing began as a study of the *Raising of Lazarus*, in which the dark cave of Lievens's painting and the figures standing on the rock ledge are clearly seen. They appear in reverse to those of the painting because they were taken from the print by Louys which is a mirror image of the painting.[12] The surface of the drawing shows evidence that parts were subsequently rubbed out, when as an afterthought Rembrandt added in figures carrying the body of Christ down towards Lazarus in the tomb.

Rembrandt's use of Lievens's Lazarus image as the starting point for an Entombment subject can be understood both doctrinally and in terms of studio practice. To a 17th-century audience the link between the two New Testament subjects would have been immediately apparent, since the miracle of Christ bringing Lazarus back to life prefigures his own later Resurrection. In practical terms, as he prepared to paint a scene of the Entombment for the Passion Series, it is possible that the dark cave in which Lazarus was buried came to mind as a setting to emulate for the burial of Christ. The artist who emulates naturally reverts to the image regarded as the original or best, and interestingly this meant Lievens's painting rather than his own. The drawing is inscribed by Rembrandt with the date '1630', which, as Royalton-Kisch has shown, cannot be the date

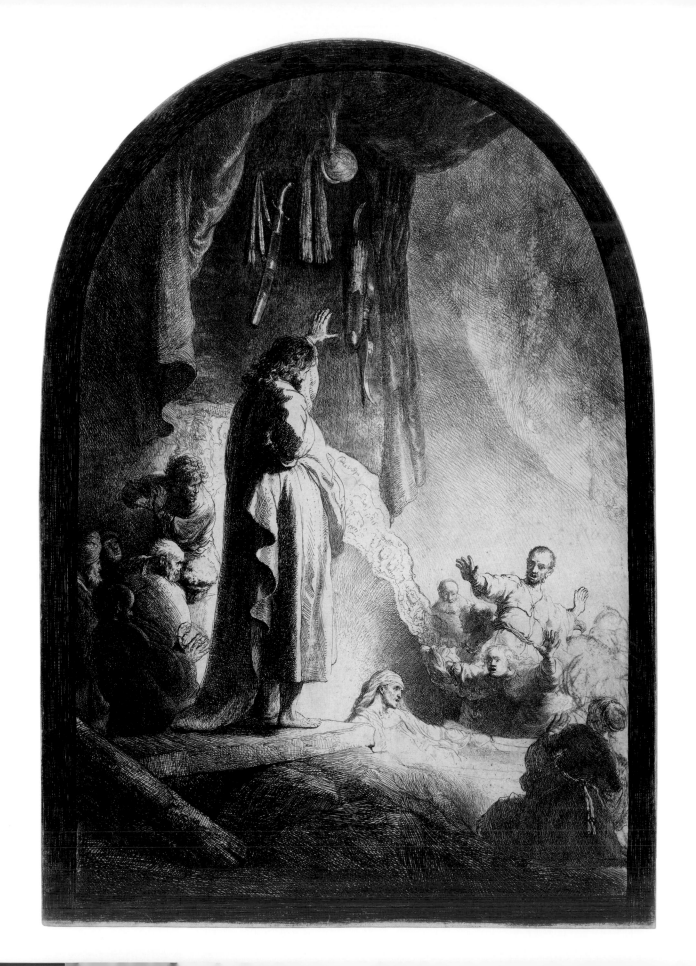

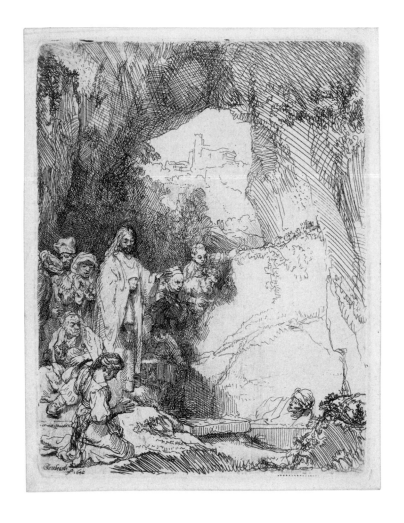

Fig. 48 │ *The Raising of Lazarus: Large Plate*, c.1632,
etching, retouched by Rembrandt with black chalk, 36.8 × 25.8 cm,
British Museum (cat. 11)

Fig. 49 │ *The Raising of Lazarus: Small Plate*, 1642,
etching, 14.9 × 11.2 cm, The Hunterian (cat. 13)

Lazarum Resuscitatum et Mundi Recreati Autoramentum. Mea Observantia et Fiducia Argumentum
Tibi Vir Clarissime, Cognate Francisce De Kies P. Soutman offero.

P. S. Exud.

I. L. Pinxit

I. Louijs Sculpsit Cum Privil.

of execution, although it might be an accurate memory of the date of the original conception of the Lazarus subjects by both Rembrandt and Lievens. The drawing can be dated stylistically to about 1635, by comparison with other red chalk studies including another Passion subject, that of heads from Leonardo's *Last Supper* [fig. 40].

So, the red chalk drawing based on the *Raising of Lazarus* seems to be Rembrandt's earliest version of the Entombment. It shows the artist wrestling with the new subject at about the time (c.1635–36) that he was working on the second group of paintings for the Passion Series, including the Munich *Entombment*. The drawing establishes fundamental aspects of the composition of Rembrandt's *Entombment*, including the vault of rock which curves upwards from the left towards the centre in both the Munich and the Hunterian versions.

Preparatory drawings for paintings by Rembrandt are very rare, and the majority of his drawings are personal notations rather than designs for paintings. There are no preparatory drawings made specifically for either *Entombment* painting, but there are two further drawings by Rembrandt that treat the topic of the Entombment. These fall into another category of drawing, and they exemplify the kind of study undertaken in his *kunst caemer* that underpinned Rembrandt's invention of his own Passion imagery. Both create a classical frieze from the figures involved in the burial of Christ, and both are believed to be copies that Rembrandt made of precious Renaissance drawings preserved in the *kunst caemer*, in this case by 'Raphael' and Mantegna. They have been dated on the basis that Rembrandt copied them just before his collection was dispersed in 1656, but stylistically they also belong with work of the mid-1650s. Rembrandt's copies reveal to us that these drawings were available to him for inspiration and emulation in his own work.

Several versions are known of the Raphaelesque drawing of the Entombment that Rembrandt copied [fig. 55], and which he may have believed to be by Raphael while it was in his collection. The version that he owned was the somewhat smaller drawing, in brown ink and brown wash, heightened with white gouache, on cream antique laid paper, 11.7 × 18.3 cm, which is now in the Fogg Art Museum, Cambridge, Massachusetts.[13] It is impossible to say exactly when Rembrandt acquired the original, but he was actively acquiring drawings while he was working on the Passion Series, including extravagant purchases of prints and drawings from sales of the collections of Jan Basse in 1637 and Gommer Spranger in 1638.[14] The drawing has been linked by scholars to the related etching of the *Entombment* [fig. 30], which probably dates from c.1654–56. From the drawing, Rembrandt took the arch-shaped niche that is to be seen in the wall behind

Fig. 50 | Jacob Louys after Jan Lievens, *The Raising of Lazarus*, c.1632, etching, 41 × 31.5 cm, British Museum (cat. 10)

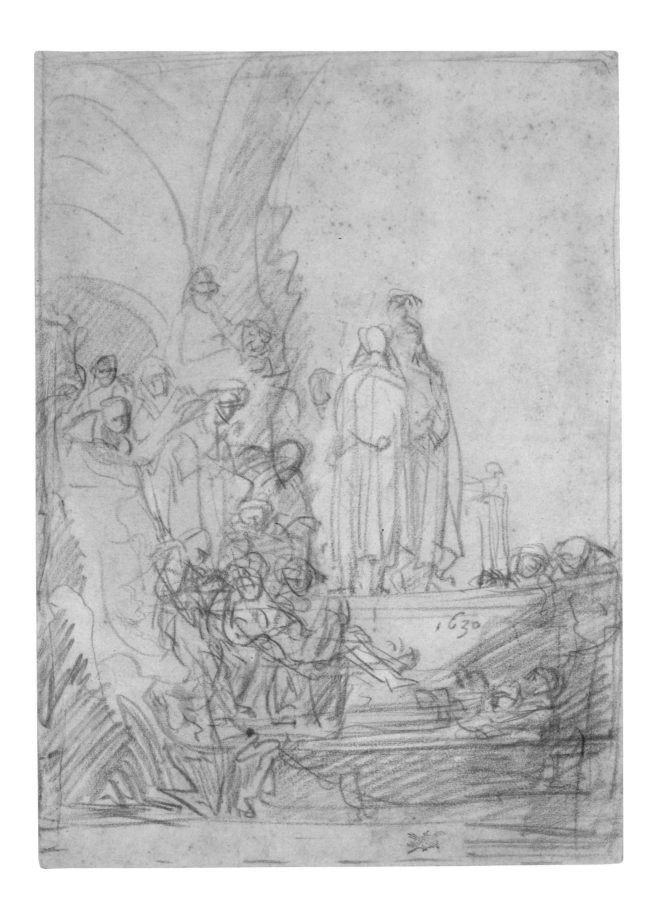

in the etching. The two skulls that appear in the etching reflect the one skull (that of Adam, who was buried on the site where Christ was crucified) in the drawing. It is interesting to note that in the Hunterian *Entombment Sketch*, a skull can just be seen to the right of Christ's body. It was painted over as the two figures to Christ's right were developed, but it can easily be made out on the X-ray [fig. 63].

Fig. 51 | *'The Entombment' over a 'Raising of Lazarus'*, c.1635, red chalk, 28.2 × 20.4 cm, British Museum (cat. 12)

Rembrandt's other drawing of the *Entombment* [fig. 54], now in the Metropolitan Museum of Art in New York, preserves the image of a drawing by Mantegna, now lost.[15] This drawing, which differs from and was not based on Mantegna's famous engraving [fig. 52], has measurements similar to Rembrandt's copy of the *Calumny of Apelles* in the British Museum. If we compare this drawing with the *Entombment* and the *Entombment Sketch* paintings, we can see that Mantegna's original drawing may have been the source for several components. Following Mantegna, Rembrandt's burial is about to take place to the left. There is also some overlap in the placing and types of the figures. Most telling of all, however, is the domination of the composition's centre by a young man holding Christ's weight by gripping the triangles of white shroud.[16]

In addition to the Italian drawings that may have influenced him, there are two engravings that appear to supply parts of the *Entombment* image. One of these is by Lucas Vorsterman (1595–1675) after Rubens's *Adoration of the Magi* in Lyon [fig. 36]. We know that Rembrandt had an impression of this engraving because he quoted figures from it in several paintings, for example the figures of Saul and the youths bearing his train in the painting of *David with the Head of Goliath before Saul*, 1627, in Basel (*Corpus* I, A9).[17] In the background of the Hunterian *Entombment Sketch*, the figures to the right, coming down into the cave, are placed in an arrangement very similar to those who press around Christ in Vorsterman's print. Rembrandt's preference for groupings inspired by Rubens is hinted at in Hoogstraten's *Inleyding*. He advises: 'Divide the figures in your picture into attractive groups…' Going on to praise Rembrandt's groupings, he reveals Rembrandt's predilection for groupings invented by Rubens: 'Rembrandt often showed an understanding of this virtue, and the best pieces of Rubens and his follower Jordaens have a particularly felicitous spatial arrangement and grouping of figures.'[18]

The tall, arched format of the Passion Series paintings compelled Rembrandt to experiment with the kind of spiralling composition in which Rubens specialised, often placing important figures in impossibly high positions. To accommodate part of the action of the Munich *Entombment* in this challenging uppermost zone of the picture, Rembrandt appears to have turned to an engraved *Entombment* by Jan Sadeler (1550–c.1600)

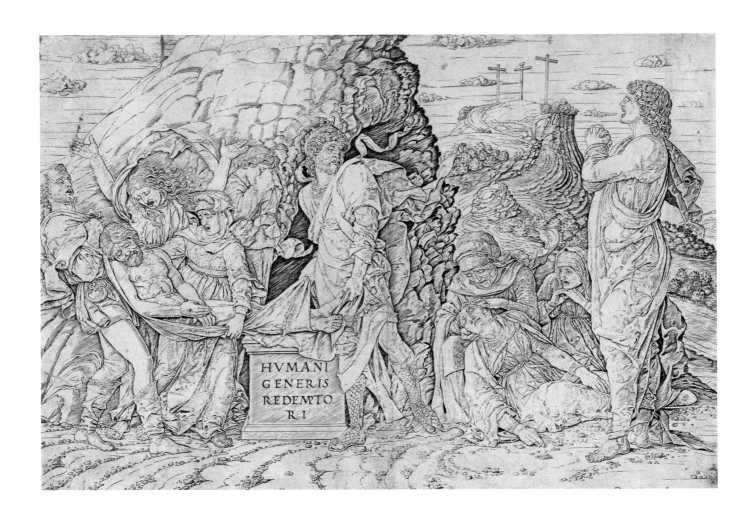

Fig. 52 | Andrea Mantegna,
The Entombment, c.1480, engraving, 28 × 42 cm,
The Hunterian (cat. 26)

Fig. 53 | Jan Sadeler after Dirck Barendsz.,
The Entombment, c.1580, engraving, 24.2 × 19.8 cm,
The Hunterian (cat. 28)

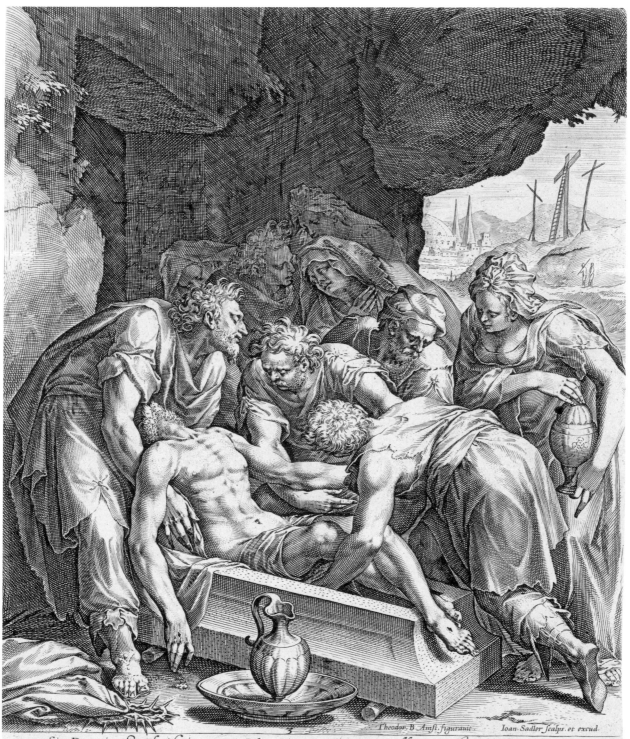

Theodor. B. Amst. figurauit. Ioan. Sadler. fcalps. et excud.

Sic Deus intacta de Virgine natus Iesus, Crimina vt ablueret noſtri commiſſa parentis,
Quem crucis in ligno ſcelerata infamia fixit: Noctibus occluſus tribus eſt in viſcere terræ.

Fig. 54 | Rembrandt after Mantegna, *The Entombment*,
c.1640–50, pen and brown ink over red chalk, with brown and
grey wash, heightened with white, 26.2 × 38.9 cm, Metropolitan
Museum of Art, New York, Walter C. Baker Bequest (cat. 25)

Fig. 55 | Rembrandt after Polidoro da Caravaggio,
The Entombment, c.1656, pen and chalk, 18.1 × 28.4 cm,
Teylers Museum, Haarlem (cat. 27)

Quarta Parte della via dolorosa
A. Porta Giudiciaria.
B. valle de i Corpi morti
C. il Sacro Santo monte Caluario.
D. il Santissimo Sepolcro di nosto Sig: Giesu Cristo.

Fig. 56 │ Jacques Callot, *The Hill of Calvary*, plate 21
from Bernardino Amico, *Trattato delle piante & immaginj
de sacri edifizi di Terra Santa...*, Florence, 1620, Glasgow
University Library, Special Collections Department
(cat. 33)

[fig. 53], taking from it the scene of the crosses glimpsed through the mouth of the cave. Sadeler's engraving reproduces a drawing by Dirck Barendsz. (1534–1592) in the Rijksmuseum, Amsterdam (inv. no. 68:35). According to Van Mander, Barendsz. was a painter of fine altarpieces in Amsterdam; Rembrandt's interest in a print designed by Barendsz. could conceivably have been stimulated by knowledge that he was the first Dutch painter to come back from Italy having mastered the Italian manner of painting. Barendsz. trained with Titian, an artist whom Rembrandt greatly admired. Another work that Rembrandt may have consulted, and in this case we know from the inventory that he actually owned it, is a book of meticulously accurate plans and views of the sacred buildings of the Holy Land etched by Jacques Callot (c.1592–1635). This work, the *Trattato delle piante & immaginj de sacri edifizi di Terra Santa disegnate in Ierusalemme…* of 1620 by the Franciscan Bernardino Amico, is one of the very few books named as present in the *kunst camer*, appearing in the 1656 inventory as 'gants Jerusalem van Jacob Calot' (all of Jerusalem by Jacques Callot).[19] Plate 21 shows the position of the cave where Christ was buried in relation to the site of his crucifixion [fig. 56].

Like Rubens, that other great painter of the Low Countries in the 1630s, Rembrandt had exceptional collections of old masters with which to feed his imagination. The invention of a new image was understood to be a rare and precious moment, and Rembrandt clearly showed pupils, including Hoogstraten, how to appreciate images that had stood the test of time. As an accomplished art theorist, Hoogstraten could look back nostalgically after his master's death to the great collection housed in Rembrandt's *kunst caemer* and encourage the next generation of artists to follow a similar route. The process of *imitatio* and *aemulatio*, if properly understood, was essential because of the paramount importance of good design:

> Certainly it becomes a painter to respect prints and drawings by past masters; for besides the general honour due to art he will, through them, constantly come across certain designs which speak to his spirit and may lead him to conceive a few inventions of his own.[20]

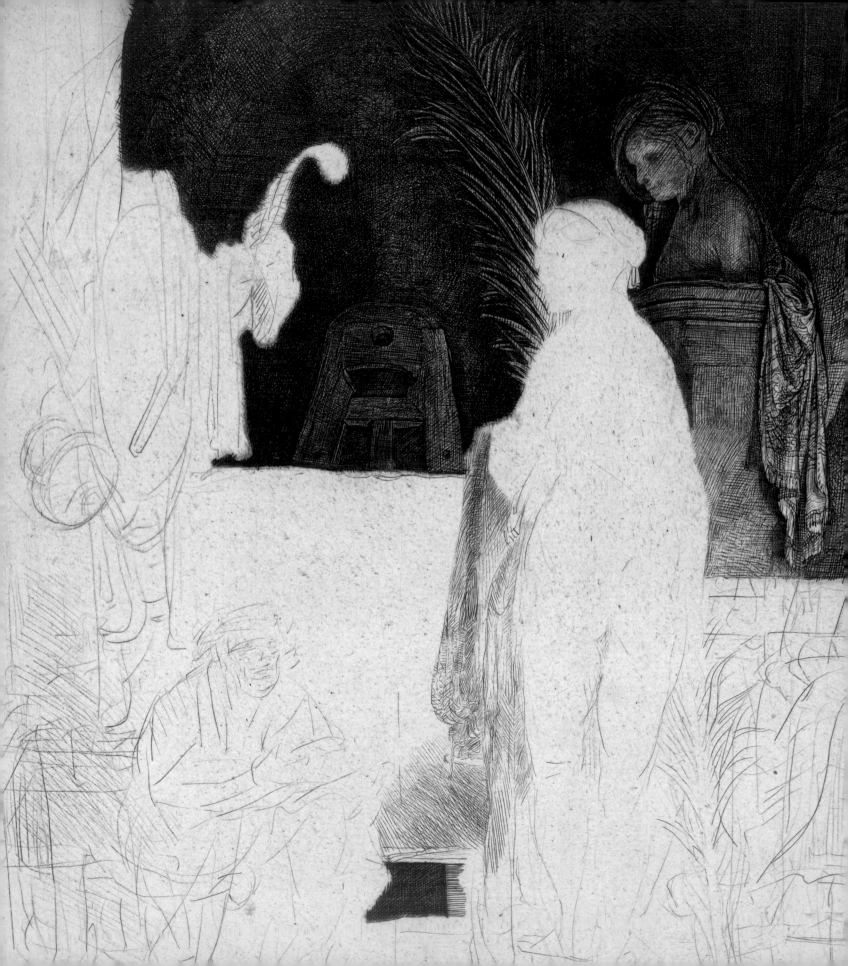

4 THE PASSION IN PAINT: A TECHNICAL INVESTIGATION ERMA HERMENS

Rembrandt's *Entombment Sketch* is described in the Rembrandt *Corpus* as '[a] well preserved, authentic work with the character and probably also the function of a preparatory sketch, datable not later than 1635'.[1] In the summary, the authors note that 'Though it is in its partly extremely sketchy treatment hard to compare with any other Rembrandt work, this monochrome oil sketch convinces one of its authenticity...'[2] The difficulty experienced by the authors of the Rembrandt Research Project and others in placing the unsigned *Entombment* within Rembrandt's oeuvre has led to proposals for its date as early as 1633[3] and as late as 1649.[4] Most scholars, however, connect the sketch with Rembrandt's painting of the *Entombment* now in Munich (c.1635–39, Alte Pinakothek, fig. 2), which is part of the Passion Series executed for Prince Frederik Hendrik that was begun in the early 1630s. The Munich *Entombment* was probably started at the end of 1635 and was finished and delivered in 1639.[5]

The authenticity of the Glasgow *Entombment* has never been in doubt, and the small panel is often described as a preliminary sketch for, or as a sketch after the Munich composition, or as a preparatory sketch or 'grisaille' design made for an etching. In Volume v of the *Corpus* (2011), which is dedicated to Rembrandt's small-scale history paintings, the *Entombment Sketch* is included in a series of oil sketches, or grisailles depicting scenes from the Life of Christ, and intended as designs for a hypothetical Passion series in print.[6] With the exception of the *John the Baptist Preaching* (62.7 × 81.1 cm, Gemäldegalerie, Berlin), which is on canvas adhered to panel, these sketches are executed on paper mounted on panel or canvas. The group is listed above, p. 34, and two works are illustrated: the *Lamentation over the Dead Christ* (c.1635, oil on paper and canvas mounted on panel, 31.9 × 26.7 cm, National Gallery, London, fig. 13), and the *Ecce Homo* (signed and dated 1634, oil on paper stuck to canvas, 54.5 × 44.5 cm, National Gallery, London, fig. 9). The Glasgow sketch, however, is the only one of the group painted directly on panel.

This short and by no means comprehensive overview of the notions of the function, date and character of the Glasgow *Entombment* gives some indication of the complexity and inconsistency of its paint handling, which

Fig. 57 | Detail from *The Artist Drawing from the Model*, c.1639, etching and drypoint, 23.1 × 17.9 cm, The Hunterian (cat. 36)

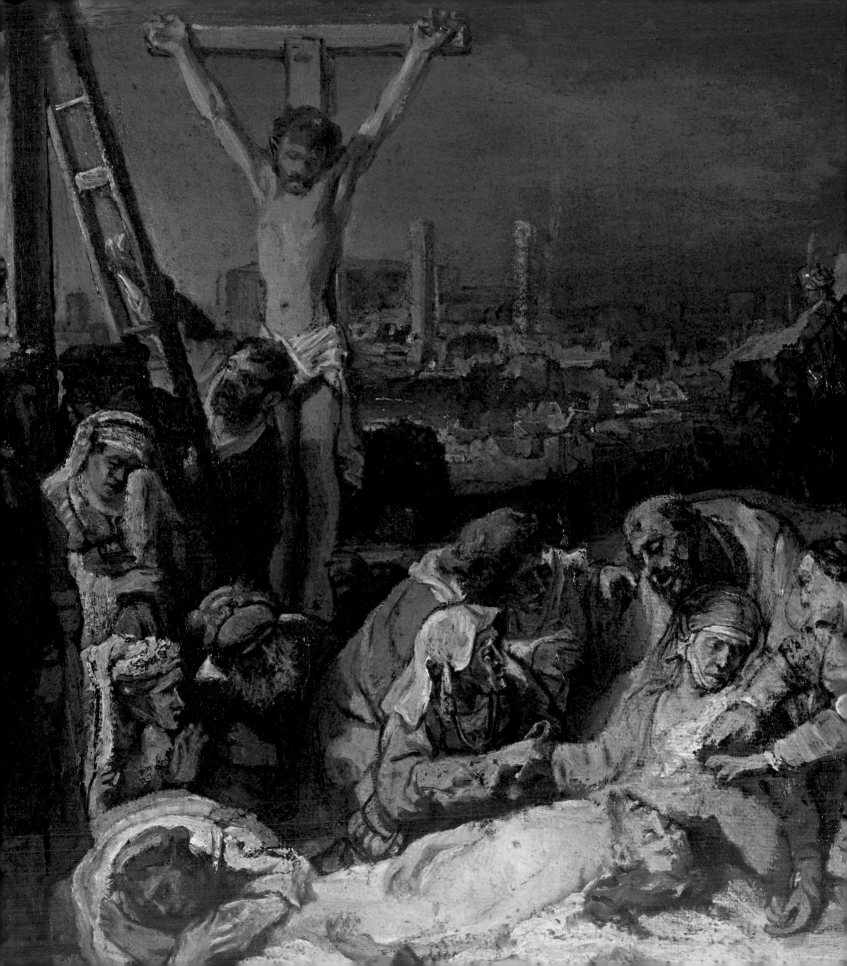

makes a clear placing within Rembrandt's oeuvre, in terms of date, function and type very difficult. Its combination of relatively detailed, smooth paint application in the central figures, with the loosely brushed-in procession on the right and the extreme impasto and sketchiness in the two figures on the left is difficult to interpret if we assume that the panel was painted in one go or at least within a short time span.

The term 'grisaille', indicating a picture executed in a monochrome palette, is seemingly easy to apply. Yet, close scrutiny of the Glasgow painting shows the presence of a variety of colours, although in a limited range of whites, yellows, ochres, sienas, browns and greys. From the latter half of the 16th century, grisailles were often made as preparatory designs for prints, a function which has been attributed by some authors to our sketch.[7] Its suitability for reproduction in print is questionable, however, due to the sketchiness of the figures surrounding the central scene. Compared to the other grisaille designs for prints of the hypothetical Passion series, there is a definite lack of 'drawing', and converting this scene into an etching could probably only have been pursued by the master himself; moreover, no such print is known.

Understanding the making of the Glasgow *Entombment* has proved challenging due to the variability in the paint application visible with the naked eye, and has been further complicated by the ample new data obtained through recent technical research. An X-radiograph was the only technical information available to the authors of Volume III of the *Corpus*, published in 1989. We therefore decided to employ several other methods, collaborating with a team of researchers from the Scientific Department of the National Gallery, London,[8] the University of Glasgow and University College Dublin. The panel has now been investigated using dendrochronology, infrared (IR) imaging, new X-radiography and scientific analyses of paint samples using Polarised Light Microscopy (PLM) to understand the build-up of ground and paint layers, Scanning Electron Microscopy with Energy-dispersive Spectroscopy (SEM-EDX) to identify the pigments, and Gas Chromatography–Mass Spectrometry (GC–MS) to identify binding media. (For a full description of these investigative techniques, see Technical Glossary on pp. 131–33).

The results provide some tentative answers to the many questions surrounding the making and meaning of this fascinating and beautiful painting, and help us move towards a more accurate interpretation. In particular, they provide an answer to existing theories which describe the sketch as made in the mid-1630s, as a grisaille or design for a print. The most difficult question to settle is why the work was left in a state that some see as unfinished. On the one hand, the lack of a signature

Fig. 58 | Detail from *The Lamentation over the Dead Christ*, c.1635, oil on paper and pieces of canvas, mounted onto oak, 31.9 × 26.7 cm, National Gallery, London (cat. 23)

Fig. 59 | *Christ Healing the Sick*: (*The 'Hundred
Guilder Print'*), c.1648, etching 27.7 × 39.5 cm,
Scottish National Gallery, Edinburgh (cat. 20)

suggests that Rembrandt had not completed it. A similar puzzle surrounds the famous etching known as the *Hundred Guilder Print*, which is also not signed [fig. 59], and which Houbraken cites as an example of Rembrandt's odd and unsatisfactory attitude to finish:

> One regrettable thing is that, being so easily inclined to make alterations, or his attention being led elsewhere, he left so many things only half finished; this certainly applies to his paintings but even more so to his etched work, in which the unfinished works give us an idea of all the beautiful things we might have had from his hand, if he had only brought to completion each thing according to its initial promise, and this can nowhere be better seen than in the hundred guilder print, the execution of which leaves us astonished; because we cannot understand how he could have completed it in this way over an initial rough sketch...[9]

But it is possible that the sketch-like finish of both the *Hundred Guilder Print* and the *Entombment Sketch* was deliberate and the literature available to Rembrandt does speak of the mastery contained in the skilful freehand sketching of a work onto a panel such as this. Thus in *Den grondt der edel vry schilderkonst* (The Foundations of the Noble and Free Art of Painting), Karel van Mander's didactic poem that accompanies his *Schilder-Boeck* (1604), with which Rembrandt was probably familiar, the author tells of excellent masters who needed no drawing aids to establish their design on a panel. It is, of course, the best way, but can only be achieved by true masters, who work '[with] a steady and accurate hand (not carelessly wandering off along narrow paths): they proceed, and draw freehand skilfully onto the panel an image that was painted already in the mind'.[10]

The technical investigation indicates that the story of this painting is rather more complex than Van Mander's description of the skills of a true master might suggest, and that the execution of the painting as we know it now, of an 'image that was already painted in the mind', took place over a longer period of time, represented by the different techniques and styles that can be detected in its making.

THE SKETCH: TECHNICAL INVESTIGATION

A simple visual inspection immediately shows the different qualities of the various parts of the picture. The paint handling in the central, strongly lit group of Christ, the young shroud bearer, his companion Nicodemus, and the older man supporting Christ's body, Joseph of Arimathea, is relatively smooth and detailed. It seems that they were first sketched in with a dark grey paint, followed by fine brushstrokes and small dabs of ochres, whites and greys that subtly define the facial expressions, with tiny dots of white paint for Nicodemus's eyes and Christ's teeth, and a beautifully placed

Fig. 60 | The verso of the panel showing
bevelling on all four sides

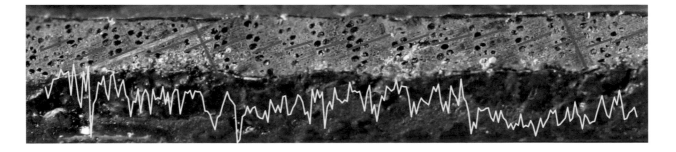

Fig. 61 | Section of the panel edge
showing a small number of the tree-rings.
In the dendrochronological analysis every
tenth ring is marked (red), and then every
ring width, from innermost to outermost (in
this case left to right), is measured (blue).
The resulting long series of measurements
can then be plotted (yellow) for
comparison with known sequences.

white highlight on Joseph of Arimathea's forehead. Details in the clothing such as the embroidered border of Nicodemus's garment and the outline of Christ's ear are drawn in the wet paint with the wooden end of the brush. These lines show up black in the X-radiograph as the paint has been scratched away [fig. 76]. As De Bruyn et al. state in Volume III of the *Corpus* (1989), these elements of the Glasgow *Entombment* are characteristic of Rembrandt's style in the early 1630s.

Yet, the paint application in this central group differs markedly from that of the other figures. On the right, a solemn procession can just be discerned in the darkness of the cave. These figures seem to have been painted with opaque dark earth tones and a few highlights of warm yellow indicating a lantern, directly over the loosely brushed-on dark background paint; faces, garments and lantern are suggested with just a few touches. Brushstrokes indicating the turban of the bearded man with the lantern suggest the application of stiff pigment, which has been dragged over the horizontal wood grain, resulting in a streaky pattern [fig. 74]. With a few strokes, his neighbour is effectively portrayed, his face emerging from the dark background as it catches the light of the lantern. The paint in this group is applied smoothly with straightforward simple brushstrokes: a method that contrasts strongly with that used for the two figures to the left of Christ, where quick and vigorous brushstrokes result in extreme sketchiness in the bearded man, and in thick impastos in the woman holding a candle, where detail has been replaced with an impression of light and shadow [fig. 65].

The combination in the one work of what are often referred to as Rembrandt's early smooth, and later rough style of painting, the latter often seen as influenced by Titian, is remarkable. Although we know that this distinction cannot be rigorously maintained, it is safe to say that the heavy impasto used in the woman sitting to Christ's left would have been unusual in the 1630s. It is a combination that brings to mind Arnold Houbraken's description of some of Rembrandt's works in which he saw that some 'things were executed in great detail, while the rest was smeared on with what looks like a rough tar brush without any attention to drawing'.[11] Similarly, the English painter Marshall Smith notes in his treatise *The Art of Painting* (1692) how Rembrandt would lay in the paint with 'a great Body' and 'extraordinary deep shadows'. Smith describes Rembrandt's '… Colours being layd on Rough and in full touches, though sometimes neatly Finish'd'.[12] Both comments seem to be accurate descriptions of the paint handling and use of chiaroscuro in the Glasgow *Entombment*.

To interpret this discrepancy in paint application in the different areas of the panel we need to investigate the whole making process: sourcing the

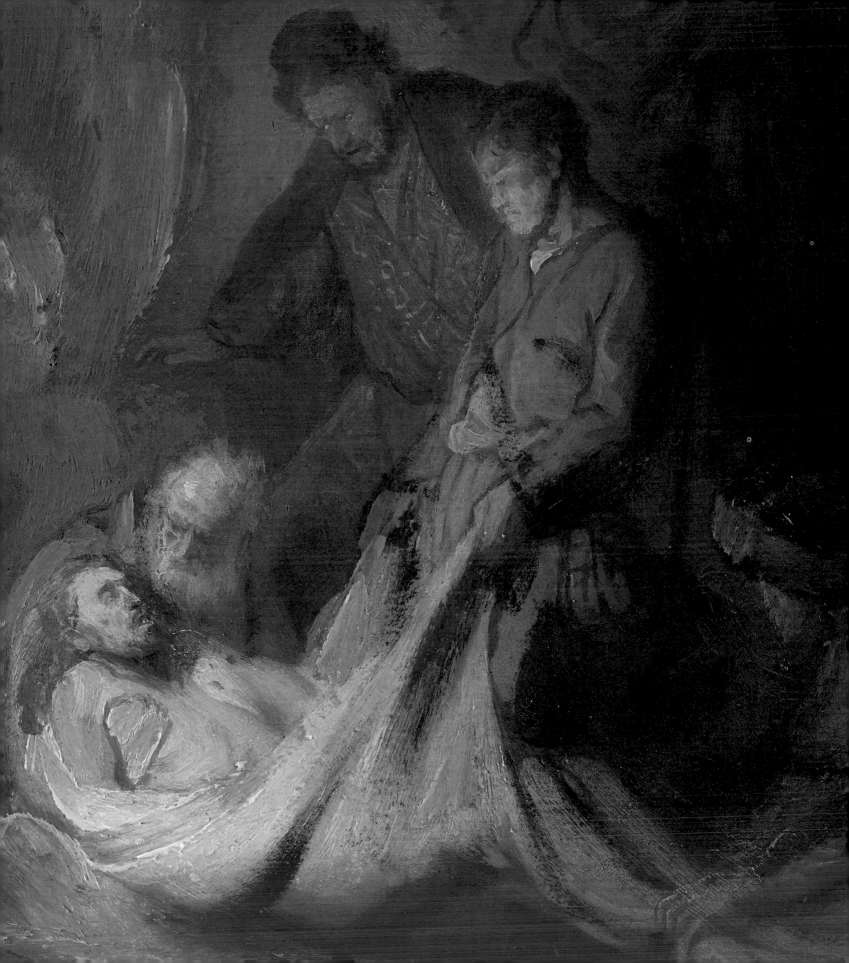

panel, applying the ground layers and underdrawing and, finally, executing those heavy impastos.

THE PANEL

The *Entombment Sketch* is painted on an oak panel with a horizontal grain clearly visible in the X-radiograph, consisting of a single plank. It is known that Rembrandt obtained his panels in batches from panel makers and used readily available formats. Research into Rembrandt's panel paintings has indicated that landscape-format panels often follow an average width: height ratio of around 1.33:1.[13] Sizes of panels seem to have been standardised and our panel's measurements are close to this ratio and close to those of several other panels used by Rembrandt dating from the 1620s and 30s. All four sides of the panel are bevelled at the back with rounded edges [fig. 60]. This, and the closeness to standard measurements, makes a reduction in size unlikely.[14]

The panel was dated by means of dendrochronology. In the timber used for the panel, 239 tree-rings were measured [fig. 61] and compared to reference databases in order to establish a possible felling date. The tree-ring 'curve' matches known patterns covering the years 1385–1623.[15] In the Glasgow panel the possible presence of sapwood rings was noted but could not be conclusively confirmed as that part of the panel is rather thin and the edge irregular. However, as the tree-ring pattern measured corresponds with data from the eastern Baltic area, for which dendrochronologists have established that a median 12 years (-6, +7) need to be added to account for the missing sapwood, this provides a felling date for the tree used for our panel between 1629 and 1642. In the 16th and early 17th century Amsterdam was an important trade centre for wood imported from the Baltic regions.[16] Taking into account that the timber had to be transported to Amsterdam and needed seasoning and processing before it would be suitable as a painting support, the earliest date or *terminus post quem* for the use of the panel seems to be in the late 1630s or early 1640s.

GROUNDS AND UNDERDRAWING

Ground layers are applied to prepare the panel or canvas support for painting. Rembrandt's use of ground layers has been extensively researched and documented, although with a focus on grounds used on a canvas support.[17] In general it has been found that panels used in Rembrandt's workshop – he only started painting on canvas supports in 1631 – were prepared following general 17th-century practice, and probably by professional primers, with a first ground of chalk in animal glue to fill the pores of the wood, followed by a second oil-based ground or priming with lead

Fig. 62 | Detail of the central group showing its detailed paint handling with fine touches of paint and subtle highlights

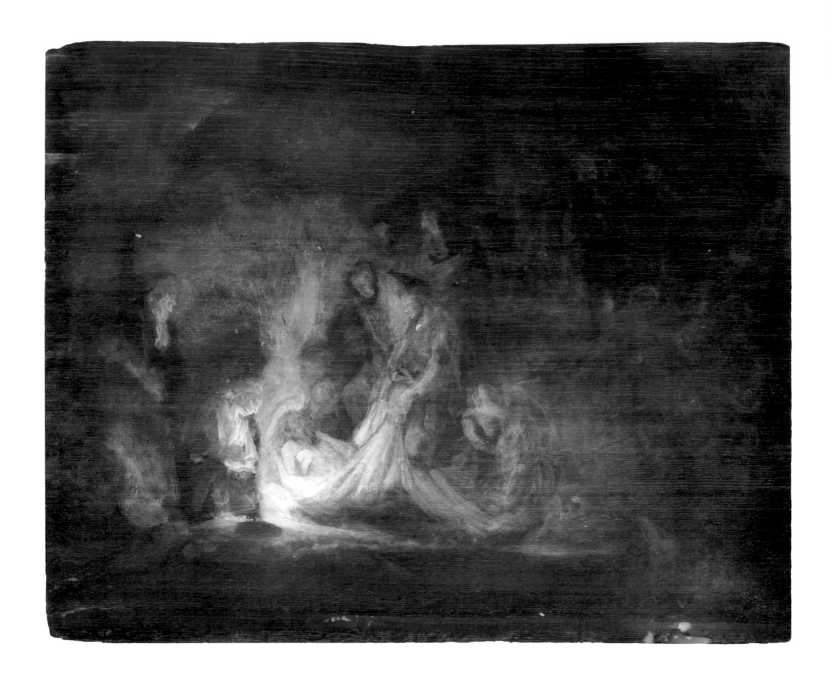

Fig. 63 | X-radiograph of the *Entombment Sketch*

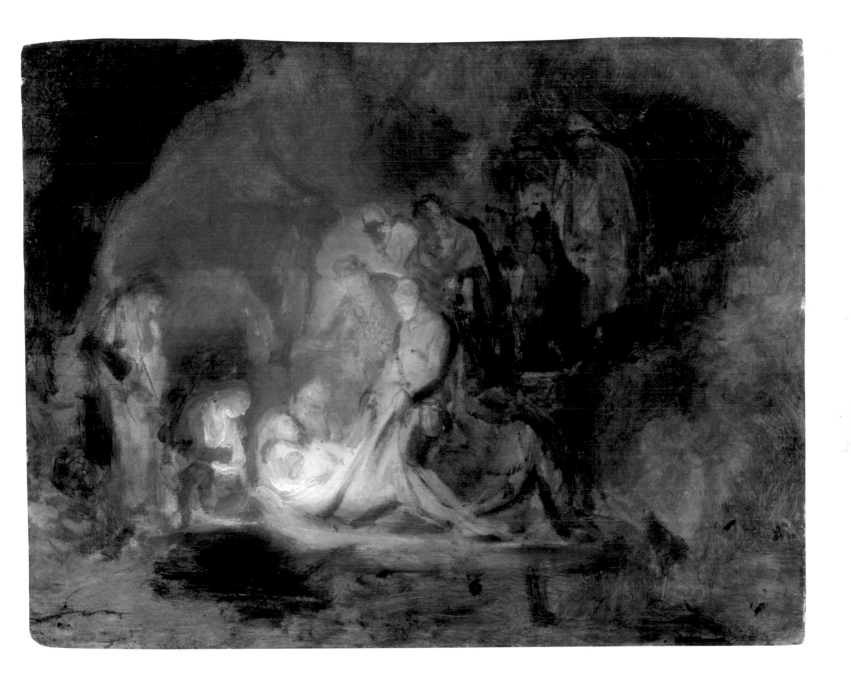

Fig. 64 | Infrared reflectogram of the *Entombment Sketch*

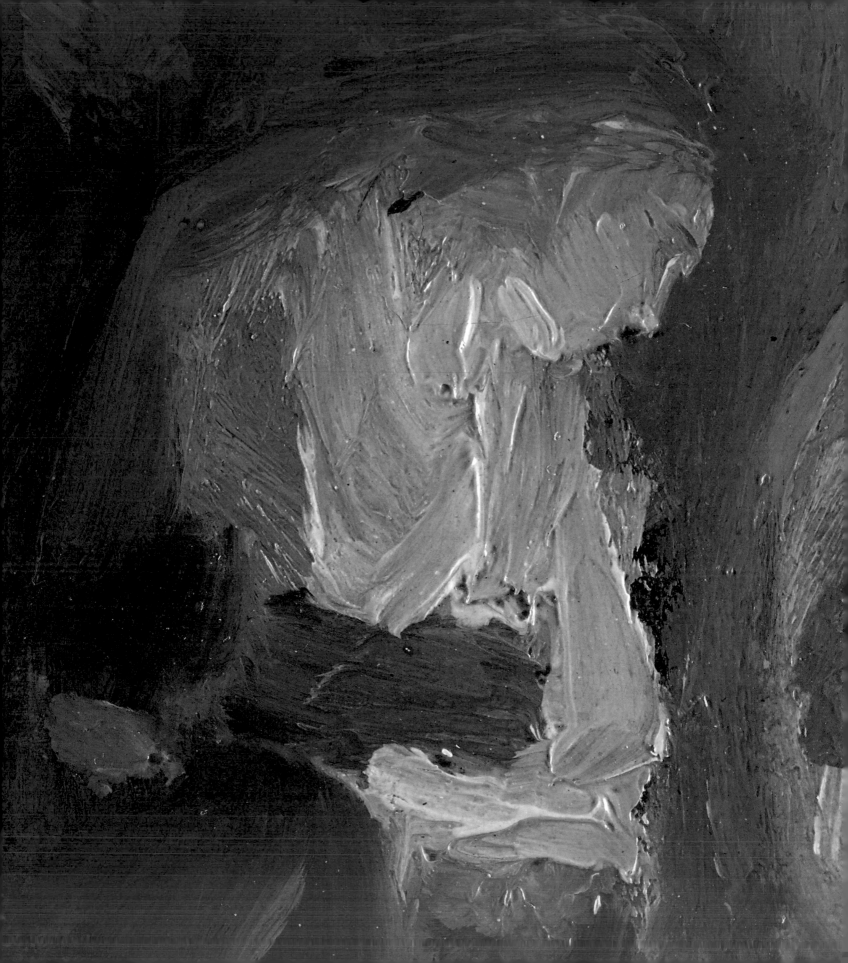

white and small amounts of earth pigments, ochres or umber, and sometimes a little black.[18]

The Glasgow panel is no exception as it is indeed prepared with a very thin whitish chalk ground followed by an oil-based priming or *primuersel* which contains lead white (EDX: Pb), chalk (EDX: Ca) and umber (EDX: Fe, Mn). In the X-radiograph [fig. 63] the larger lead white particles are clearly visible 'embedded' in the wood grain all over the panel. The *primuersel* functions as an isolation layer that prevents absorption by the chalk ground of oil from subsequent paint layers. However, Rembrandt often used its warm colour as a middle tone in the first lay-in of the composition, and left the warm tone visible as part of the final depiction. This is also the case here where the *primuersel* can, for example, be clearly distinguished in the upper part of the garment of the bearded man on the left [fig. 72], and in the reserve just visible around Nicodemus's head and arm [fig. 62].

The next stage in the creative process would be the application of an underdrawing with a drawing material – either dry such as charcoal or chalk, or wet, for example black ink or paint – or of a preparatory sketch in oil. It is often assumed that Rembrandt did not use underdrawings in a dry material such as black chalk, or made many preliminary sketches on paper, but sketched his composition directly in paint on the prepared support, often in a dark brown, or brownish grey tone in a monochrome composition. Samuel van Hoogstraten, one of Rembrandt's pupils, states in his treatise the *Inleyding tot de hooge schoole der schilderkonst* (1678) that a painter 'would design the whole scene in his imagination and made the painting in his mind's eye, before putting paint on his brush', a typical characteristic of a talented artist.[19]

We were, however, intrigued by the prominent black lines visible to the naked eye in the sketchily depicted bearded man on the left, especially as it did not seem to be connected to the figure. To unveil what may be hidden by the paint layers, the panel was examined with infrared (IR) imaging by Rachel Billinge. Infrared radiation is absorbed by any materials containing carbon black, such as a charcoal or black chalk underdrawing, which show up as black or dark grey in the IR image, and is reflected by those materials that do not absorb IR, such as light-coloured grounds.

The resulting IR image [fig. 64] is complex and hugely informative on the making process of our panel. The thicker paint layers in the central group, especially in the most brightly lit areas, prevent IR radiation from penetrating. However, in the more thinly painted figures of the young bearer, Nicodemus and Joseph of Arimathea, drawn lines are visible in IR indicating the positioning of the figures, sketchy lines in the sleeve and garments of Nicodemus, around the top of the head of the young bearer

Fig. 65 | Detail of the woman holding a candle, showing heavy impasto and wet-in-wet application

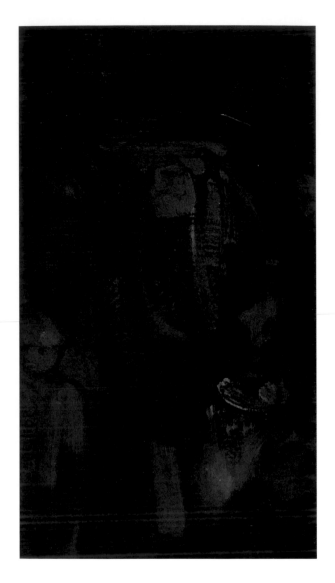

Fig. 66 | Detail of man with turban in normal light

Fig. 67 | Detail of man with turban in infrared light

and indicating the position of his purse. Next to his left hand we see a line describing the round opening of the shroud. The lines appear to have been made with a very fine brush and a black ink or diluted black paint which in some places flows into the horizontal wood grain. The blackness of the lines depended on the amount of ink or paint on the brush. The full extent of the black lines in the bearded man standing on the left is now visible in IR [figs 64 and 72], and the revealed underdrawing is reminiscent of the sweeping lines used by Rembrandt in his sketches on paper to indicate the space in which a scene is set, as for example in *Tobias Healing his Father's Blindness*, c.1640–45[20] and *The Star of the Kings*, c.1645 [fig. 68].

Sketchy lines with a similar function are visible in the foreground bottom left, and above the procession group on the right. Here, black lines indicate the position of some figures, although a part of the underdrawing

Fig. 68 | *The Star of the Kings*, c.1645, pen and brown ink, brown wash, 20.4 × 32.3 cm, British Museum, inv. PD1910,0212.189

may be obscured by the broad, black brushstrokes applied as dark shadows, to which we will return later. In the tall hooded figure, the black under-drawing roughly indicates shoulders, garment, arms and the outlines of the face and headgear [figs 66 and 67]. A curved line around the back of the woman sitting to the right of Christ indicates her position without any further detail. A thin line is visible along the bottom of Christ's feet. These mere 'indications' do not always connect closely with the painted figures; as we have seen, the bearded man on the left is painted over an underdrawing that indicates space but not him.

Although the presence in the painting of an underdrawing might seem unusual for Rembrandt, Jørgen Wadum has found a similar phenomenon in the *Andromeda*, a small panel dated c.1630 and securely attributed to Rembrandt (34.5 × 25 cm, Mauritshuis, The Hague; *Corpus* I, A 31). IR imaging of the *Andromeda* indicated the use of a fine drawing tool to set out the position of the figure with just a few lines.[21] The approach of using scant lines to describe a space or indicate the position of a figure is very similar to what we have found in the *Entombment Sketch* [figs 64 and 72]. Wadum points out that, for example, Pieter Lastman, one of Rembrandt's teachers, as well as Gerrit Dou, Rembrandt's pupil and associate in Leiden, both used underdrawings, the latter in particular for a general orientation

of the composition and indication of figures and objects.[22] It should be emphasised that Rembrandt's panel paintings have not systematically been researched with IR. Present IR imaging techniques can visualise an extensive grey scale from pure black to light grey, revealing not just underdrawings, if present, but also brushstrokes, their texture and direction. Further IR imaging of Rembrandt's panels would indeed be fruitful, as the IR of the Glasgow panel demonstrates.

THE PAINT PROCESS

In the introduction we referred to the description of the Glasgow *Entombment* as either a grisaille – in Rembrandt's case often made as a model for a print, although not always used as such – or a sketch. The interpretation of the actual painting process may help us to arrive at the correct reading of the panel as this has implications for its function.

The 1656 inventory of Rembrandt's household drawn up at the time of his bankruptcy lists 'Een schets van de begraeffenis Cristi van Rembrant' ('A sketch of the Entombment of Christ by Rembrandt').[23] The historian Jaap van der Veen discusses the inventory in the context of the value of autograph paintings in the 17th century, as the interpretation of inventory listings depends on who made the inventory and for what purpose, and on how the terminology was used at the time.[24] The inventory of Rembrandt's household was made for the so-called *Desolate Boedelkamer*, where financial agreements were sought between creditors and debtors, for which it was standard practice that the compiler was accompanied by the owner of the goods, in this case Rembrandt. Knowing this, the inventory makes very interesting reading. In most entries on paintings, the artist is named and a short mention of the subject matter given, but in some cases certain, albeit very brief, terms are added that shed some light on the type and treatment of the paintings. We find religious scenes, landscapes, paintings 'nae 't leven' (done from life), and many *tronies*, or generic figure paintings, some by Rembrandt's contemporaries, others by the master himself. Some works are described as 'van Rembrant geretukeerd' (retouched by Rembrandt). In total six retouched and two overpainted paintings by Rembrandt were listed. Significantly, however, it seems that a clear distinction is being made between grisailles, which appear listed as *graeuwties*, or as works painted 'in het grauw', and *schetsen* (sketches); the latter is the term used for the *Entombment*. As these are very likely Rembrandt's own terms, we should clearly consider the Glasgow panel to be a sketch, and not a grisaille.

The IR image of the Glasgow *Entombment* also provides significant insights into the process of paint application. Seventeenth-century painting technique was quite systematic, often following the stages described by Gérard de Lairesse in his *Groot schilderboeck* of 1707, as dead colouring, second colouring, and finishing or retouching. Rembrandt's methods are often a combination of both idiosyncratic and traditional practice, and therefore might not necessarily fully conform to this, and each case needs careful consideration.[25]

Rembrandt started with a first sketch of the composition and lay-in of tone on the warm hue of the *primuersel*, also setting out the dark and light areas; this is a characteristic aspect of Baroque painting with its often dramatic contrasts of chiaroscuro.[26] He seems at first to have reserved the figures in the background, as we can see here in the IR where a light edge is visible around Nicodemus's right shoulder, face and left arm, showing the *primuersel* layer.

In IR we can also distinguish the freely applied brushstrokes of the first brownish layer, due to the presence of black pigment in the paint. The direction of the brushstrokes of this first lay-in of a monochrome under-modelling, or dead colouring, indicates the cave, the horizontal plane in the foreground, the shapes of the figures in the procession. It also resulted in what seem to be two figures on the bottom right next to the woman holding Christ's feet, only one of whom is, rather sketchily, present in the final scene. In this first monochrome lay-in, Rembrandt also planned the shadows: the brown tones that surround the centrally lit scene with tonal gradations to register the diminishing strength of the light and model the rocky cave. Yet, the IR image shows a next stage, namely the application of a rather dark paint that appears black in IR and was applied to broad areas that were clearly selected to add shape and depth to the cave and to counterbalance the strongly lit central group in the overall composition. Deep shadows are also projected by the candle held by the woman sitting to the left of Christ which is the main light source in the composition. It should be noted that those darkest shadows would originally have been more prominent and therefore the whole background would have been more descriptive, and have more depth. However, due to darkening of the oil-rich brown layers of the undermodelling and the subsequent paint layers of the back and foreground, the true darks are no longer clearly distinguishable within the overall brown background tone, and the three-dimensional effect and balancing of contrasts has lost some of its force.

A cross-section taken from the top left edge [figs 69–71] shows the chalk ground followed by a very thin *primuersel* containing relatively coarse

particles of lead white, chalk and umber (EDX: Pb, Ca, Mn, Fe; see fig. 70 for an Elemental SEM-EDX map of each element in the sample). This is followed by two brownish layers consisting of earth pigments (EDX: Fe, Mn: iron oxides and umber), fine lead white particles (EDX: Pb), lake pigments on a hydrated aluminium (red lakes, EDX: Al), possibly also yellow lakes on a chalk substrate (EDX: Ca with C), bone black (EDX: P), chalk and a single particle of vermilion (EDX: Hg).[27] Chalk was often added by

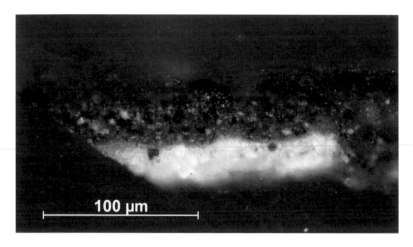
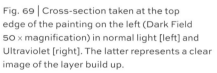

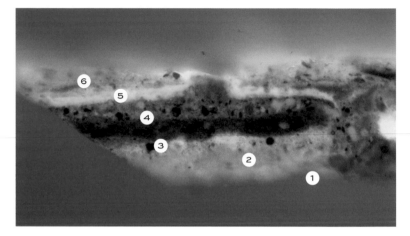

Fig. 69 | Cross-section taken at the top edge of the painting on the left (Dark Field 50 × magnification) in normal light [left] and Ultraviolet [right]. The latter represents a clear image of the layer build up.

[1] Chalk/glue ground (only partially present in the sample)

[2] *Primuersel* containing lead white (Pb) and umber (Mn, Fe)

[3] First brownish layer, containing lead

white (Pb), chalk (Ca), bone black (P), red and yellow lakes (Al and Ca), quartz (Si) and a few particles of vermilion (Hg)

[4] Second brownish layer, with a similar composition but more bone black

[5] Oiling-out layer, highly fluorescent

[6] Glaze layer containing red and yellow lakes, bone black and chalk (most likely the yellow lake substrate)

Rembrandt as an extender, especially in layers where a relatively low proportion of pigments to oil were essential but some body was needed.[28] We also found some silicon (EDX: Si), most likely quartz, probably added as an extender. As chalk becomes transparent when mixed with oil, Rembrandt often added it to glaze-like paints such as the transparent brown paints that were used here, a method found in other works as well.[29] The binding medium in these oil-rich layers was identified as heat-bodied linseed oil.[30]

The pigment mixture identified in the brown paint layers of the brownish dead colouring in the background is similar to that found, for example, in the transparent browns used in the background of the *Woman Taken in Adultery* (1644, oil on oak panel, 83.8 × 65.4 cm, National Gallery, London), where proportions of the various pigments in the mixture were adapted depending on the tone required.[31] We found a similar variation

Fig. 70 | The different colour elemental maps of the back-scattered Scanning Electron Microscope (SEM) image of the cross-section, each represent the presence of an element. The maps were obtained by using the SEM with Energy Dispersive X-ray micro analysis. This allows pigments to be identified. For example, the presence of aluminium (Al) and calcium (Ca) in the top layer probably indicate the presence of red and yellow lake pigments for which alum and chalk were used as substrates. There is just one particle of mercury (Hg) indicating vermilion in the brownish background paint, but plenty of earth pigments such as iron oxides (Fe: iron), and umber (Mn: mangenese), but also bone black (P: phosphorus), lead white (Pb: lead) and chalk (Ca), as well as quartz (Si: silicon). The map at the bottom right shows an overlay of lead (Pb: red), phosphorus (P: green) and chalk (Ca: blue). The other elements K (potassium), Mg (magnesium), S (sulphur), are probably connected to chalk and alum.

Fig. 71 | SEM image showing the structure of the cross-section

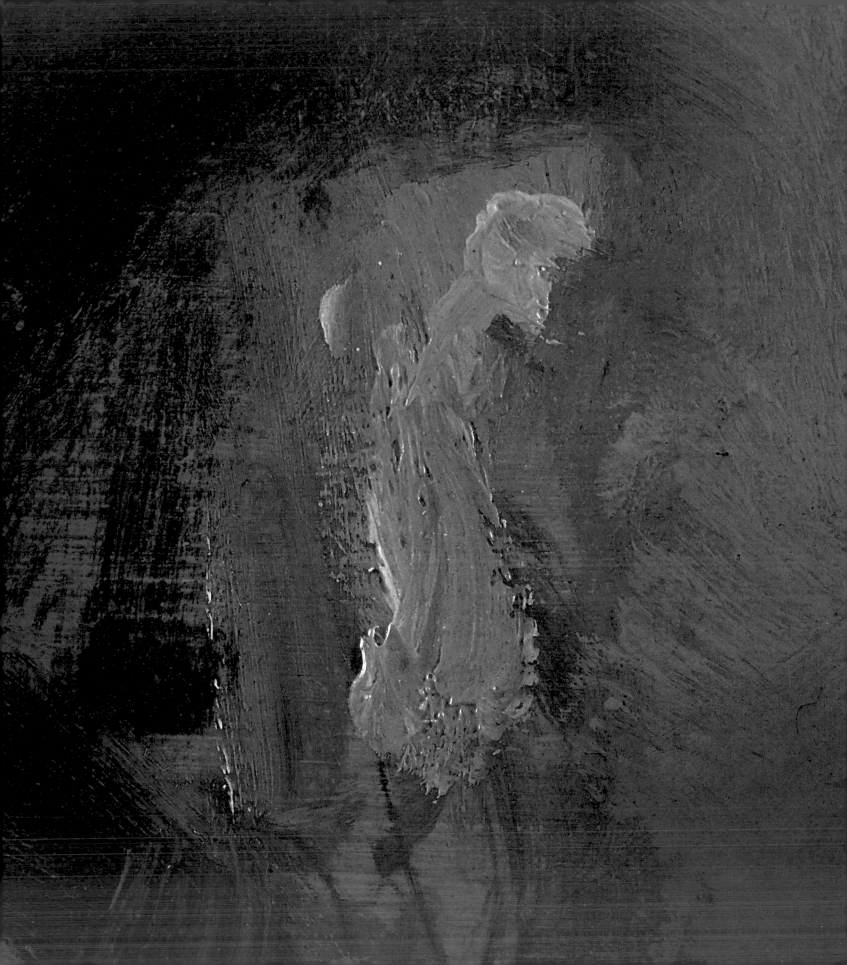

Fig. 72 | Detail of the bearded
man at left showing the warm
primuersel and underdrawing

in the two subsequent brown layers in the *Entombment Sketch*. This shows
that these mixtures were not the result of the use of oil from a *pencelier* or
kladpot, a vessel containing oil in which the painter would place his used
brushes. Pigments from the paints on the brushes, obviously a wide range,
would settle at the bottom, resulting in a brownish paint mixture. Instead,
Rembrandt selected and mixed each combination of pigments with a clear
purpose. In *Susanna* (1636, oil on oak panel, 47.7 × 38.6 cm, Mauritshuis,
The Hague), a similar paint composition, including red and yellow lake
pigments, was used in the brownish undermodelling, and the warm browns
used in the tree. For deep shadows, bone black was added.[32] Similarly in
the *Woman Taken in Adultery*, the deep shadows were made with bone black
with a little red lake. It is very likely, although no cross-section was taken
to confirm this, that the dark shadows in the Glasgow *Entombment* have a
similar composition.

The cross-section also shows a transparent layer that strongly fluoresces
in UV light, followed by a thin glaze including calcium, aluminium and
phosphorus: probably yellow and red lakes and bone black. The trans-
parent layer may be an oiling-out layer, used to saturate the paint before
modifying the tone again by applying another glaze.

WORKING UP AND RETOUCHING AND FINISHING

The next stages of second colouring, the working up – which preceded the
retouching or finishing – would introduce detail and colour, highlights
and darkest shadows, with or without the use of the undermodelling as
a middle tone in the final composition. For the *Entombment Sketch* these
stages were a play of lights, darks and definition.

Joachim von Sandrart, a German painter, theorist and contemporary of
Rembrandt who lived in Amsterdam from 1638 to 1644, writes how Rem-
brandt used little light in his works except in the most significant area and
how he 'kept light and shade together artfully'.[33] The careful and 'artful'
handling of lights and darks mentioned by Sandrart, with subtle gradations
of shadows preventing harsh contrasts, is extensively described by Samuel
van Hoogstraten who, inspired by *De pictura veterum* (The Painting of the
Ancients, 1641), written by Franciscus Junius (1591–1677), talks about the
careful arrangement of shadows by the ancient Greeks and Romans:

> Let your strong lights be lovingly accompanied by lesser lights, and I assure
> you that they will shine all the more wonderfully; let your deepest darks be
> surrounded by lighter darks, so that they will make the power of light stand
> out all the more powerfully.[34]

The above is fully illustrated in the *Entombment Sketch* with its subtle grada-tion of light. However, Van Hoogstraten is even more specific, and his sys-tematic description of the strengths and tonal values of lights and shadows in interior spaces is worth quoting.[35] He first ranks the light strengths:

> Let us say that the brightness of the Sun itself is one hundred, but the light that it sheds on things that are illuminated by it, ten: the shadow in the open air five; the brightest light within a room four; its reflections two; open shadows one and the hollow depth zero: that is without light, or at least extremely dark.[36]

Van Hoogstraten also elaborates on the tonal values and use of colour, explaining how lead white and lead tin yellow could be used for the brightest light but not of course for the highest lights in 'painted [col-oured] material' or 'something that is naturally brown' or even 'the pale nude', but, he states:

> I think one should only equate these with the very brightest lights, and thus place them in the first grade. In the second grade we put, as half lit, areas just touched by light, and equate those with our mezzo-tints, or half-tones of the browns of ochres. In the third grade, only illuminated by a fourth [of the light], we put the general reflections and transparencies, and anything that can be recognised in the shadows; and equate these with brown-red. We put the real shadows, which are nevertheless affected by some half-light, perhaps for an eighth part, in the fourth grade, and approximate to this using umber. But the hollow depths, those bereft of all light and reflection we put in the fifth or last grade, and approach these with our blacks and very darkest pigments.[37]

Hoogstraten's text seems fully applicable to the *Entombment* both in terms of the force of light and of tone. As here we see yellow/white highlights, accompanied by ochres, warm browns with some reddish brown touches, umbers and indeed the 'blacks and very darkest pigments'. He also informs us that if a candle is the main light source, the flame should be covered as it is in our painting, since – exposed – it would prevent the eyes from perceiving details and nuances: 'And certainly, when one shows something special in a painting and wants it to be fully seen, it is worthwhile hiding the flame of the candle or torch behind something; for if left naked, it would need the capacity of our first grade of light only.'[38]

It seems clear that in his treatment of lighting, describing its effect on colour and tonal value, Van Hoogstraten is describing its handling by Rembrandt. He joined Rembrandt's studio in 1642, and therefore was familiar with Rembrandt's methods and ideas. He tells us specifically that 'Rembrandt developed this virtue so that he excelled in it, and he was very skilled in combining friendly colours'.[39] What is meant here are

schijnen, de gordijnen geopent zijnde, zoo vallen de schaduwen op den
papiere voorhang: die dichtst by 't licht zijn schijnen zeer groot, daer en
tegen, die voor aen 't toneel zijn, minder. Welken dans, door aerdige
geesten gespeelt wordende, vermakelijk om te zien is. Ik zal hier een print
van een schaduwendans inlassen, en vertellen, hoe geestich ik die heb lae-
ten speelen.

De Gordijnen opgeschoven zijnde, zoo vertoonden zich, voor een
menichte toezienders, een dans van gehoornde Faunen en Veltnimfen,
of, om beter te zeggen, haere schaduwen op den verlichten voorhang, vro-
lijk, zoo 't scheen, in 't verwelkomen van den jongen Acis, en de kool-
zwarte Galaté, terwijl Kupido in de locht zwevende veelerley fratsen be-
dreef tot vermaek van de feest. Daer op volgde den manken Vulkaen dans-
sende in 't midden zijner werkgezellen, vry ruim zoo groot als Reuzen,
zich spoedende na Etna, om d'uiterste duisternis voor Pluto te smeeden.
Daer op quam Acis en Galaté wederom met een minnedans, de welke ge-
eyndicht zijnde, zoo stelden zy zich in een hoek van 't toneel tot onderlinge
lief-

liefkoozery. En korts daer op sprong Poliphemus aen de stranden hervoor, zich
kemmende met een egge, en 't scheen ook, dat hy zijn baert met een
zeyssen schrapte. Hy speelde op zijn hondert rietige ruispijp, of iemant
anders voor hem op grover speeltuig, en scheen behagen te nemen in zijn
bruine schoonheit, tot dat hy, Acis gewaer wordende, begon te bulderen.
Galaté verzwond, maer haer minnaer wiert door Poliph* met een oor-
kussen, ik wil zeggen, met een stuk van een rots verplet. Hier op danste
de Reus met zeegesprongen, en de Siklops in Mulcibers smis begosten te sme-
den. Wijder quam 'er een schip met Grieken aen, die al t'samen van Poli-
pheem gevangen, en met zijn schapen in zijn hol gedreven wierden. Maer
hy wiert van een der zelve, zoo 't scheen, met een goede kruik wijn be-
schonken, en die uitgedronken hebbende, zette hy zich neer, en scheen
in slaep te vallen. Hier op quamen de gevangene met den staf van de Reus,
of den mast van haer schip, rechtende de zelve, en drukten die in het oog
van Poliphéem: hy daer op ontwakende danste den blinden dans, en zocht
te vergeefs nae Ulisses knechten. Eindelijk quamen de Faunen, Nimphen,
en de bedroefde Galaté wederom, als ter lijkstasy van Acis. Maer Eskulapius
was reets bezich om hem weder op te wekken. Acis rees, en wert hoe langs
hoe grooter, verzwond, en verscheen wederom, nu als een mensch, dan
als een reus; dezen trant wiert van al zijn gestoet gevolgt, dan scheenen 't
Siklops, dan gestaerte Faunen, dan niet, tot datze
eindelijk al nae malkander in de papiere locht verdweenen. Dit spel, hoe
slecht, is voor den Schildergeest dienstich, om het af kanten der nacht- | Zijn nuttic-
schaduwen recht te begrijpen, en het straelen des lichts te verstaen. Wy | heit.
hebben in de plaet verscheiden beelden op verscheide plaetsen gestelt, naby
en verre van 't licht: en, tot meerder bevatlijkheit, een vierdepartkring | Graden van
met de sijffers, 1. 2. 3. 4: 5. 6. 7. 8. beschreven, door welks middel de ver- | vuur of
mindering van licht tusschen de figueren A. B. en C. zeer licht te begrijpen | kaerslicht.
is. Want daer een van de beelden A. door zijn nabyheit tot het licht, ge- | Vermeerde-
heele 4 streeken beslaet, B. niet boven 2, en C. noch minder, zoo moeten | ring of ver-
de beelden A. nootzakelijk tweemael zoo licht zijn, als B, of zoo veel | mindering.
meer, als zy in 't vatten der streeken verschillen. Daer en tegen moeten de
beelden C, of andere noch verder, zoo veel minder verlicht zijn, als zy
van minder straelen bescheenen worden. 't Welk alles nader te berekenen
ware, als men de straelen of streeken 1. 2. 3. &c. elk in 't byzonder in vier of
meer streeken verdeelde. Maer ick acht het genoech, dat een Schildergeest
alleen het begrip hier van hebbe, om alles deur het oog te leeren gissen.
Want heerlijker is 't

De reden te weten,
Als altijt te meten.

Kk 3 Het

Fig. 73 | The painter and theorist Samuel van Hoogstraten
trained with Rembrandt in the 1640s and later wrote a book
in which he described the effects of lighting which he almost
certainly learned from Rembrandt: Samuel van Hoogstraten,
Inleyding tot de hooge schoole der schilderkonst
(Introduction to the Academy of Painting), Rotterdam,
1678, Edinburgh University Library, Special Collections
Department (cat. 34)

those colours that were closely related, and which provide a very gradual change of tone and intensity; the colours to use as described above could well be such a series of 'friendly colours' which Rembrandt employed to depict space or *houding*, a Dutch 17th-century concept indicating the correct rendering of space.[40] Sandrart explains how colours should be broken and mixed to prevent any coarseness and he speaks highly of Rembrandt's masterly skill in doing just this, a skill that is beautifully represented in the *Entombment*.[41]

Fig. 74 | Detail of the procession on the right of the panel, showing faces and clothing catching the light of the candle and painted in opaque earth tones directly over the loosely brushed-on background paint

ONE GO OR MORE?

What remains after a careful examination of the detail is the stark contrast in paint handling between the various parts of the composition. It seems correct to interpret the central group as typical 1630s style. Yet the development of the surrounding figures seems to stem from a different period.

The X-radiograph shows how Nicodemus's arm first held the shroud but was then changed to its present position which corresponds with that in the Munich *Entombment*. The X-radiograph show another face above Joseph of Arimathea, and the IR indicated more figures to the right of the woman holding Christ's feet, which would have made the scene more populated. Also, in the X-radiograph the right shoulder and arm of Joseph of Arimathea – a figure not present in the Munich composition – is clearly painted over with a thick lead white paint, as is the area under Christ's right arm and the rocky background of the cave just above. These thick lead white brushstrokes seem to be used to cover up the figure who holds Christ from behind in the Munich painting, and similar strokes also simplify the shroud. Interestingly, in the X-radiograph more folds are visible, and in its first execution it was closer to the form of the shroud in the Munich painting.

Does this mean that the Glasgow panel is a preliminary sketch or model for that composition? This is difficult to confirm because no other preliminary oil sketches by Rembrandt are known. It is possible to imagine that the panel was intended as a small-scale painting of the *Entombment*, and the central figures were worked up to a certain degree of finish, but the background was still in the dead colouring stage. This was then conveniently used for the central part of the Munich composition, although it was not made as a preparatory sketch. This would place its first making just before 1636, which is in keeping with the dating of the Rembrandt *Corpus* and is not in conflict with the dendrochronological analysis of the panel. Yet there, the correspondences stop. The Munich composition with the many interacting figures, its vista on to Golgotha, its different format and function, is far removed from the contemplative mood of the Glasgow

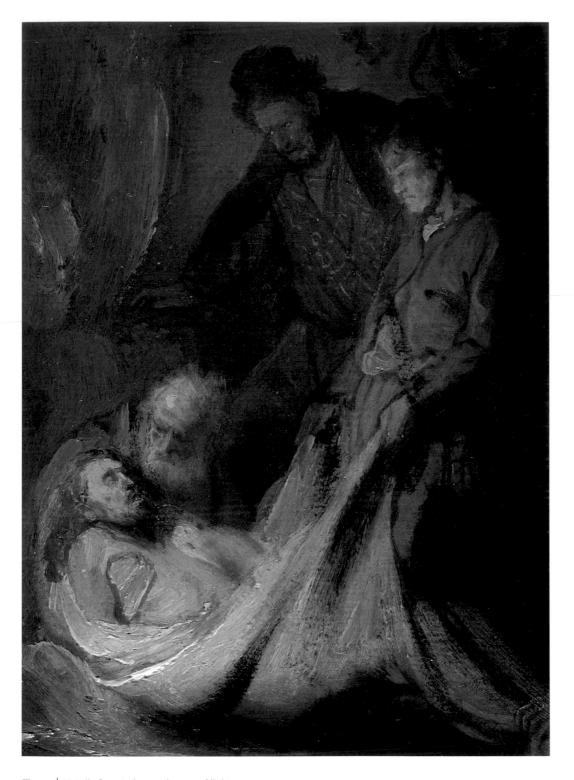

Fig. 75 | Detail of central group in normal light

Fig. 76 | X-radiograph: detail of central group

Fig. 77 | Infrared reflectogram: detail of central group

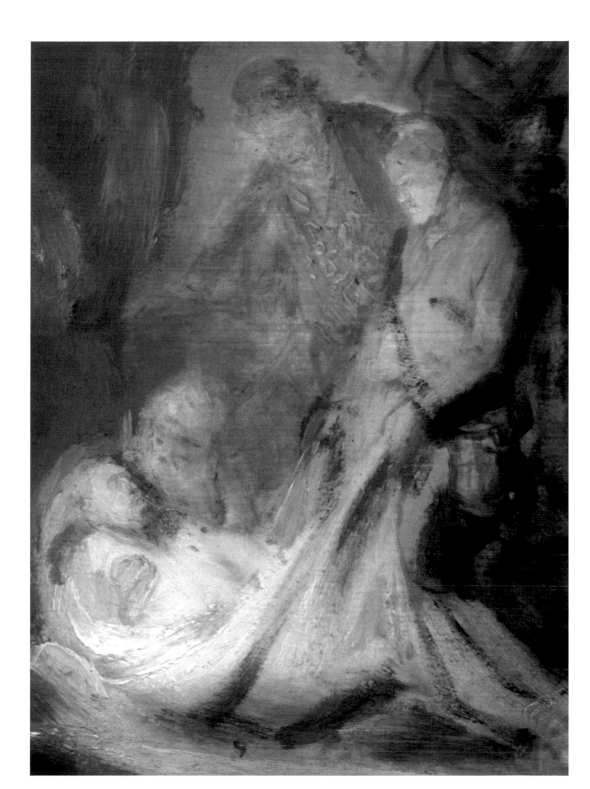

Entombment, which is distinguished by its closed-in setting of the dark cave and the solemn procession on the right.

Rembrandt is known to have made many changes in his sketches on paper, as well as in his paintings, to which the regular presence of *pentimenti* testifies. According to his biographer Houbraken, he constantly explored variety in his compositions: 'In his art, at least, he had a wealth of ideas, which often led to the number of different sketches one sees of the same composition, and at the same time these are full of variations in the figures shown, in their postures and in the arrangement of their clothing...'[42] Such a change can be seen in the woman holding Christ's feet [figs 62–64]. In the X-radiograph we see what might have been her hands folded in prayer in front of her. Her headgear looks different, and she is probably sitting more upright. Rembrandt in the end painted her slightly more bent over Christ's feet, holding them, her hands painted over earlier work. Interestingly, he also painted out a skull positioned just behind her which provided a link with Golgotha, the site of Adam's burial.

As the *Entombment* was listed in Rembrandt's 1656 inventory as a sketch, it is possible that a variation on an existing theme is what was intended there. However, a conclusive date of execution of the central group that is more precise than late 1630s to early 1640s, based on dendrochronology and stylistic characteristics, is hard to give.

The changes in the central group seem to coincide with the addition of the bearded man and the woman with the candle on the left. The latter could have been added after the figure holding Christ was painted out. The bearded man is painted over the underdrawing that indicates the space but has no connection with his position. Both figures seem to relate to those in Rembrandt's etching of the *Entombment*, which is not dated but fits into a series of Passion etchings from c.1654–56 [fig. 30]. It cannot be excluded that the application of the darkest shadows, equated by Van Hoogstraten to zero, were also applied at this stage to increase contrast and 'finish' the composition of lights and darks.

Indeed, the 'reworked' scene, and the heavy impasto in the woman holding the candle, are more characteristic of Rembrandt's work of the late 1640s and early 1650s. Rembrandt tended to use such heavy impastos in the light tones as they reflect light more effectively and, as Rembrandt himself stated in a letter to Constantijn Huygens, they make it 'sparkle at its best'.[43] Interestingly, most of the areas reworked with thick lead white paint have been toned down with ochres and siennas, which are also present, mixed in wet-in-wet in the highlighted part of the woman with the candle. It seems that this whole reworking exercise was part of one campaign, including the application of the very dark blackish paint

applied on top of the undermodelling to counterbalance this now strongly lit area, but also used to shadow the bearded man on the left, and the procession, as well as to put extra shadow behind the young bearer's left arm and correct the position of the woman holding Christ's feet. The dark background allowed Rembrandt a minimalist but highly effective depiction of the procession.

The technical investigation of the Glasgow *Entombment* makes it very plausible that this intriguing panel was painted in at least two sessions with a considerable time lapse between them. It explains its appearance, and makes us reconsider its place within Rembrandt's oeuvre, and its redefinition and return to that of the 'sketch' which the artist kept and hung in his private living room.

5 TECHNICAL GLOSSARY

DENDROCHRONOLOGY

This method measures the patterns of growth rings in wood since their width depends on climate influences in the tree's place of origin, with long or short winters, dry or damp summers registering as different growth patterns within the timber used to make a panel. These patterns are compared with databases containing reference patterns established for oak from specific ecological zones, as well as with tree-ring patterns found in other (art) objects. As good-quality planks were usually radially cut, that is perpendicular to the growth rings, a large part of the plank would contain the inner heart wood, while the outer side would contain the latest growth, the so-called sapwood, which is lighter in colour. The latter is usually cut off by the panel maker as it is softer and less stable; the sapwood rings, however, if present, are helpful in establishing an accurate felling date.

INFRARED IMAGING

Underdrawings concealed under paint layers can in some cases be revealed by use of infrared (IR) radiation, the portion of the electromagnetic spectrum just beyond visible light. Paint, opaque in the visible part of the spectrum, becomes more transparent in longer wavelengths such as IR, so IR may penetrate below the visible surface of paintings to the underdrawing. The underdrawing is only visible if a black material is used (charcoal, black chalk, ink, etc.) as this absorbs the IR radiation while the white ground layer reflects it. To register the reflected IR radiation we must use a special technique called IR reflectography, or IR imaging, since IR is not visible to the human eye. The IR camera filters out any other light and only registers IR light that is reflected back. When reading reflectograms one should be aware that there could be areas where black paint is used in the final composition in paint. These will also clearly show in the reflectogram and should not be interpreted as underdrawing. As the artist sometimes started with, for example, black chalk for a sketch and then used ink to confirm certain lines, the IR reflectogram can present various stages in the underdrawing process. The IR reflectogram can also reveal changes

Fig. 78 | Detail of X-radiograph of the *Entombment Sketch*, showing the impasto of lead white paint built up to the left of Christ and in the woman with candle

in composition, additions/omissions, and characteristic style of drawing, which may connect anonymous artists/workshops or confirm attributions.

X-RADIOGRAPHY

X-rays are a form of radiation that passes through solid objects and that is obstructed to differing degrees by different materials. The heavier the atoms of which a substance is made, the more opaque it is to X-rays. Lead compounds and thus pigments are therefore especially opaque to X-rays, those containing lighter metals less so. An X-ray image, an X-radiograph, shows areas containing lead pigments as almost white, while areas covered in pigments with lighter elements appear as a shade of grey or dark. All layers of the painting, including panel, wooden stretcher, canvas tacks and canvas-weave are superimposed and overlie the image of the painting itself. The technique is particularly useful in revealing changes made in the composition beneath the surface of the final paint layer, or in showing the first stages of undermodelling in lead white.

CROSS-SECTIONS AND PIGMENT IDENTIFICATION USING POLARISED LIGHT MICROSCOPY (PLM)

Samples of paint and ground (+varnish) layers are taken with a small scalpel (the sample is the size of a salt grain). The samples are mounted in a block of polyester resin, then polished. The result is a 'sandwich' of paint and ground (+varnish) layers. This so-called cross-section can be studied with a polarised light microscope in both reflected light and in ultraviolet light. This informs us about the build-up of the paint layers and the pigments present.

SCANNING ELECTRON MICROSCOPY (SEM)

SEM is a microscopy technique that can reveal fine details at a far higher magnification than is possible with the optical (light) microscope. It uses a beam of electrons to scan the sample under examination, and the electrons scattered by the surface are collected and used to generate a video image. SEM will show surface topography and three-dimensional structure at a magnification up to 100,000×. The image, however, is monochrome. Other techniques, for example EDX, may be used to identify elements present, and can be used to detect individual pigments.

ENERGY-DISPERSIVE X-RAY ANALYSIS (EDX)

A small area imaged in SEM, such as a single paint layer in a cross-section or just one pigment particle, can be selected and analysed for compound elements. An electron beam falls on the sample in the SEM and generates

X-rays which are characteristic in their energies for the elements in the sample. Other techniques, for example Energy Dispersive X-ray analysis (EDX) may be used to identify elements present, and thus to detect individual pigments.

GAS CHROMATOGRAPHY–MASS SPECTROSCOPY (GC–MS)

GC is an extensively used chromatographic technique which was developed in the 1950s. It is used for the qualitative and quantitative analysis of organic materials. A liquid sample is injected into a port, which is held at a high temperature (150–250°C); the sample is then vaporised and moved by the inert carrier gas across a solid column phase. The components within a mixture interact with the column and are then eluted from the column with differing retention times, flowing into the mass spectrometer detector. Compounds and derivatives can be identified by using a spectral library as each compound has a unique fragmentation pattern. Successful GC–MS depends on samples having suitable vapour pressures and thermal stabilities. It is an extremely sensitive technique and is therefore able to identify the constituents of very small amounts of sample material.

6 CATALOGUE

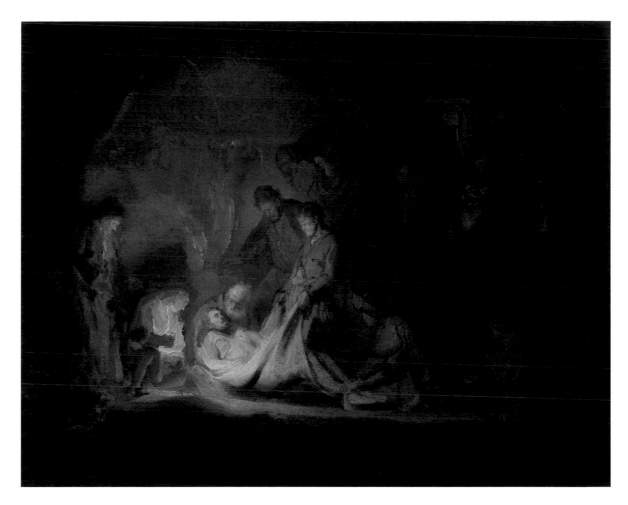

1 *The Entombment Sketch*

Oil on panel · 32.2 × 40.5 cm
The Hunterian, GLAHA 43785

LITERATURE:
Oeuvre catalogues: Smith 1836, vol. VII, nos.
100, 158; Blanc 1873, vol. I, no. 434; Vosmaer
1877, p. 519 note 2; Bell 1899, pp. 63, 142; Bode
1897–1906, vol. II, no. 130, vol. III, pp. 29–30;
Rosenberg 1908, pp. 158, 554; Hofstede de

Groot 1916, vol. VI, nos. 107d, 139; Meldrum
1923, no. 159; Bauch 1966, no. 74; Gerson 1968,
no. 217; Bredius/Gerson 1969, no. 554, pp. 468,
606; Lecaldano 1971, no. 223; Bolten 1978, no. 213;
Brown 1980, vol. II, no. 204; Schwartz 1985, p. 117;
Corpus III, A 105, pp. 65–9 and *Corpus* V, pp. 178–84;
Slatkes 1992, no. 50, p. 36, pp. 105, 110

Lectures: Brown 1987

Rembrandt literature: Hofstede de Groot 1893, pp. 129–48; Brown 1907, pp. 215, 218–19; Lavalleye 1931, pp. 97–101; Van Gelder 1950, p. 328; Benesch 1954, p. 22; Valentiner 1956, pp. 390–404, note 14; Sumowski 1956–57, p. 259; Benesch 1957, pp. 51–53; Meijer 1958, pls XVI and XVII; Roger-Marx 1960, pp. 146–48; Brochhagen 1967, p. 66; Wright 1975, pl. 36, pp. 48–50; Monneret 1980, pp. 70–71; Rotterdam-Braunschweig 1983, p. 97; New Haven 1983, p. 112; Gregory 1985, p. 1451; Guillaud 1986, pl. 663, p. 583; Tümpel 1986, no. 59, p. 163; Wright 1989, p. 234; Amsterdam-Berlin-London 1991b, pp. 73–75; Kitson 1992, no. 12, p. 54; White 1992, p. 265; Baker 1993, pp. 80–81, 112; Raupp 1994, pp. 403–20; Amsterdam-London 2000, pp. 55–56

General literature: Laskey 1813, no. 32, p. 87; Dibdin 1838, vol. II, p. 721; Waagen 1854, p. 283; Dennistoun 1855, p. 180; Landseer 1871, vol. I, pp. 200–2; Young 1880, no. 14, p. 2; Brydall 1889, pp. 367–68; Waterhouse 1950, vol. III, pp. 2, 4–6; Wright 1976, p. 169; Andrews 1982; McLaughlan 1990, pp. 30–31, 33, 37; Allan 1991, pp. 11, 26–27; West 1996, pp. 28–29

EXHIBITION HISTORY:
London 1769, no. 59; London 1930, no. 152, p. 109; Amsterdam 1932, no. 9; Edinburgh 1950, no. 13, p. 10; London 1952, no. 25; Amsterdam-Rotterdam 1956, no. 30; London 1962, no. 122; London 1973, no. 12; New Haven 1983, p. 8, no. 104 on p. 112; Edinburgh 1992, no. 48, pp. 13, 17, 120–21; Boston-Chicago 2003, no. 46, pp. 33–34, 112–13; Amsterdam-London 2006, pp. 151, 156; Glasgow 2007, no. 19, pp. 69, 72, 125–26

[fig. 1]

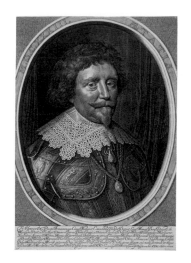

WILLEM JACOBSZ. DELFF (1580–1638)
AFTER MICHIEL VAN MIEREVELT (1566–1641)
2 *Frederik Hendrik, Prince of Orange*, 1632
Engraving · 41.9 × 29.1 cm
The Hunterian, GLAHA 724
Literature: Hollstein 62
[fig. 18]

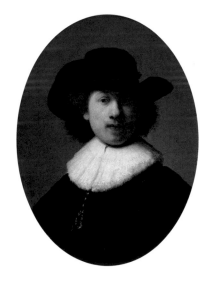

3 *Self-Portrait*, 1632
Oil on panel · 63.5 × 47 cm
Signed and dated 'RHL van Ryn / 1632'
The Burrell Collection, Glasgow Museums
Literature: Bredius/Gerson 1969, 17; London-The Hague 1999, 33; *Corpus* II, A 58
[fig. 19]

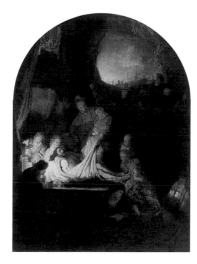

4 *The Entombment*, c.1635–39

Oil on canvas · 92.5 × 68.9 cm
Alte Pinakothek, Munich, inv. no. 96
Literature: Bredius/Gerson 1969, 560;
Corpus III, A 126
[fig. 2]

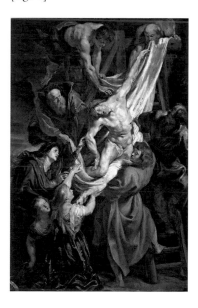

PETER PAUL RUBENS (1577–1640)
5 *The Descent from the Cross*, c.1611

Oil on panel · 115.2 × 76.2 cm
The Courtauld Gallery, London. Bequeathed by
Arthur Hamilton, Viscount Lee of Fareham, P.1947.
LF.359.
Literature: Judson 2000, cat. 43b
[fig. 17]

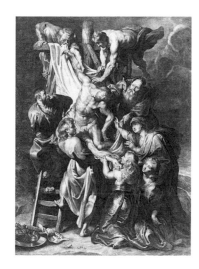

LUCAS VORSTERMAN (1595–1675)
AFTER RUBENS
6 *The Deposition*, 1620

Etching and engraving · 58 × 43 cm
The Hunterian, GLAHA 9205
Literature: Hollstein 31
[fig. 11]

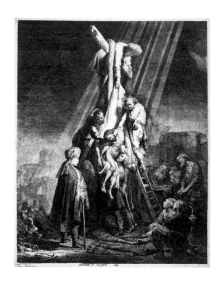

REMBRANDT AND JAN VAN VLIET
(c.1600/1610–1668?)
7 *The Descent from the Cross*, 1633

Etching · 53 × 41 cm
Signed and dated 'Rembrandt f. cum pryvl. 1633'
British Museum, F,5.2
Literature: White and Boon 1969, B. 81 ii/ii
[fig. 12]

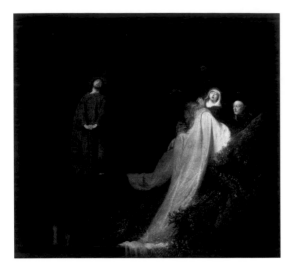

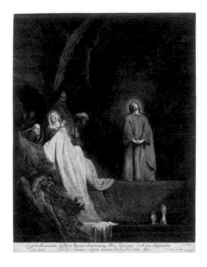

JAN LIEVENS (1607–1674)

8 *The Raising of Lazarus*, 1631

Oil on canvas · 107 × 114.3 cm
Brighton Museum & Art Gallery, FA000001
Literature: Schneider 1973, no. 31
Exhibition history: Washington-Milwaukee-
Amsterdam 2008, no. 31
[fig. 46]

JACOB LOUYS (1595/1600–c.1673)
AFTER JAN LIEVENS

10 *The Raising of Lazarus*, c.1632

Etching · 41 × 31.5 cm
British Museum, S.28
Literature: Hollstein 1.I
[fig. 50]

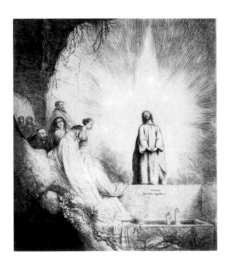

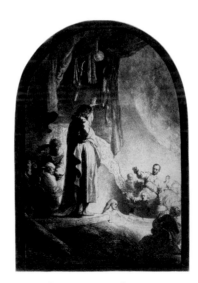

JAN LIEVENS

9 *The Raising of Lazarus*, c.1631

Etching · 35.8 × 31.2 cm
Brighton Museum & Art Gallery, inv. no. 285
Literature: Hollstein 7
[fig. 47]

11 *The Raising of Lazarus: Large Plate*, c.1632

Etching, retouched by Rembrandt with black chalk ·
36.8 × 25.8 cm
Signed 'RHL van Ryn f'
British Museum, 1848,0911.35
Literature: White and Boon 1969, B. 73 iii/x
Exhibition history: Amsterdam-London 2000, no. 17
[fig. 48]

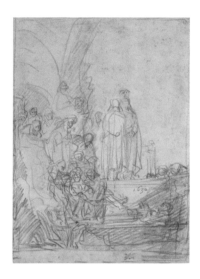

12 *'The Entombment' over a 'Raising of Lazarus'*, c.1635

Red chalk · 28.2 × 20.4 cm
Inscribed '1630'
British Museum, T,14.6
Literature: Benesch 1973, 17
Exhibition history: London 1992, no. 15
[fig. 51]

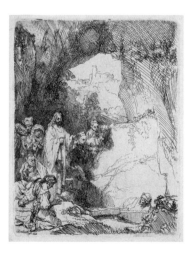

13 *The Raising of Lazarus: Small Plate*, 1642

Etching · 14.9 × 11.2 cm
Signed and dated 'Rembrandt f. 1642'
The Hunterian, GLAHA 338
Literature: White and Boon 1969, B. 72 ii/ii
[fig. 49]

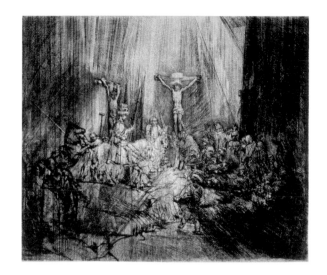

14 *Christ Crucified between the Two Thieves (The Three Crosses)*, 1653

Drypoint and burin · 35.8 × 45.5 cm
Signed and dated 'Rembrandt f. 1653'
Scottish National Gallery, Edinburgh, Rembrandt.41
Literature: White and Boon 1969, B. 78 iv/v;
Amsterdam-London 2000, no. 73
[fig. 32]

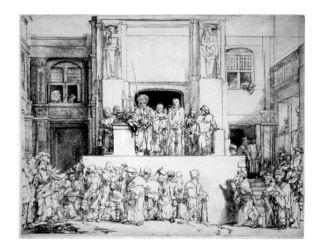

15 *Ecce Homo: Christ Presented to the People*, 1655

Drypoint · 35.8 × 45.5 cm
Scottish National Gallery, Edinburgh, Rembrandt.39
Literature: White and Boon 1969, B. 76 v/viii;
Amsterdam-London 2000, no. 78
[fig. 34]

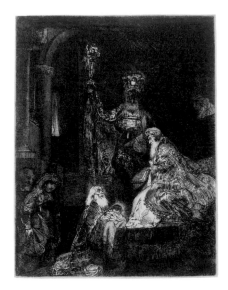

16 *The Presentation in the Temple
in the Dark Manner*, c.1654

Etching and drypoint · 21 × 16.3 cm
British Museum, F,4.97
Literature: White and Boon 1969, B. 50
[fig. 28]

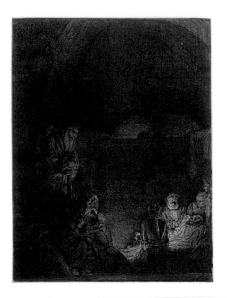

18 *The Entombment*, c.1654–56

Etching · 21.1 × 16.1 cm
Scottish National Gallery, Edinburgh, Rembrandt.47
Literature: White and Boon 1969, B. 86 iii/iv;
Amsterdam-London 2000, no. 76
[fig. 30]

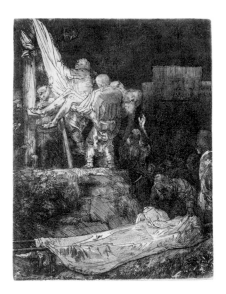

17 *The Descent from the Cross
by Torchlight*, 1654

Etching and drypoint · 21.1 × 16.3 cm
The Hunterian, GLAHA 364
Literature: White and Boon 1969, B. 83
[fig. 29]

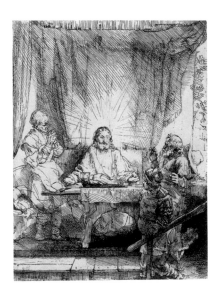

19 *Christ at Emmaus: The Larger Plate*, 1654

Etching, burin and drypoint · 20.8 × 15.8 cm
Signed and dated 'Rembrandt f. 1654'
The Hunterian, GLAHA 365
Literature: White and Boon 1969, B. 87
[fig. 31]

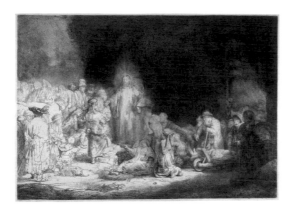

20 *Christ Healing the Sick (The 'Hundred Guilder Print')*, c.1648

Etching · 27.7 × 39.5 cm
Scottish National Gallery, Edinburgh, Rembrandt.37
Literature: White and Boon 1969, B. 74 ii/ii;
Amsterdam-Berlin-London 1991a, no. 27;
Amsterdam-London 2000, no. 61
[fig. 59]

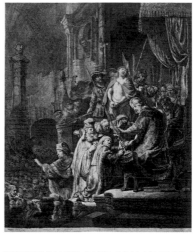

REMBRANDT AND JAN VAN VLIET
22 *Christ before Pilate: Large Plate*, 1636

Etching and burin · 54.9 × 44.7 cm
Signed and dated 'Rembrandt f. 1636 cum privile'
British Museum, 1922,0610.2
Literature: White and Boon 1969, B. 77 ii;
Amsterdam-London 2000, no. 24
[fig. 10]

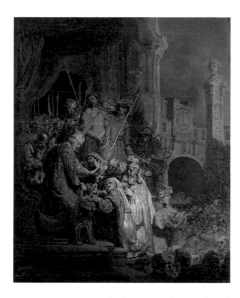

21 *Ecce Homo (Christ Before Pilate)*, 1634

Oil on paper laid on canvas · 54.5 × 44.5 cm
National Gallery, London, NG1400
Literature: Bredius/Gerson 1969, 546; *Corpus* II,
A 89; Bomford et al. 2006, pp. 75–81
[fig. 9]

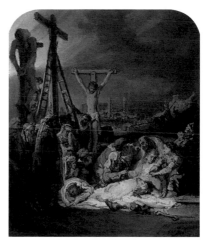

23 *The Lamentation over the Dead Christ*, c.1635

Oil on paper and pieces of canvas, mounted onto oak
31.9 × 26.7 cm
National Gallery, London, NG43
Literature: Bredius/Gerson 1969, 565; *Corpus* II,
A 107; Royalton-Kisch 1989, pp. 128–45; Bomford et
al. 2006, pp. 100–9
[fig. 13]

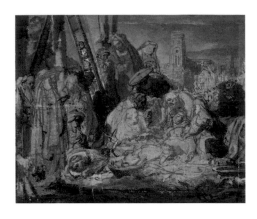

24 *The Lamentation at the Foot of the Cross*, c.1634–35

Pen and brown ink and brown wash, with red and perhaps some black chalk, reworked in oils 'en grisaille' · 21.6 × 25.4 cm
British Museum, Oo,9.103
Literature: Benesch 1973, 154; Royalton-Kisch 2010, 9
[fig. 25]

ANDREA MANTEGNA
26 *The Entombment*, c.1480

Engraving · 28 × 42 cm
The Hunterian, GLAHA 52016
Literature: Bartsch XII.229.3
[fig. 52]

REMBRANDT AFTER ANDREA MANTEGNA (c.1431–1506)
25 *The Entombment*, c.1640–50

Pen and brown ink over red chalk, with brown and grey wash, heightened with white · 26.2 × 38.9 cm
Metropolitan Museum of Art, New York, Walter C. Baker Bequest
Literature: Mules 1985, pp. 16, 17; Royalton-Kisch/Ekserdjian 2000, pp. 52–56
[fig. 54]

REMBRANDT AFTER POLIDORO DA CARAVAGGIO (c.1499–1543)
27 *The Entombment*, c.1656

Pen and chalk · 18.1 × 28.4 cm
Teylers Museum, Haarlem, o*49
Literature: Clark 1966, p. 72; Benesch 1973, 1208; Plomp 1997, 332
[fig. 55]

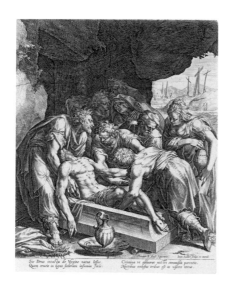

JAN SADELER (1550–c.1600)
AFTER DIRCK BARENDSZ. (1534–1592)

28 *The Entombment*, c.1580

Engraving · 24.2 × 19.8 cm
The Hunterian, GLAHA 55550
Literature: Hollstein 251
[fig. 53]

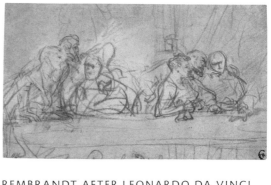

REMBRANDT AFTER LEONARDO DA VINCI
(1452–1519)

30 *The Last Supper*, c.1635

Red chalk, heightened with white, on paper probably
washed pale greyish brown · 12.5 × 21 cm
British Museum, 1900,0611.7
Literature: Benesch 1973, 444; Royalton-Kisch 2010, 11
[fig. 40]

LUCAS VORSTERMAN (1595–1675)
AFTER RUBENS

29 *The Adoration of the Magi*, 1621

Engraving · 56.9 × 73.5 cm
The Hunterian, GLAHA 17107
Literature: Hollstein 9
[fig. 36]

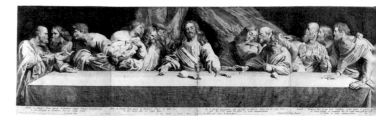

PIETER CLAESZ. SOUTMAN (1580–1657)
AFTER RUBENS AFTER LEONARDO

31 *The Last Supper*, c.1630

Etching · 29.4 × 97.7 cm
The Hunterian, GLAHA 10308
Literature: Hollstein 4
[fig. 39]

32 *De Bibel Tgheele Oude ende Nieuwe*
Testament met grooter naerstigheyt
naden Latijnschen text gecorigeert…

(The Bible: The complete Old and New Testament,
corrected with the greatest accuracy from the
Latin…)
Antwerp, Willem Vorsterman, 1528–29 · Glasgow
University Library, Special Collections Department,
Dp.b9
[fig. 15]

SAMUEL VAN HOOGSTRATEN (1627–1678)
34 *Inleyding tot de hooge schoole der*
schilderkonst

(Introduction to the Academy of Painting)
Rotterdam, Fransois van Hoogstraeten, 1678 ·
Edinburgh University Library, Special Collections
Department, E.B..7501 HOO
[fig. 73]

BERNARDINO AMICO
33 *Trattato delle piante & immaginj de sacri*
edifizi di Terra Santa disegnate in Ierusalemme
…dal R.P.F. Bernardino Amico da Gallipoli

(Treatise consisting of plans and pictures of
the sacred buildings in the Holy Land drawn
in Jerusalem…by R.P.F. Bernardino Amico of
Gallipoli)
Florence, Pietro Cecconcelli, 1620 · Glasgow
University Library, Special Collections Department,
Hunterian H.3.16
[fig. 56]

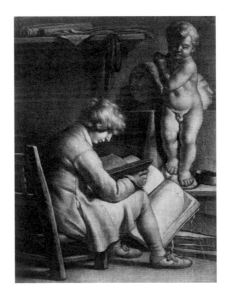

WALLERANT VAILLANT (1623–1677)
AFTER JAN LIEVENS
35 *A Young Artist at Work*, c.1650

Mezzotint engraving · 27.4 × 21.3 cm
The Hunterian, GLAHA 23901
Literature: Hollstein 98

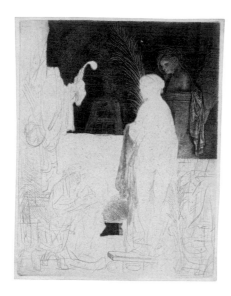

36 *The Artist Drawing from the Model*, c.1639

Etching and drypoint · 23.1 × 17.9 cm
The Hunterian, GLAHA 347
Literature: White and Boon 1969, B. 192
[fig. 57]

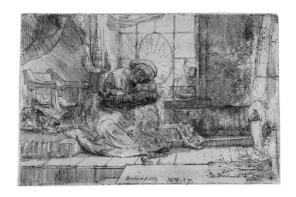

38 *The Virgin and Child with the Cat and Snake*, 1654

Etching · 9.6 × 14.6 cm
Signed and dated 'Rembrandt f. 1654'
The Hunterian, GLAHA 360
Literature: White and Boon 1969, B. 63 ii/ii
[fig. 41]

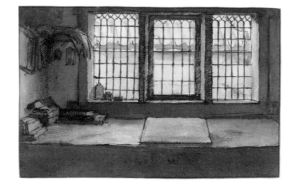

ATTRIBUTED TO WILLEM DROST
(c.1630–after 1680)

37 *An artist's worktable by a window overlooking a river; a long table with a drawing board at centre and various boxes*, c.1650–55

Pen and brown ink with brown and grey wash, touched with white, over indications in red chalk
13 × 19.8 cm
British Museum, 1848,0911.4
Literature: Royalton-Kisch 2010, Drost 10
[fig. 37]

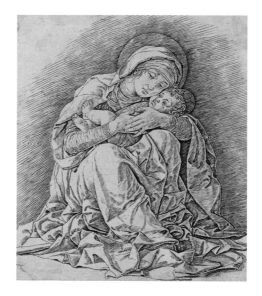

ANDREA MANTEGNA
39 *Madonna and Child*, c.1470–80

Engraving · 21.9 × 19 cm
The Hunterian, GLAHA 3622
Literature: Bartsch XIII.232.8
[fig. 42]

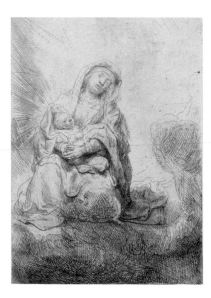

40 *The Virgin and Child in the Clouds*, 1641

Etching · 14.6 × 10.8 cm
The Hunterian, GLAHA 3639
Literature: White and Boon 1969, B. 61
[fig. 43]

FEDERICO BAROCCI (c.1535–1612)
41 *The Virgin Seated on a Cloud*, c.1580

Etching · 15.3 × 10.9 cm
The Hunterian, GLAHA 6144
Literature: Bartsch XVII.3.2
[fig. 44]

CHRONOLOGY

1606

Rembrandt Harmenszoon van Rijn was born in the Dutch university town of Leiden on 15 July, according to Jan Jansz. Orlers.

1610s

Rembrandt was educated at the Latin School in Leiden where he would have studied Latin, Greek, history and classical literature.

1612–14

The Flemish master Peter Paul Rubens completed his great Antwerp Cathedral altarpiece, *The Descent from the Cross*, in 1614 (the earlier *Raising of the Cross* was not moved there until the early 19th century). The influence of Rubens's *Descent* can be seen within Rembrandt's later Passion Series.

1619–22

Lucas Vorsterman, the first engraver to work with Rubens on a regular basis, made many engravings after Rubens's religious subjects during this period.

1620

In May Rembrandt enrolled at Leiden University but he never studied there.

1620–25

Rembrandt was apprenticed to the artist Jacob Isaacz. van Swanenburg in Leiden. In 1624 he spent six months training with Pieter Lastman in Amsterdam.

1625

Prince Maurits of Orange died on 23 April and was succeeded as Stadholder by his brother, Prince Frederik Hendrik.

1625–32

Rembrandt worked closely with his Leiden contemporary, Jan Lievens, during this period. The Stadholder's secretary, Constantijn Huygens, discovered and wrote about the artists as a pair. He visited them in Leiden in 1628, possibly at a shared studio. Rembrandt and Lievens frequently painted the same subjects at this time, as well as painting one another.

1630

Huygens expressed admiration for Rembrandt and Jan Lievens in his manuscript autobiography.

1631

Rembrandt painted *Christ on the Cross* (Church of Saint-Vincent, Le Mas d'Agenais, France). This painting shares many characteristics with the Passion Series Rembrandt was about to undertake; it has an arched top, depicts a key moment from the Passion story and shows the influence of engravings after Rubens's Passion subjects.

1631–32

Rembrandt and Lievens both painted a *Raising of Lazarus* (cat. 8) and made etchings of the subject (cat. 9, cat. 11).

1631–34

Rembrandt settled in Amsterdam around 1631. Here, he worked in the studio of the art dealer Hendrick Uylenburgh, with whom he also lived. Uylenburgh facilitated numerous profitable portrait commissions. While he was with Uylenburgh, Rem-

brandt's prints changed in style and became more biblical in focus.

1632

Rembrandt painted a portrait of Frederik Hendrik's wife, Amalia van Solms (Musée Jacquemart-André, Paris). Rembrandt had already sold at least two history paintings to Frederik Hendrik, including *Samson and Delilah* and *Simeon in the Temple*.

1632–35

Jan Lievens visited London where he worked as a painter at the court of King Charles I. He moved to Antwerp in 1635.

1633

By 1633 two Passion Series paintings, the *Elevation* and the *Descent from the Cross* (both Alte Pinakothek, Munich), were complete, leading to a commission for three more.

1633–35

Rembrandt made a group of oil sketches, at least one of which, *Ecce Homo (Christ before Pilate)* (cat. 21), was a design for an etching (cat. 22).

1634

Rembrandt married Saskia van Uylenburgh.

1635

Rembrandt made sketches on Passion themes around this time: *'The Entombment' over a 'Raising of Lazarus'* (cat. 12), and a sketch after Leonardo da Vinci's *Last Supper* (cat. 30).

Rembrandt and Saskia left Hendrick Uylenburgh's house to live in the Nieuwe Doelstraat. Their first son, Rumbartus, was born in December but lived for only two months.

1636

The surviving correspondence between Rembrandt and Huygens, begun in 1636, relates to the Passion Series.

The *Ascension* (Alte Pinakothek, Munich) was completed by 1636. Rembrandt wrote that two other paintings for the Passion Series were 'more than half done'.

1637

At the auction of the art collection of Jan Basse, Rembrandt purchased a great many prints and drawings for use in his studio as inspiration. The most expensive lot, a book of drawings by Lucas van Leyden, ''t kunstboeck…', was purchased by Rembrandt's pupil Leendert van Beijeren.

1638

A daughter named Cornelia was born in July but lived less than a month.

1639

On 12 January the *Entombment* and *Resurrection* (Alte Pinakothek, Munich) from the Passion Series were finally complete. In the third letter to Huygens, Rembrandt gave his address as being on the Binnen Amstel in a house called De Suyckerbackerij ('The Sugar Bakery').

Rembrandt gave Huygens a painting, most likely the *Blinding of Samson* (executed 1636).

The correspondence between Rembrandt and Huygens ended in February.

On 1 May Rembrandt moved to the Sint-Anthonisbreestraat, to what is now the Rembrandthuis in the Jodenbreestraat.

1640

A second daughter, also named Cornelia, was born but only lived for a few weeks.

1641

On 22 September Rembrandt and Saskia's son Titus was baptised. He was the only child of the couple to survive beyond infancy.

1642

Rembrandt paid the incredibly high price of 179 guilders for Lucas van Leyden's 1520 engraving *Family of Beggars*. The print may have inspired Rembrandt's *Beggars Receiving Alms at the Door* of 1648.

Samuel van Hoogstraten, future author of the *Inleyding tot de hooge schoole der schilderkonst* (Introduction to the Academy of Painting), entered Rembrandt's Amsterdam studio as a pupil around this time.

On 19 June Rembrandt's wife Saskia was buried.

1646

In or shortly before 1646 Rembrandt was commissioned by Prince Frederik Hendrik to augment the Passion Series with earlier

episodes from the life of Christ, a *Birth of Christ* (Alte Pinakothek, Munich) and a *Circumcision* (now lost). He received 2,400 guilders for these paintings in November 1646.

c.1647–49

It is recorded that Rembrandt exchanged an impression of his *Christ Healing the Sick*: (*The 'Hundred Guilder Print'*) (cat. 26) for 100 guilders' worth of prints by Marcantonio Raimondi. It was his most famous print throughout the 18th century and much of the 19th century.

1653

State III of Rembrandt's *The Three Crosses* (cat. 14) drypoint is dated 1653. It is one of the great masterpieces of printmaking.

1654

Around this time Rembrandt made an etching of the *Entombment* (cat. 18). This was one of four etchings made in the 1650s that form a Passion series.

Cornelia, illegitimate daughter of Rembrandt and Hendrickje Stoffels, was baptised in October.

1655

Rembrandt completed another drypoint masterpiece, *Christ Presented to the People* or *Ecce Homo* (cat. 15). The influence of Lucas van Leyden's *Ecce Homo* of 1510 can be seen, but by the final state Rembrandt had gone much further than his predecessor. Its size links the print to *The Three Crosses*, and

a series of large Passion prints may have been planned.

1656

From 15 July 1656 to 15 December 1660 Rembrandt's bankruptcy was processed by the courts involving the forced sale of his possessions. The 1656 inventory includes 'A sketch of the Entombment of Christ', which probably refers to the Hunterian's *Entombment Sketch* (cat. 1).

In anticipation of losing his precious old master drawings, Rembrandt made copies of several, including the *Entombment* after Mantegna (cat. 25) and the *Entombment* (cat. 27) after 'Raphael'.

1657–58

The liquidation sales of Rembrandt's house and possessions occurred; presumably he lost the *Entombment Sketch* along with the rest of his art collection at this time.

1658

Rembrandt, Hendrickje and Titus rented a more modest home in the Jordaan district of Amsterdam.

1660

Rembrandt's art business was transferred into the names of Hendrickje and Titus.

1663

Hendrickje died on 21 July.

1665

Rembrandt's final print dates from 1665.

1667

The inventory of the property of Amalia van Solms, widow of Frederik Hendrik, lists seven Passion Series paintings by Rembrandt: the *Nativity*, *Circumcision*, *Crucifixion*, *Raising of the Cross*, *Entombment*, *Resurrection* and *Ascension*.

1668

Rembrandt's son Titus married Magdalena van Loo, niece of Saskia's sister Hiskia, in February, resolving long-term tension regarding his inheritance from Saskia. But Titus died and was buried on 7 September, leaving his widow pregnant.

1669

Rembrandt died and was buried in Amsterdam on 8 October.

1678

Samuel van Hoogstraten's *Inleyding* was published in 1678, the year of Hoogstraten's death, and includes first-hand accounts of Rembrandt and his studio.

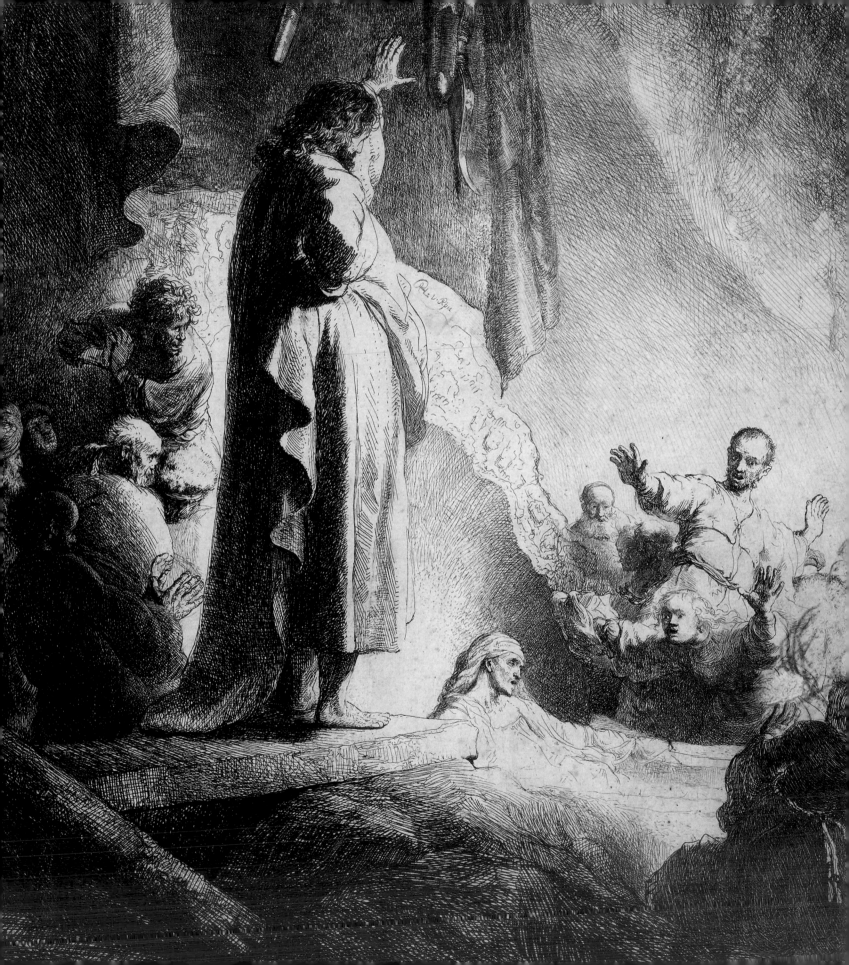

BIBLIOGRAPHY

ABBREVIATIONS

BARTSCH
Adam Bartsch, *Le Peintre Graveur*, 21 vols, Vienna (J. V. Degen) 1803–21

CORPUS
J. Bruyn, B. Haak, S. H. Levie, P. J. J. van Thiel and E. van de Wetering, *A Corpus of Rembrandt Paintings*, vols. I–V, Dordrecht (Martinus Nijhoff Publishers) 1982–2011

HOLLSTEIN
Friedrich Wilhelm Heinrich Hollstein, *Dutch and Flemish Etchings, Engravings and Woodcuts ca. 1450–1700*, Amsterdam (Van Gendt) 1949–

LITERATURE

Literature is listed by author and date. Exhibition catalogues are listed separately at the end by place and date.

ALLAN 1991 Christopher J. Allan, *Hunterian Art Gallery Guidebook*, Glasgow (Hunterian Art Gallery) 1991

ANDREWS 1982 Keith Andrews, 'Die Hunterian Collection der Universität Glasgow', *Neue Zürcher Zeitung*, 9 January 1982

BAKER 1993 Christopher Baker, *Rembrandt*, Greenwich, CT (Brompton) 1993

BAUCH 1966 K. Bauch, *Rembrandt: Gemälde*, Berlin (Walter de Gruyter & Co.) 1966

BELL 1899 Malcolm Bell, *Rembrandt van Rijn and His Work*, London (G. Bell) 1899

BENESCH 1954 Otto Benesch, *The Drawings of Rembrandt*, 6 vols, London (Phaidon) 1954

BENESCH 1957 Otto Benesch, *Rembrandt*, Lausanne (Éditions d'Art Albert Skira) 1957

BENESCH 1973 Otto Benesch, *The Drawings of Rembrandt*, 6 vols, 2nd edition enlarged and edited by Eva Benesch, London (Phaidon) 1973

BLANC 1873 Charles Blanc, *L'Œuvre complet de Rembrandt décrit et commenté…Catalogue raisonné de toutes les eaux-fortes du maître et de ses peintures, orné de bois gravés et de quarante eaux-fortes*, etc., vol. I, Paris (A. Lévy) 1873 (first published 1859)

BLANKERT 1982 Albert Blankert, *Ferdinand Bol (1616–1680): Rembrandt's Pupil*, Doornspijk (Davaco) 1982

BODE 1897–1906 Wilhelm Bode, *The Complete Work of Rembrandt*, 8 vols, Paris (C. Sedelmeyer) 1897–1906

BOLTEN 1978 J. H. Bolten and H. Bolten-Rempt, *The Hidden Rembrandt*, Oxford (Phaidon) 1978

BOMFORD ET AL. 2006 David Bomford, Ashok Roy, Jo Kirby, Axel Rüger and Raymond White, *Rembrandt: Art in the Making*, London (National Gallery) 2006

Fig. 79 | Detail from *The Raising of Lazarus: Large Plate*, c.1632, etching, retouched by Rembrandt with black chalk, 36.8 × 25.8 cm, British Museum (cat. 11)

BREDIUS/GERSON 1969 A. Bredius revised by H. Gerson, *The Complete Edition of the Paintings [of] Rembrandt*, London (Phaidon Press) 1969

BROCHHAGEN 1967 E. Brochhagen, *Holländische Malerei des 17. Jahrhunderts*, Munich (Alte Pinakothek München Katalog III) 1967

BROWN 1907 G. Baldwin Brown, *Rembrandt: A Study of His Life and Work*, London (Duckworth) 1907

BROWN 1980 Christopher Brown, *Rembrandt: The Complete Paintings*, vol. II, London (Granada) 1980

BROWN 1987 Christopher Brown, unpublished lecture about the *Entombment Sketch*, University of Glasgow 1987. Copies held at the Hunterian (*Entombment Sketch* object file) and at the Rijksbureau voor Kunsthistorische Documentatie, The Hague

BRUYN 1979 J. Bruyn, 'Een onderzoek naar de 17-de eeuwse schilderijformaten, voornamelijk in Noord-Nederland', *Oud Holland* 93 (1979), pp. 96–115

BRYDALL 1889 Robert Brydall, *Art in Scotland: Its Origin and Progress*, Edinburgh and London (William Blackwood and Sons) 1889

CLARK 1966 Kenneth Clark, *Rembrandt and the Italian Renaissance*, London (John Murray) 1966

CORNELIS/FILEDT KOK 1998 Bart Cornelis and Jan Piet Filedt Kok, 'The Taste for Lucas van Leyden Prints', *Simiolus: Netherlands Quarterly for the History of Art* 26, 1/2 (1998), pp. 18–86

DENNISTOUN 1855 James Dennistoun, *Memoirs of Sir Robert Strange and Andrew Lumisden*, vol. 2, London (Longman, Brown, Green, and Longmans) 1855

DIBDIN 1838 Thomas Frognall Dibdin, *A Biographical, Antiquarian and Picturesque Tour in the Northern Counties of England and in Scotland*, vol. II, London 1838

VAN EIKEMA HOMMES/VAN DE WETERING 2006 Margriet van Eikema Hommes and Ernst van de Wetering, 'Light and Colour in Caravaggio and Rembrandt, as Seen through the Eyes of their Contemporaries', in D. Bull (ed.), *Rembrandt, Caravaggio*, Zwolle (Waanders) and Amsterdam (Rijksmuseum) 2006

VAN GELDER 1950 J. G. van Gelder, 'The Rembrandt Exhibition at Edinburgh', *The Burlington Magazine* 572, 92 (1950), pp. 327–28

GERSON 1961 Horst Gerson, *Seven Letters by Rembrandt*, The Hague (Boucher) 1961

GERSON 1968, Horst Gerson, *Rembrandt Paintings*, Amsterdam (Harrison House) 1968

GOLAHNY 2003 Amy Golahny, *Rembrandt's Reading*, Amsterdam (Amsterdam University Press) 2003

GOLAHNY 2007 Amy Golahny (ed.), *In His Milieu: Essays on Netherlandish Art in Memory of John Michael Montias*, Chicago (Chicago University Press) 2007

GREGORY 1985 Clive Gregory (ed.), 'Rembrandt van Rijn, the Artist at Work: A Compassionate Eye', *The Great Artists* 46 (1985)

GROEN 2005 K. Groen, 'Earth matters: the origin of the material used for the preparation of the Night Watch and many other canvases in Rembrandt's workshop after 1640', *ArtMatters: Netherlands Technical Studies in Art* 3 (2005), pp. 138–54

GUILLAUD 1986 Jacqueline and Maurice Guillaud, *Rembrandt: The Human Form and Spirit*, Paris (Guillaud Editions) 1986

HAVEMAN ET AL. 2006 Mariëtte Haveman, Eddy de Jongh, Ann-Sophie Lehmann and Annemiek Overbeek (eds), *Ateliergeheimen*, Amsterdam (Uitgeverij Kunst en Schrijven) 2006

HOFSTEDE DE GROOT 1893 Cornelis Hofstede de Groot, 'Hollandsche kunst in Schotland', *Oud Holland* 11 (1893), p. 146

HOFSTEDE DE GROOT 1916 Cornelis Hofstede de Groot (trans. and ed. Edward G. Hawke), *A Catalogue Raisonné of the Works of the Most Eminent Dutch Painters of the Seventeenth Century Based on the Work of John Smith*, London (Macmillan) 1916

VAN HOOGSTRATEN 1678 Samuel van Hoogstraten, *Inleyding tot de hooge schoole der schilderkonst,* Rotterdam (Fransois van Hoogstraeten) 1678

HOUBRAKEN 1718–21 Arnold Houbraken, *De groote schouburgh der Nederlantsche konstschilders en schilderessen*, 3 vols, Amsterdam 1718–21

JAFFÉ 2002 Michael Jaffé, *The Devonshire Collection of Northern European Drawings*, vol. II, Turin (Umberto Allemandi & Co.) 2002

JUDSON 2000 Richard Judson, *Corpus Rubenianum Ludwig Burchard*, vol. VI: *The Passion of Christ*, Turnhout (Harvey Miller) 2000

KAAK 1994 Joachim Kaak, *Rembrandts Grisaille 'Johannes der Taufer predigend': Dekorum-Verstoss oder Ikonographie der Unmoral?* New York (Georg Olms) 1994

KIRBY 1999 J. Kirby, 'The Painter's Trade in the Seventeenth Century: Theory and Practice', *National Gallery Technical Bulletin* 20, pp. 5–49.

KITSON 1992 Michael Kitson, *Rembrandt*, 3rd edition, London (Phaidon) 1992

LAIRESSE 1701 Gérard de Lairesse, *Grondlegginge ter tekenkonst*, Amsterdam (the author) 1701

LAIRESSE 1707 Gérard de Lairesse, *Groot schilderboek*, Amsterdam (heirs of Willem de Coup) 1707

LANDSEER 1871 Thomas Landseer (ed.), *Life and Letters of William Bewick*, vol. I, London (Hurst and Blackett) 1871

LASKEY 1813 Captain J. Laskey, *A General Account of the Hunterian Museum,* London and Edinburgh (John Smith and Son) 1813

LAVALLEYE 1931 J. Lavalleye, 'Une Mise au Tombeau du Christ de Rembrandt', *Revue belge d'archéologie et d'histoire de l'art* 2 (1931), pp. 97–101

LECALDANO 1973 Paolo Lecaldano, *The Complete Paintings of Rembrandt*, London (Weidenfeld and Nicolson) 1973

MAGURN 1991 Ruth Magurn, *The Letters of Peter Paul Rubens*, Chicago (Northwestern University Press) 1991

VAN MANDER 1604 Karel van Mander, *Het Schilder-Boeck*, Haarlem (Paschier van Wesbusch) 1604. Modern edition by Hessel Miedema, Doornspijk (Davaco) 1994–95

MCLAUGHLAN 1990 Robert McLaughlan, *Gifted: Personalities and Treasures of the University of Glasgow*, Edinburgh (Mainstream Publishing) 1990

MEIJER 1958 E. R. Meijer, *Rembrandt*, Novara (Istituto Geografico de Agostini) 1958

MEIJER 1991 Bert Meijer, *Rondom Rembrandt en Titiaan*, The Hague (Sdu Uitgevers) 1991

MELDRUM 1923 D. S. Meldrum, *Rembrandt's Paintings, with an Essay on his Life and Work*, London (Methuen and Co. Ltd) 1923

MIEDEMA 1981 H. Miedema, 'Verder onderzoek naar zeventiende-eeuwse schilderijformaten in Noord-Nederland', *Oud Holland* 95 (1981), pp. 31–47

MONNERET 1980 Simon Monneret, 'Rembrandt by Himself', in Claude Esteban, Jean Rudel and Simon Monneret, *Rembrandt*, London (Ferndale Editions) 1980

MULES 1985 Helen Bobritzky Mules, 'Dutch Drawings of the Seventeenth Century in the Metropolitan Museum of Art', *Metropolitan Museum of Art Bulletin* 42, 4 (1985), pp. 1–56

NOBLE AND VAN LOON 2005 Petria Noble and Annelies van Loon, 'New insights into Rembrandt's *Susanna*: changes of format, smalt

discoloration, identification of vivianite, fading of yellow and red lakes, lead white paint', *ArtMatters: Netherlands Technical Studies in Art* 2, (2005), pp. 76–97

PLOMP 1997 Michiel C. Plomp, *The Dutch Drawings in the Teyler Museum*, 2 vols, Haarlem (Teyler Museum), Ghent (Snoeck Ducaju & Zoon) and Doornspijk (Davaco) 1997

RAUPP 1994 Hans-Joachim Raupp, 'Rembrandts Radierungen mit biblischen Themen 1640–1650 und das "Hundertguldenblatt"', *Zeitschrift für Kunstgeschichte* 57, 3, Kunstgeschichte und Gegenwart: 23 Beiträge für Georg Kauffmann zum 70. Geburtstag, 1994, pp. 403–20

ROGER-MARX 1960 Claude Roger-Marx, *Rembrandt*, Paris (Pierre Tisné) 1960

ROSENBERG 1908 Adolf Rosenberg, *Rembrandt des Meisters Gemälde*, Stuttgart and Berlin (Klassiker der Kunst) 1908

ROTERMUND 1957 H.-M. Rotermund, 'Rembrandts Bibel', *Nederlands Kunsthistorisch Jaarboek* 8 (1957), pp. 123–50

ROYALTON-KISCH 1989 Martin Royalton-Kisch, 'Rembrandt's Sketches for his Paintings', *Master Drawings* 27, 2 (1989), pp. 128–45

ROYALTON-KISCH 1991 Martin Royalton-Kisch, 'Rembrandt's Drawing of *The Entombment of Christ* over *The Raising of Lazarus*', *Master Drawings* 29, 3 (1991), pp. 263–81

ROYALTON-KISCH 1994 Martin Royalton-Kisch, 'Some Further Thoughts on Rembrandt's "Christ before Pilate"', *Chroniek van het Rembrandthuis* 2 (1994), pp. 3–13

ROYALTON-KISCH 2010 Martin Royalton-Kisch, *Catalogue of Drawings by Rembrandt and his School in the British Museum*, 2010. British Museum online catalogue, available at: http://www.britishmuseum.org/research.aspx

ROYALTON-KISCH/EKSERDJIAN 2000 Martin Royalton-Kisch and David Ekserdjian, 'The Entombment of Christ: A Lost Mantegna Owned by Rembrandt?', *Apollo* CLI (2000), pp. 52–56

SANDRART 1675–80 Joachim von Sandrart, *Teutsche Academie der Bau-, Bild- und Mahlerey-Künste*, 3 vols, Nuremberg (Jacob Sandrart) 1675–80

SCHNEIDER 1973 Hans Schneider, *Jan Lievens, sein Leben und seine Werke*, Amsterdam (Israël) 1973

SCHWARTZ 1985 Gary Schwartz, *Rembrandt: His Life, His Paintings*, New York (Viking) 1985

SLATKES 1992 Leonard J. Slatkes, *Rembrandt: catalogo completo dei dipinti*, Florence (Cantini) 1992

SMITH 1692 Marshall Smith, *The Art of Painting*, London 1692

SMITH 1829–42 John Smith, *A Catalogue Raisonné of the Works of the Most Eminent Dutch, Flemish and French Painters*, 9 vols, London (Smith and Son) 1829–42

STRAUSS AND MEULEN 1979 Walter L. Strauss and Marjon van der Meulen, *The Rembrandt Documents*, New York (Abaris Books) 1979

SUMOWSKI 1956–57 Werner Sumowski, 'Bemerkungen zu Otto Beneschs Corpus der Rembrandt-Zeichnungen I', *Wissenschaftliche Zeitschrift der Humboldt-Universität zu Berlin* 6, 4 (1956–57), p. 259

TAYLOR 1992 Paul Taylor, 'The Concept of *Houding* in Dutch Art Theory', *Journal of the Warburg and Courtauld Institutes* 55 (1992), pp. 210–32

TÜMPEL 1986 Christopher and Astrid Tümpel, *Rembrandt: Mythos und Methode*, Antwerp (Langewiesche) 1986

TYERS 2010 I. Tyers, 'The European Trade in Boards, 1200–1700', in J. Kirby, S. Nash and J. Cannon (eds), *Trade in Artists' Materials: Markets and Commerce in Europe to 1700*, London (Archetype) 2010, pp. 42–49

VALENTINER 1956 W. R. Valentiner, 'The Rembrandt Exhibitions in Holland, 1956', *Art Quarterly* 19 (1956), pp. 390–404

VOSMAER 1877 Carel Vosmaer, *Rembrandt, sa vie et ses œuvres*, The Hague (Martinus Nijhoff) 1877

WAAGEN 1854 Gustav Waagen, *Treasures of Art in Great Britain*, vol. III, London (Routledge / Thames Press) 1854 (facsimile edition 1999)

WADUM 2002 Jørgen Wadum, 'Dou doesn't paint, oh no, he juggles with his brush. Gerrit Dou, a Rembrandtesque "Fijnschilder"', *ArtMatters: Netherlands Technical Studies in Art* 1 (2002), pp. 62–77

WADUM 2003 Jørgen Wadum, 'Rembrandts erster "hässlicher Akt": *Andromeda* von ca. 1630 restauriert und untersucht', *Restauro* VII (October/November 2003), pp. 496–502

WATERHOUSE 1950 E. K. Waterhouse, 'Rembrandt 1606–1669', *The Scottish Art Review* III (1950), pp. 2–6

WEST 1996 Shearer West in Jane Turner (ed.), *The Dictionary of Art* 15, Basingstoke (Macmillan) 1996, pp. 28–29

WHITE 1992 Christopher White, 'Amsterdam and London: Rembrandt' *The Burlington Magazine* 134 (1992), p. 265

WHITE AND BOON 1969 Christopher White and Karel G. Boon, *Rembrandt's Etchings: An Illustrated Critical Catalogue in Two Volumes*, Amsterdam (Van Gendt & Co.) and London (A. Zwemmer Ltd) 1969

WRIGHT 1975 Christopher Wright, *Rembrandt and His Art*, London (Hamlyn) 1975

WRIGHT 1976 Christopher Wright, *Old Master Paintings in Britain*, London (Sotheby Parke Bernet Publications) 1976

WRIGHT 1989 Christopher Wright and Richard Lockett (eds), *Dutch Paintings in the Seventeenth Century: Images of a Golden Age of British Collections*, London (Lund Humphries) 1989

YOUNG 1880 John Young, *Catalogue of Pictures, Sculptures and Other Works in the University of Glasgow*, Glasgow (James MacLehose) 1880

EXHIBITION CATALOGUES

AMSTERDAM 1932 F. Schmidt-Degener, *Rembrandt tentoonstelling. Ter plechtige herdenking van het 300-jarig bestaan der Universiteit van Amsterdam. Rijksmuseum-Amsterdam, 11 juni–4 september 1932*, Amsterdam (Druk de Bussy) 1932

AMSTERDAM-BERLIN-LONDON 1991a Holm Bevers, Peter Schatborn and Barbara Welzel, *Rembrandt: The Master & His Workshop. Drawings and Etchings*, New Haven and London (Yale University Press with the National Gallery) 1991

AMSTERDAM-BERLIN-LONDON 1991b Christopher Brown, Jan Kelch and Pieter van Thiel, *Rembrandt: The Master & His Workshop. Paintings*, New Haven and London (Yale University Press with the National Gallery) 1991

AMSTERDAM-LONDON 2000 Erik Hinterding, Ger Luijten and Martin Royalton-Kisch, *Rembrandt the Printmaker*, Amsterdam (Rijksmuseum and Waanders Publishers) 2000

AMSTERDAM-LONDON 2006 Friso Lammertse and Jaap van der Veen, *Uylenburgh & Son: Art and Commerce from Rembrandt to De Lairesse 1625–1675*, Amsterdam (Museum Het Rembrandthuis) and Zwolle (Waanders Publishers) 2006

AMSTERDAM-ROTTERDAM 1956 A. van Schendel, *Rembrandt tentoonstelling*, Amsterdam (Rijksmuseum) and Rotterdam (Museum Boymans) 1956

BOSTON-CHICAGO 2003 Clifford Ackley, Ronni Baer et al., *Rembrandt's Journey: Painter, Draftsman, Etcher*, Boston (Museum of Fine Arts) 2003

EDINBURGH 1950 Ellis Kirkham Waterhouse, *An Exhibition of Paintings by Rembrandt, arranged by the Arts Council of Great Britain for the Edinburgh Festival Society*, London (Arts Council of Great Britain) and Edinburgh (National Gallery of Scotland) 1950

EDINBURGH 1992 Julia Lloyd Williams, *Dutch Art and Scotland: A Reflection of Taste*, Edinburgh (National Gallery of Scotland) 1992

GLASGOW 2007 Peter Black (ed.), *"My Highest Pleasures": William Hunter's Art Collection*, London (Paul Holberton) 2007

LONDON 1769 Sir Robert Strange, *A Descriptive Catalogue of a Collection of Pictures Selected from the Roman, Florentine, Lombard, Venetian, Neapolitan, Flemish, French and Spanish Schools…*, London 1769

LONDON 1930 Royal Academy of Arts, *Commemorative Catalogue of the Exhibition of Dutch Art held in the galleries of the Royal Academy, Burlington House, London, January–March, 1929*, London (Oxford University Press) 1930

LONDON 1952 Andrew McLaren Young, *The Hunterian Collection: An Eighteenth Century Gentleman's Cabinet*, London (London County Council) 1952

LONDON 1962 *Primitives to Picasso: An Exhibition from Municipal and University Collections in Great Britain*, London (Royal Academy of Arts) 1962

LONDON 1973 Andrew McLaren Young, *Glasgow University's Pictures*, London (P & D Colnaghi & Co.) and Glasgow (University of Glasgow Press) 1973

LONDON 1992 Martin Royalton-Kisch, *Drawings by Rembrandt and his Circle in the British Museum*, London (British Museum Press) 1992

LONDON-THE HAGUE 1999 Christopher White and Quentin Buvelot (eds), *Rembrandt by Himself*, London (National Gallery) and The Hague (Mauritshuis) 1999

NEW HAVEN 1983 Christopher White, David Alexander and Ellen d'Oench, *Rembrandt in Eighteenth-century England*, New Haven (Yale Center for British Art) 1983

ROTTERDAM-BRAUNSCHWEIG 1983 J. Giltaij et al., *Schilderkunst uit de eerste hand: Olieverfschetsen van Tintoretto tot Goya*, Rotterdam (Museum Boymans-van Beuningen) and Braunschweig (Herzog Anton Ulrich-Museum) 1983

WASHINGTON-MILWAUKEE-AMSTERDAM 2008 Arthur K. Wheelock Jr. (ed), *Jan Lievens, A Dutch Master Rediscovered*, New Haven and London (Yale University Press) 2008

NOTES AND REFERENCES

1 · PAGES 19–42

1. Hofstede de Groot 1916, vol. VI, no. 107d, p. 86, no. 139, p. 106.
2. These are: Philips Koninck, *Landscape in Holland*, canvas 117 × 155 cm, GLAHA 43744; Carel van der Pluym, *Old Man at Study*, canvas 51.7 × 41.2 cm, GLAHA 43779; Circle of Rembrandt, *Portrait of a Lady*, canvas 53.4 × 44.7 cm, GLAHA 43786.
3. Hoogstraten 1678, p. 183 describes the *John the Baptist Preaching* as 'one of the most precious works' ('dit was ten hoogsten prijslijk').
4. London 1769. Example in Glasgow University Library, Special Collections Department, BG44-e.16. The *Entombment Sketch* is cat. 59, 'Rembrandt, The Entombing of Lazarus'.
5. Mariette's letter was published in Strange's Descriptive Catalogue. See note 4.
6. Marcel Roux, *Inventaire du fonds français: Graveurs du 18ème siècle*, Paris (Bibliothèque Nationale) 1933, cat. 5. There are many proof impressions of this plate, one inscribed 'Basan sculpsit', which suggests that the project was of particular importance to Basan. I am very grateful to Antony Griffiths for this information.
7. Basan's print was known to the 19th-century English scholar John Smith, author of the *Catalogue Raisonné of...Dutch, Flemish and French Painters* (Smith, 1829–42), but he was apparently not aware that the painting itself was on display in Glasgow in the Hunterian Museum.
8. The insolvency inventory is given in various books on Rembrandt, including Strauss and Meulen 1979, 1656/12, pp. 349–87.
9. Strauss and Meulen 1979, 1656/12 no. 111, p. 359.
10. This was his second marriage, to Anna van Arckel. Bol's inventory is given in Blankert 1982, p. 77. Number 13 describes 'een graflegginngh van Rembrant'.
11. *Corpus* III, A 105.
12. Oil on panel, 30.5 × 21.3 cm, Fitzwilliam Museum, Cambridge, PD.16-2000. Related drawings are in the Scottish National Gallery (D 4931), dated 1835–36, and in the Hunterian (GLAHA 43361), undated.
13. Waagen 1854, p. 283.
14. *Corpus* III, pp. 65–69.
15. These are the oil sketches of Ephraim Bueno (1647, Rijksmuseum, Amsterdam) and Lieven Coppenol (c.1658, Metropolitan Museum of Art, New York).
16. Boston-Chicago 2003, pp. 33–34.
17. Boston-Chicago 2003, pp. 111–13.
18. Schwartz 1985, p. 117.
19. 'Remarks on Rembrandt's Oil Sketches for Etchings', in Erik Hinterding, Ger Luijten and Martin Royalton-Kisch, *Rembrandt the Printmaker*, London (British Museum Press) 2000, pp. 36–63.
20. Nadine Orenstein demonstrates that the claim of having applied for a privilege is false in her essay 'Sleeping Caps, City Views, and State Funerals: Privileges for Prints in the Dutch Republic, 1593–1650', in Golahny 2007, pp. 313–46.
21. For Rembrandt's business relationship with Uylenburgh, see Jaap van der Veen, 'Hendrick Uylenburgh's Art Business', in Amsterdam-London 2006, pp. 117–60.

2 · PAGES 43–72

1. On Rembrandt's Bible, see Rotermund 1957, pp. 123–50.
2. Schwartz 1985, p. 69.
3. The Rubens had been painted as a gift for one of the greatest of all art collectors, King Charles I (Royal Collection) and would have been known to Rembrandt, as with the *Descent from the Cross* altarpiece, through an engraving, which made a more obvious impact on Rembrandt's related *Self-Portrait in a Soft Hat and Patterned Cloak* etching of 1631 (White and Boon 1969, B. 7).
4. Schwartz 1985, pp. 73–76 quotes at length from Huygens's autobiography.
5. The letters are widely published; the extracts reproduced here are taken from translations published in Gerson 1961.

6. Washington-Milwaukee-Amsterdam 2008, no. 32.

7. Pieter van Thiel in Amsterdam-London-Berlin 1991b, no. 13. Before his move to Amsterdam in c.1631, all Rembrandt's paintings were on panel.

8. Quoted by Pieter van Thiel in Amsterdam-London-Berlin 1991b, no. 13.

9. Schwartz 1985, p. 117.

10. Houbraken 1718–21, vol. 1, p. 258, my translation: 'Hy was in opzigt van de Konst ryk van gedagten, waar om men van hem niet zelden een menigte van verschillige schetzen over een zelve voorwerp ziet verbeeld, ook vol van veranderingen zoo ten opzigt van de wezens, en wyze van staan, als in den toestel der kleedingen; waar in hy boven anderen (inzonderheid zulken, die dezelve wezens en kleedingen, even of het al tweelingen waren, in hunne werken te pas brengen) is te pryzen. Ja hy munte daar in boven allen uit: en niemant weet ik dat zoo menige verandering in afschetzingen van een en 'tzelve voorwerp gemaakt heeft; 't welk ontspruit uit aandagtige bedenkingen der menigerhande Hartstochten...'

11. Hoogstraten 1678, p. 75, my translation: '...maer van de laetste tot een proef, zoo was Durer gezet op meest eenerley stof van kleederen, Lukas van Leyden op zedicheit, Rubens op rijklijke ordinantien, Antony van Dijk op bevallijkheit, Rembrand op de lijdingen des gemoeds, en Goltsius op eenige groote Meesters hand eigentlijk na te volgen.'

12. Benesch 1973, 482.

13. The sketch of the executioner on the verso relates to the etching of the *Beheading of John the Baptist* (White and Boon 1969, B. 92) which is dated 1640.

3 · PAGES 73–100

1. Strauss and Meulen 1979, 1656/12.

2. Rembrandt's restored house is now a museum, the Rembrandthuis. A guidebook by Fieke Tissink, Amsterdam-Ghent (Ludion) 2003, gives an excellent idea of the layout.

3. Strauss and Meulen 1979, 1656/12: no. 345.

4. Lairesse 1707, p. 28, my translation. The link between Lairesse and this painting was made by Haveman et al. 2006, p. 223. 'Doch eer men de kóól op papier begint te brengen om te schetsen, zo is het nodig, en byzonder voordeelig, dat den Leerling, zyn voorwerpen daar hy naar tekenen zal, een wyl tyds, met een goede en starke aandacht overziet, waarneemende hoe de Beelden en voornaamste Leeden te zaamen koppelen, waar het hoogste, en laagste &c. Ja zo lange, dat hy de stand

der beelden, daar van in zyn geheugenis vast gedrukt heft, door het welke men een groote verligtinge, en vaardigheid in zyne oeffening zal bespeuren.'

5. For the taste for Lucas van Leyden's prints, see Cornelis/Filedt Kok 1998. Hoogstraten 1678, p. 221, exaggerating somewhat, specifies the figure of 80 rijksdaalders, which is equivalent to 200 guilders.

6. Strauss and Meulen 1979, 1656/12 lists in the *kunst caemer* 'Another [book] with copper prints by Vanni and others, including Barocci'. In September 1641 Rembrandt and Saskia's son Titus was born; the couple had previously had three children all of whom died in infancy.

7. Hoogstraten 1678, pp. 192–93, my translation: 'Poog met al uw kracht, ô yverige Schilderjeugt, u te bequamen tot eygen vindingen. Apelles en Protogenes weken van de wegen van Micon, Diores, en Arymnas haere voorgangers af. Zoo deden Paulo Kalliary en Tyntoret, en sloegen nieuwe wegen in. Wie weet of de konst noch hooger te brengen is. Tast stoutelijk toe, en waeg'er uw papier aen, mooglijk zal u d'oeffening overvloeiende rijk van ordinantie maeken. Niettemin zal't u geoorloft zijn, wanneer u eens anders wel geordent stuk te vooren komt, de vois of wijze der toonen, dat is, de zwier van koppeling en sprong daer uit t' ontleenen... Ten is geen schande op een bekende vois, die reets al de werelt behaegt, eenige vaerzen te dichten. Maer hier in moetmen toezien, datmen een andere stoffe verhandele: en aldus heeftmen dien Schilder prijswaerdich geacht, die dezelve kracht der konst in zijn Schilderye van Achilles te weeg bracht, die men weleer in den Alexander van Apelles bespeurt hadde.'

8. Strauss and Meulen, 1979, 1656/12: no. 38 was 'A Raising of Lazarus by the same [Rembrandt]' and no. 42 'A Raising of Lazarus by Jan Lievensz'.

9. Other subjects painted by both artists include *Samson* (c.1627–30) and *Christ on the Cross* (1631, fig. 22).

10. Schwartz 1985, pp. 73–76. Van Mander's *Schilder-Boeck* (1604) has a long section based on Pliny about ancient painters.

11. London 1992, no. 15. Royalton-Kisch 2010, no. 12; Benesch 1973, 17.

12. London 1992, no. 15.

13. Inv. no. 1932.348; it is currently attributed to Raphael's pupil Polidoro da Caravaggio (c.1499–1543).

14. Strauss and Meulen 1979, 1637/2, 1638/2.

15. Royalton-Kisch/Ekserdjian 2000, pp. 52–56.

16. In his *Entombment*, the Pala Baglione of 1507, Raphael based his principal figure group on this engraving by Mantegna.

17. In the exotic *Self-Portrait* of 1631 (Petit Palais, Paris; *Corpus* I, A 40), Rembrandt portrayed himself in the oriental costume of Balthasar, the king who appears at far right in the print with hand on hip.

18. Hoogstraten 1678, p. 190: 'Rembrant heeft deeze deugd dikmaels wel begrepen, en de beste stukken van Rubens, en zijn navolger Jordaens, hebben een by zonder welstandige sprong en troeping.'

19. Golahny 2003, pp. 81–88.

20. Hoogstraten 1678, p. 212, my translation: 'Zeeker, het past een Konstenaer wel, dat hy de printen en teykeningen der voorgaene Meesters in eeren houd: want buiten dat hy de konst in 't geheel in achting stijft, zoo vind hy gestadich eenige voorwerpen, die hem den geest wakkeren, en aen eenige nieuwe vindingen doen gedenken.'

4 · PAGES 101–129

1. I am grateful to Arie Wallert, Rijksmuseum Amsterdam/University of Amsterdam, and Jørgen Wadum and Anne Haack Christensen, National Gallery of Denmark /CATS, Copenhagen, for the interesting and inspiring discussions we had about the *Entombment*.

2. *Corpus* III, A 105, pp. 65–69.

3. Hofstede de Groot 1893.

4. Valentiner 1956.

5. *Corpus* III, A 126.

6. *Corpus* V, pp. 183–84.

7. Kaak 1994, p.101.

8. Infrared reflectography was performed by Rachel Billinge, Conservation Department, National Gallery using the digital infrared scanning camera OSIRIS which contains an indium gallium arsenide (InGaAs) sensor. For further details of the camera see www.opusinstruments.com/index.php. I am indebted to Rachel for her advice on this chapter. In the Scientific Department, David Peggie performed GC–MS for binding media analyses, Helen Howard carried out PLM and SEM on the cross-section. I thank them both for their help. Joe Padfield assisted with imaging the painting. We are grateful to Ashok Roy for making the arrangements for the panel to come to London for the technical investigation.

9. My translation, Houbraken, 1718–21, pp. 258–59: 'Maar een ding is te beklagen dat hy zoo schigtig tot veranderingen, of tot wat anders gedreven, vele dingen maar ten halven op gemaakt heeft, zoo in zyne schilderyen als

nog meer in zyn geëtste printkonst, daar het opgemaakte ons een denkbeeld geeft van al 't fraais dat wy van zyne hand gehad zouden hebben, ingevallen hy yder ding naar mate van het beginsel voltooit hadde, als inzonderheid aan de zoo genaamde honderd guldens print en andere te zien is, waar omtrent wy over de wyze van behandelinge moeten verbaast staan; om dat wy niet konnen begrypen hoe hy het dus heeft weten uit te voeren op een eerst gemaakte ruwe schets…'

10. Van Mander 1604, 46 (v), my translation: 'Ick en derf u niet prijsen noch versmaden/Dat eenighe wel gheoeffent expeerdich/ En vast in handelinghe cloeck beraden/ (Niet licht'lijck verdolend' in cromme paden/ maer om hun Const zijn Meesters name weerdich)/ Gaen toe, en uyt der handt teyckenen veerdich/ Op hun penneelen, t'ghene nae behooren/ In hun Ide' is gheschildert te vooren.'

11. Houbraken 1718–21, p. 259: 'En dus ging het ook met zyne schilderyen, waar van ik er gezien heb, daar dingen ten uitersten in uitgevoert waren, en de rest als met een ruwe teerkwast zonder agt op teekenen te geven was aangesmeert.'

12. Smith 1692, p. 22.

13. Miedema 1981, pp. 31–33. See also Bruyn 1979.

14. Bomford et al. 2006, p. 23.

15. Dendrochronological research on the Glasgow panel was performed by Dr Aoife Daly, Marie Curie Research Fellow, University College Dublin, CCA-report 7, 2012, and we are grateful for her work. It should be noted that although an increasing amount of tree-ring data is being collected from a larger area, the greatest number of references is still from the wider Baltic region (Tyers 2010, p. 47).

16. Kirby 1999.

17. On the subject of grounds on canvas, see Groen 2005.

18. *Corpus* V, pp. 318–34, pp. 60 ff with Table showing grounds used on panels and canvases.

19. Hoogstraten 1678, p. 238: 'Maer de lief-hebbers gaeven den moedt bynae verlooren, als zy zagen hoe traegelijk hy met zijn penseelen handelde, jae het scheen in 't eerst, dat hy moedwillens den tijdt verquiste, of niet en wist, hoe te beginnen: en dit quam, om dat hy eerst in zijn inbeelding 't geheele bewerp van zijn werk formeerde, en in zijn verstandt een schildery maekte, eer hy verw in 't penseel nam.'

20. *Tobias Healing his Father's Blindness*, pen and brown ink touched with gouache, framing lines in brown ink, 21.1 × 17.7 cm, Cleveland Museum of Art.

21. Wadum 2003, p. 501.

22. Wadum 2002, pp. 62–77.

23. Strauss and Meulen, 1979, 1656/12: no. 111, p. 359.

24. *Corpus* IV, pp. 3–44.

25. Bomford et al. 2006, p. 32 and pp. 35–36.

26. This aspect is extensively discussed in Van Eikema Hommes/Van de Wetering 2006, which makes a comparison between Caravaggio and Rembrandt.

27. Analyses done by Helen Howard, Scientific Department, National Gallery, London and Peter Chung, ISAAC, Geographical and Earth Sciences, University of Glasgow, using a FEI Qanta 200F Edax Microanalysis SEM system.

28. Bomford et al. 2006, p. 37.

29. Bomford et al. 2006, p. 95.

30. We thank David Peggie, Scientific Department, National Gallery, London for these results. A sample from the top edge above Christ's head containing a light-coloured layer, probably the *primuersel* layer: *GC-MS analysis* – heat-bodied linseed oil [A/P 1.1; P/S 1.6; A/Sub 4.2]; a sample at top edge above figure holding Christ's feet, containing brown earth pigments, probably the dead colouring layer: *GC-MS analysis* – heat-bodied linseed oil [A/P 1.2; P/S 1.6; A/Sub 3 1]. Both samples also contained some old and new dammar resin most probably associated with varnish layers.

31. Bomford et al. 2006, p. 131.

32. Noble and Van Loon 2005, p. 87.

33. Sandrart 1675–80, vol. 2, Book 3, Chapter 22, p. 327: 'In seinen Werke ließe unser Künstler wenig Liecht sehen, außer an dem fürnehmsten Ort seines Intents, um welches er Liecht und Schatten künstlich beysammen hielte…'

34. Hoogstraten 1678, pp. 305–6: 'Laet uwe sterkste lichten met minder lichten minlijk verzelt zijn, ik verzeeker u, datze te heerlijker zullen uitblinken; laet uwe diepste donkerhaen met klaere bruintens omringt zijn, opdat ze met te meerder gewelt de kracht van het licht mogen doen afsteeken. Rembrant heft deeze deugt hoog in top gevoert, en was volleert in 't wel, byeenvoegen van bevriende verwen.'

35. For an extensive discussion of light and shade in Rembrandt, see *Corpus* V, pp. 71–80. See also Van Eikema Hommes/Van de Wetering 2006, who compare the use of light and shade by Rembrandt and Caravaggio, pp. 173–79.

36. Hoogstraten 1678, p. 267: 'Laet dan, om deze zaek wel te verstaen, gezegt worden de klaerheit van de Zonne zelf hondert, maer haer licht, dat zy aen de dingen, die zy beschijnt, gevende is, tien te zijn: de schaduwe in d'ope lucht vijf: het lichtste in een kamer vier: de weerglansen twee: de opene schaduwen een: de holle dieptens O: dat is, zonder licht, of ten uitersten donker.'

37. Hoogstraten 1678, p. 267: 'Ik meyne hier niet, datmen geverfde kleederen of iets dat van natueren bruin is, noch zelfs het blanke naekt, met witten of mastekotten moet ophoogen, want dat acht ik belachelijk; maer ik wil datmen deeze verwen alleen met d' alderklaerste lichten vergelijke, en haer dus met zijn gedachten in den eersten graet stelle. In den tweeden graedt stellen wy, als half verlicht, de schampingen, en vergelijken die met onze mezetinte, of half-verwen op de bruinte van ookers. In den derden graet stellen wy, als maer een vierdepart verlicht de gemeene reflexien of wederglansen, deur-schijningen, en al wat in de schaduwe eenige kennelijkheyt verooorzaekt; en vergelijken die tegens bruin root. De rechte schaduwen, die echter noch eenich scheemerlicht deelachtich zijn, als misschien een achtste deel, stellen wy in den vierden graet: en vergelijken die met omber. Maer de holle dieptens, die van alle licht of wederglans berooft zijn, stellen wy in den vijfden en laetsten graedt, en vergelijken die met onze zwarten, en alderdiepste verwen.'

38. Hoogstraten 1678, p. 268: 'En zeker, wanneermen iets byzonders in Schildery vertoonen, en alles in volle kracht doen zien wil, zoo is 't ook wel waert, datmen de vlam van een kaerse of fakkel ergens doe achter schuilen: want die bloot laetende, zou denze 't vermoogen van onzen eersten graed van licht alleen behoeven.'

39. Van Hoogstraten 1678, p. 306: 'Rembrant heeft deeze deugt hoog in top gevoert, en was volleert in 't wel byeenvoegen van bevriende verwen.'

40. Taylor 1992.

41. Sandrart 1675–80, vol. 1, book 3, chapter 13, p. 85.

42. Houbraken 1718–21, p. 258: 'Hy was in opzigt van de Konst ryk van gedagten, waar om men van hem niet zelden een menigte van verschillige schetzen over een zelve voorwerp ziet verbeeld, ook vol van veranderingen zoo ten opzigt van de wezens, en wyze van staan, als in den toestel der kleedingen.'

43. Rembrandt's fifth letter, Gerson 1961, p. 54.

PHOTOGRAPHIC CREDITS

AMSTERDAM
Collection Rijksmuseum Amsterdam, p. 24 (fig. 3) / Collection Rijksprentenkabinet, Rijksmuseum Amsterdam, p. 60 (fig. 27) / Stadsarchief Amsterdam, p. 33 (fig. 8)

ANTWERP
The *Descent from the Cross* in its surroundings in the Cathedral of Our Lady, Antwerp, photographed by Mark Walker on 13 December 2011, p. 45 (fig. 16)

BRIGHTON
© The Royal Pavilion & Museums, Brighton & Hove, p. 84 (fig. 46) and p. 86 (fig. 47)

CAMBRIDGE, MASSACHUSETTS
Houghton Library, Harvard University, p. 51 (fig. 21)

DUBLIN
National Gallery of Ireland Collection, Photo © National Gallery of Ireland, p. 69 (fig. 33)

EDINBURGH
Edinburgh University Library, Special Collections Department, p. 57 (fig. 24) and p. 123 (fig. 73) / Rembrandt, *The Entombment* (Bartsch no. 86 III/4), Scottish National Gallery, p. 65 (fig. 30) / Rembrandt, *Christ Crucified between the Two Thieves (The Three Crosses)* (Bartsch no. 78 IV), Scottish National Gallery, p. 68 (fig. 32) / Rembrandt, *Christ Healing the Sick ('The Hundred Guilder Print')* (Bartsch no. 74 II/2), Scottish National Gallery, p. 104 (fig. 59) / Rembrandt, *Ecce Homo: Christ Presented to the People*, Scottish National Gallery, p. 70 (fig. 34)

GLASGOW
© Glasgow Life (Glasgow Museums), given by Sir William and Constance, Lady Burrell, 1946, p. 48 (fig. 19) / Glasgow University Library, Special Collections Department, p. 32 (fig. 7), p. 44 (fig. 15) and p. 98 (fig. 56) / The Hunterian, University of Glasgow, p. 28 (fig. 5), p. 38 (fig. 11) and p. 47 (fig. 18)

HAARLEM
Teylers Museum Haarlem, The Netherlands, p. 97 (fig. 55)

LONDON
© The Trustees of the British Museum, p. 27 (fig. 4), p. 37 (fig. 10), p. 39 (fig. 12), p. 58 (fig. 25), p. 63 (fig. 28), p. 71 (fig. 35), p. 74 (fig. 37), p. 76 (fig. 40), p. 88 (fig. 48), p. 90 (fig. 50), p. 92 (fig. 51) and p. 115 (fig. 68) / © The Samuel Courtauld Trust, The Courtauld Gallery, London, p. 46 (fig. 17) / Rembrandt, *Ecce Homo (Christ before Pilate)* © National Gallery, London, p. 36 (fig. 9) / Rembrandt, *The Lamentation over the Dead Christ* © National Gallery, London, p. 40 (fig. 13) / Thomas de Keyser, *Portrait of Constantijn Huygens* © National Gallery, London, p. 49 (fig. 20) / Technical images of the *Entombment Sketch* (The Hunterian, University of Glasgow) courtesy of the National Gallery, London

LE MAS D'AGENAIS
Rembrandt, *Christ on the Cross*, Church of Saint-Vincent, Le Mas d'Agenais, France / Giraudon / Credit: The Bridgeman Art Library, p. 53, (fig. 22)

LOS ANGELES
Los Angeles County Museum of Art (www.lacma.org), p. 83 (fig. 45)

MUNICH
© bpk, Berlin / BStGS / Alte Pinakothek, Munich, p. 21 (fig. 2) and p. 60 (fig. 26)

NEW YORK
Rembrandt, *The Entombment* after Mantegna, Metropolitan Museum of Art, Bequest of Walter C. Baker, 1971 (1972.118.285). © 2012 Image copyright The Metropolitan Museum of Art / Art Resource / Scala, Florence, p. 96 (fig. 54)

PARIS
Fondation Custodia, Collection Frits Lugt, Paris, p. 30 (fig. 6) / © Erich Lessing p. 75 (fig. 38)

ROTTERDAM
Museum Boijmans Van Beuningen, Rotterdam, p. 55 (fig. 23)

INDEX OF NAMES AND WORKS